Renaissance Florence

The Invention of a New Art

Renaissance Florence

The Invention of a New Art

A. Richard Turner

PERSPECTIVES

PRENTICE HALL, INC.,

and HARRY N. ABRAMS, INC., PUBLISHERS

Acknowledgments

A short work of synthesis devoted to such well-ploughed territory as early Florence incurs huge debts. The bibliography will have to do as thanks, but at the risk of exclusion by inclusion, the work of the following has been especially important to me: Brucker, Burke, Dempsey, Elkins, Goldthwaite, Hood, King, Klapisch-Zuber, Martines, C. Smith, and Trexler.

The book grows directly from two seminars taught in 1995, one with New York University colleague Leonard Barkan, the other in Edmondo Danon's program in Spoleto, "Hesperia." Special thanks to Leonard and Edmondo, and to our students. Working with Calmann and King was a pleasure. Thanks to Lesley Ripley Greenfield, Susan Bolsom-Morris, and Tim Barringer, who provided invaluable suggestions, Celia Jones, and most especially to series editor Jacky Colliss Harvey. Simone Clemente-Martinez gained beatitude by converting my Visigothic script to computer disc.

Jane, as always, was supportive in every way. The book is for our sons Louis and David, and daughters-in-law Rodden and Robin.

Frontispiece ANONYMOUS *The Execution of Savonarola,* page 155 (detail)

Series Consultant Tim Barringer (University of Birmingham)
Series Director, Harry N. Abrams, Inc. Eve Sinaiko
Senior Editor Jacky Colliss Harvey
Designer Sara Robin
Cover Designer Judith Hudson
Picture Editor Susan Bolsom-Morris

The Library of Congress has cataloged the Abrams edition as follows:
Turner, Richard, 1932-
 Renaissance Florence : the invention of a new art / A. Richard Turner.
 p. cm. — (Perspectives)
 Includes bibliographical references and index.
 ISBN 0-8109-2736-5
 1. Art, Italian — Italy — Florence. 2. Art, Renaissance — Italy — Florence
 I. Title. II. Series: Perspectives (Harry N. Abrams, Inc.)
N6921.F7T83 1997
709'.45'5109024 — dc20 96–33309

The Prentice Hall edition ISBN for this book is 013-618448-0

Copyright © 1997 Calmann & King, Ltd.
Published in 1997 by Harry N. Abrams, Incorporated, New York
A Times Mirror Company
Prentice Hall, Inc.
Simon & Schuster/A Viacom Company
Upper Saddle River, NJ 07458

This book was produced by Calmann & King, Ltd., London
Printed and bound in Hong Kong

Contents

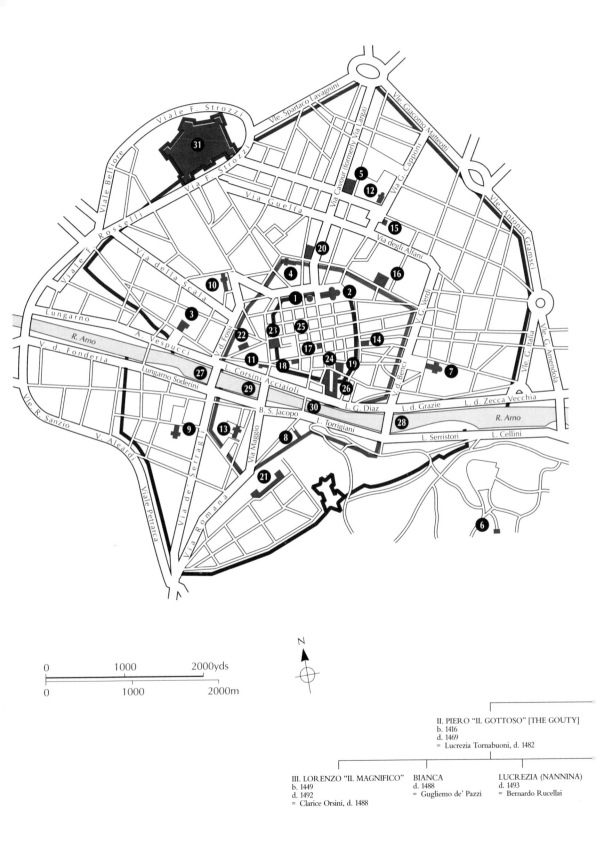

0 1000 2000yds

0 1000 2000m

N

Renaissance Florence

Genealogy of the Medici in Florence, 1360 – 1503

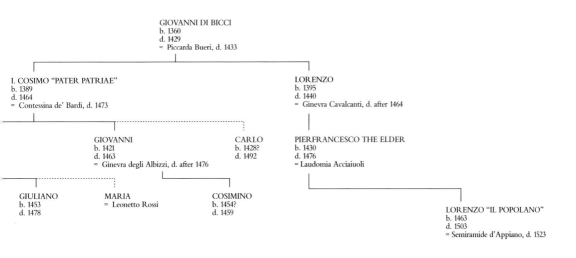

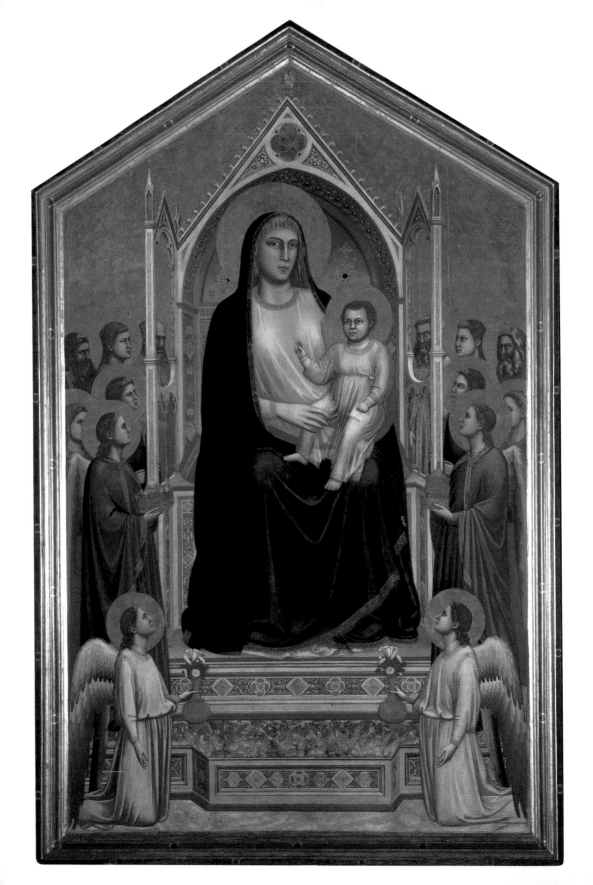

Introduction

1. GIOTTO DI BONDONE
Ognissanti Madonna,
c. 1306-10. Tempera on
panel, 10′8″ x 6′8¼″
(325 x 204 cm). Uffizi,
Florence.

Giotto's innovations
brought a new sense of
sculpted mass to the painted
human figure, placing it in
a more credible illusion of
space.

A trip to Florence itself, or vicarious voyaging there via prose and illustrated book, vividly reveals what everyone learned as a child, that the city nurtured a constellation of remarkable persons, many of whom left an indelible mark on the city in the form of buildings and works of art. Indeed Florence, like Athens in the fifth century BC, is as much or more a cultural idea and ideal in the mind of the west as it is a physical place.

Reading the words of Florentines, now dead more than five hundred years, one discovers a palpable sense of energy and enthusiasm, and the recurrent use of the word *rinascità*, rebirth. Rebirth of what? Rebirth of excellent performance, excellent product, a better way of living, no doubt; notions ineluctably linked to an invigorating confrontation with a rediscovered "other," the people and thought of Greek and Roman antiquity. Beyond writing well, these people led exemplary lives. From them one could imbibe wisdom at a time when daily behavior was increasingly in conflict with traditional tenets of Christianity.

The concept of *rinascità* was adduced in relation to disparate Florentine activities, such as letters or the visual arts, but with scant agreement on the key players, events, or dates. No one at the time used the word to connote a holistic rebirth or revival of all aspects of society.

The idea of such a holistic revival – *il rinascimento*, the Renaissance – was a nineteenth-century invention, first sketched in 1855 by the French historian Jules Michelet (1798-1874), and then brilliantly elaborated by the Swiss scholar Jacob Burckhardt (1818-79) in his *Die Kultur der Renaissance in Italien (Civilization of*

the Renaissance in Italy), published in 1860. Burckhardt's thesis was that Italians lifted the dead hand of medieval thought and social arrangements, and in so doing formulated values and behaviors that prefigure those of the modern world.

Rather than being a traditional chronological story of rulers and wars, Jacob Burckhardt's book is about cultural history, with the emphasis on intellectual and artistic achievements. His approach is thematic, with cross-sections taken through six topics, drawing on material from about 1300 to 1500 throughout Italy. A mere listing of the titles of Burckhardt's six parts reveals his approach: "The State as a Work of Art"; "The Development of the Individual"; "The Revival of Antiquity"; "The Discovery of the World and of Man"; "Societies and Festivals"; "Morality and Religion."

Burckhardt's book is in itself a work of art, compellingly organized and ocular-erotic in its descriptions. No matter that modern scholarship has modified some of his interpretations, seeing continuity where he saw a sharp break with the Middle Ages, criticizing his overly optimistic views concerning the autonomy of the individual and the place of women, and pointing out his failure to assess properly the continuity and pervasive presence of traditional Christianity. Nonetheless, the book remains a beautifully written and powerful mental construct that has set the agenda for over a century and a half of scholarship on the Renaissance.

Burckhardt claimed that his contemporaries were the descendants of the first-born sons and daughters of modern Europe. For us, however, the "Renaissance" seems a remote age, and we see things that Burckhardt chose not to see. Arguably the roots of modernity lie rather in the eighteenth century. It was then that Europe moved from being an agricultural society to an industrial one, from aristocratic political arrangements towards democracy, from moral philosophy to belief in the evidence of nature, from religion to science as the primary source of the explanation of natural phenomena and the basis for solving human problems. Slightly later, the rise of the transportation revolution saw locomotion by foot and animal give way to the machine. Since Burckhardt's death the gap between us and the old Florentines has widened further with the advent of the automobile and airplane, and the more recent communications "revolution," all of which foster the imperfectly realized ideal of a global community.

What, then, is the rationale for a book on art in its social context which takes the period c. 1300-1500, with emphasis on the latter century, as its subject? First, fifteenth-century Florentine art, culminating in the polymath Leonardo da Vinci (1452-1519)

and Michelangelo Buonarotti (1475-1564), laid the foundation for three centuries of practice and theory in European art. The articulation of that position was first laid out by Leon Battista Alberti (1404-72), humanist (student of Greek and Roman letters) and architect, in his *De Pictura* (*On Painting*) of 1435.

Second, republican freedom, which had been the glory of Florence for more than two centuries, was extinguished towards the end of the fifteenth century. The keynote events of this complex demise were the death in the spring of 1492 of Lorenzo de' Medici (1449-92), de facto ruler of Florence and one of its intellectual luminaries, and the invasion of Italy by the French in 1494, which was the precursor of centuries of foreign domination. The Florentine historian Francesco Guicciardini (1483-1540) tersely described the 1490s as the "calamità d'Italia" – the calamity of Italy.

Third, though not evident to a Guicciardini or a Burckhardt, the years c. 1300-c. 1500 can be characterized as having two major successive phases. The first was an economic boom, culminating in the early fourteenth century, that had the disturbing side-effect of confronting traditional Christian beliefs with new and incompatible secular behavior. The second phase began around 1350, when the words and images of pagan antiquity were called upon as a resource in an attempt to reconcile these old beliefs and new forms of behavior.

The Geography of Renaissance Italy

The basic geographical fact of the Italian peninsula is its lengthwise division by substantial mountains (the Apennines), with spurs running to either side towards the sea, a configuration that one fifteenth-century writer likened to the skeleton of a fish. Before the appearance of air pollution, there were few places in Italy where mountains could not be seen in the distance. These mountains made Italy, like the ancient city-states of Greece, a compartmentalized landscape of separated valleys and plains, and travel from one to the other was difficult, especially during the winter months (FIG. 2).

This sort of terrain meant two things. First, it inhibited regional, let alone national, unification. Physical separation bred local dialects, customs, and a multiplicity of systems of weights, measures, and coinage. Second, until the consolidation of the monarchies of Europe in the fifteenth century, no army had an adequate chain of supply to permit effective military operations on the Italian peninsula. Bellicose behavior among the Italian towns was mainly carried out in rural territory, and until the advent of

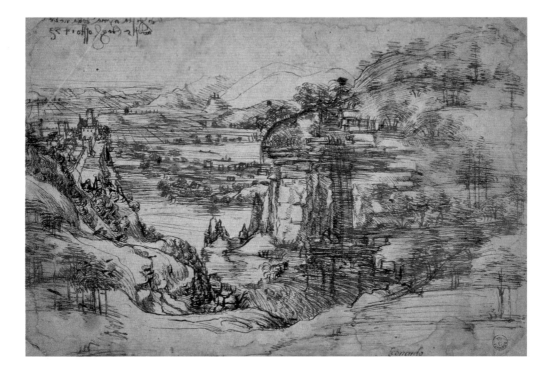

2. LEONARDO DA VINCI
Landscape, 1473. Pen and
ink on paper, 7³/₄ x 11³/₄"
(19 x 28.5 cm). Uffizi,
Florence.

This drawing, inscribed *5
August 1473*, was probably
done at an unidentified
elevation overlooking the
Arno valley. Such
juxtaposition of hills and
plain is found throughout
Italy.

effective cannon in the later fifteenth century, rarely involved high
casualties or a physical threat to the towns themselves.

The Towns of Renaissance Italy

During the Renaissance, no town in the western world, save pos-
sibly the present Mexico City, was larger than 200,000 persons.
Fourteenth- and fifteenth-century Europe was pervasively rural,
consisting mainly of small settlements characterized by mutual
obligations of peasants who worked the land and the lords who
lived off their produce and, in turn, offered them protection. Con-
stellations of towns were the exception, and found in three places,
the Netherlands, the Rhine valley, and Italy.

Two things set Italy apart. The towns often had Roman
origins, and to a degree survived the social disorder of the bar-
barian invasions of the earlier Middle Ages. Not only was phys-
ical infrastructure often in place, but also the glue which gave
order to civic arrangements, in the form of the hardy survival
of Roman law. Each town had its myth of origin, which not
surprisingly usually featured an illustrious Roman, in the case
of Florence variously Julius Caesar or the Emperor Augustus. The
map of Italy in these years is a map of city-states, with villages
scattered among them.

The Florentine Economy

Every town had its distinct economic basis, for instance maritime trade in Genoa and Venice, an arms industry in Milan, and in Florence banking, the cloth industry, and international trade. Early on Florence developed the most sophisticated economic methods in Europe. Her "florin" (FIG. 3), first minted in 1252, became the international monetary standard, and the invention of double-entry book-keeping facilitated efficient business procedures. Florentines were bankers to the popes, and lenders to European monarchs, and they established mercantile colonies from the Netherlands to the Iberian peninsula, to Constantinople, not to mention the major cities of Italy. Badly shaken by loan defaults in the earlier fourteenth century, the system nonetheless survived, producing the greatest bankers of the Italian fifteenth century, the house of Medici, whose power crystallized in Cosimo de' Medici (1389-1464), dubbed soon after his death "Pater Patriae," father of his country.

The guilds (associations of master craftsmen and tradesmen) constituted the infrastructure of the Florentine economic system. In 1393 a poet described Florence as "la terra di mercantatia," and indeed it was the land of mercantilism and manufacturing. The various guilds represented the recognized commercial enterprises, ranging from butchers to lawyers. There were seven major guilds (*Arti Maggiori*), and fourteen minor ones (*Arti Minori*). Since only members of the former were eligible for elective civic office, membership was essential to any man who aspired to public office.

Guilds set the standards for the occupation in question – conditions of apprenticeship, qualifications for guild matriculation, quality of materials and workmanship, and strictures against misrepresentation and fraud. Guilds disciplined their own members, and a merchants' court adjudicated any disputes arising between them.

Beyond strictly business matters, the guilds were centrally involved in religious activity and charity (FIG. 4). Each guild participated in the major religious holidays of the city, and each had responsibility for the celebration of the feast day of its specific patron saint. The guilds also oversaw and had financial responsibility for the city's major churches, and for its some thirty-odd "hospitals," hospitals both in the modern sense, and charitable foundations. Therefore to imagine a Florence without the guilds is to see a city gutted of its financial strength and philanthropic compassion.

3. The Florentine florin, showing the lily of the city. Museo Bardini, Florence.

Noted for the purity of its gold, the coin was later imitated in other European countries. St. John the Baptist is represented on the other side.

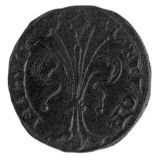

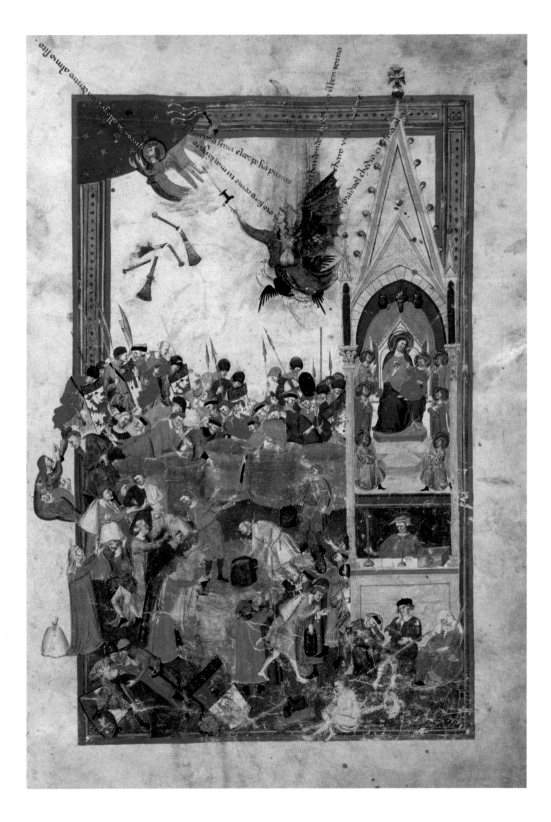

Florentine Education

A city dedicated to banking, manufacture, and international trade presupposes, at least above the level of manual labor, citizens both verbally and numerically literate. While the evidence is sporadic, it is likely that Florence possessed the highest literacy rate – perhaps at least a third of males – of any city in Europe. Children achieved the rudiments of reading and calculation in the equivalent of an elementary school, some of them then passing to an abacus school, where practical mathematics was taught. By the mid-teens a decision was taken that determined their fortune and associates for a lifetime. They could enter a trade (and for many this happened at a much younger age), a world of the workshop, apprenticeship, hands-on training, and vernacular Italian. Or they might follow a path to the university, the world of intellectual work and Latin (the universal language of the learned), in preparation for a career in religious or bureaucratic circles. Only one minor full-time artist of the period is known to have gained a university degree, and many-sided men who managed to straddle the worlds of the artist's studio and intellectual's study, such as Alberti and Leonardo da Vinci, were rare.

The Politics of Renaissance Florence

The political landscape of early Europe is sufficiently complex and confusing almost to defy responsible summary. The city-states of Italy each found themselves at various times attracted to or in retreat from the two "super powers" of the time ("super" more in allegation than fact), the papacy and the Holy Roman Empire, the latter centered on Germany. The papacy had trouble enough keeping its own affairs in order after its claims to being a universal institution began to fade by the mid-thirteenth century. The Holy Roman emperors always craved the peninsula, but internal weakness and the formidable peaks of the Alps and the Apennines prevented the dream from becoming a reality. Nonetheless, both powers became rallying points for individual cities and leagues of cities, indeed for contesting alliances of opposing families within each city.

Textbooks simplify the matter: the Guelfs were the party of the papacy, the Ghibellines of the emperor. While until about 1300 this was largely true, in the fourteenth century the distinction faded to meaninglessness as pragmatic and opportunistic alliances often flew in the face of Guelf/Ghibelline ideology.

For Florence the crucial distinction lay between republic

4. BIADAIOLO MASTER *Distribution of Grain to the Needy at Orsanmichele,* c. 1335-40. Manuscript illumination. Biblioteca Medicea Laurenziana, Florence.

The income of the Orsanmichele was enormous. The miniature shows how a "safety net" for the poor was provided long before the rise of the welfare state.

and principality. The mode of city-state government in north Italy, Venice excepted, was the autocratic rule of a princely family. Tuscany, in contrast, boasted three genuine republics in which the nobles were excluded from rule: Lucca, Siena, and Florence. More than any other person, the first Florentine chancellor (executive secretary of the bureaucracy), Coluccio Salutati (1331-1406), was the articulate champion of republican freedom, equating the actual freedom of Florence with the potential freedom of all of Italy. Salutati was the crucial figure of one of Florence's greatest crises, when the city's defeat by Milan in 1402 was averted only when the latter's leader unexpectedly died. While the details of republican government varied over time, the constants were a minority of males eligible for elective office (members of the major business guilds), brief terms of office to forestall plots and corruption, and a bureaucracy of men ineligible for elective office who provided governmental continuity.

Barely a generation after Salutati's death the republican ideal began to be compromised. Cosimo de' Medici returned to Florence in 1434 after brief exile in Venice caused by the temporary rise to power of the rival Albizzi family, and began his covert political career as a brilliant behind-the-scenes manipulator of the public machinery of republicanism. Over the course of the century the chancellorship, at first a position of moral and intellectual leadership, declined to titular impotency. Lorenzo de' Medici, Cosimo's grandson, became prince of Florence in all but name between 1469 and his death in 1492. This was but a harbinger of Medici princely rule, which from 1512, with brief interruption, was to dominate Florence for several centuries.

The Religion of the City

Christianity permeated Italian life, atheism and agnosticism being all but unknown. Of course, anticlericalism, of the sort notorious in Giovanni Boccaccio's (c. 1313-75) tales in the *Decameron*, was widespread, but bad behavior and tenets of faith should not be confused.

The role of the guilds has been touched upon, and two further religious institutions require exploration, the monastic orders and the confraternities. Reformed orders (those committed to a return to the ideals of their founders), among them the Augustinians, Carmelites, Dominicans, Franciscans, and Servites, were a dynamic factor in the religious life of Florence. The largest and most influential were the mendicants (begging friars): the Dominicans (founded by St. Dominic; 1170-1221), whose main

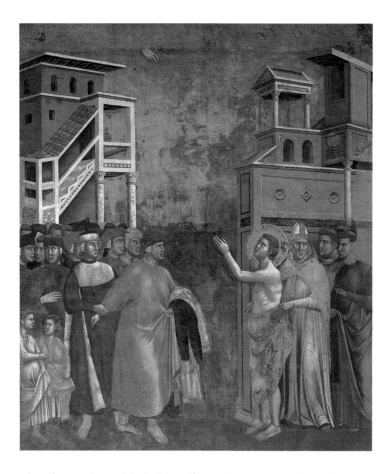

5. ANONYMOUS
St. Francis renounces his Patrimony, c. 1295-1305. Fresco. San Francesco, Assisi.

The twenty-eight monumental scenes of the life of St. Francis in the nave of the upper church were previously attributed to Giotto, but most scholars doubt this, preferring an attribution to several masters, who originated in Rome, Florence, or both.

church was Santa Maria Novella on the western edge of town; and the Franciscans (founded by St. Francis; 1182-1226), whose church of Santa Croce was to the east. Like the other orders, the Franciscans ministered to the growing population of the city through preaching and good works, and served as the bothersome conscience to the moneymakers of the city. St. Francis, the son of a wealthy merchant, had dedicated his life to poverty, chastity, and obedience, after the definitively symbolic gesture of removing his clothing and thus renouncing his patrimony (FIG. 5).

The numerous confraternities of the city were assemblies of lay persons dedicated to strict religious observance, including singing hymns of praise (*laude*), the performance of good works, ministering to the sick and burying the dead, and the presentation of religious dramas, later in the fifteenth century called *sacre rappresentazioni* (sacred representations). The confraternities had a high profile on the city's streets, and ensured that religious life had a thoroughly communal, as opposed to personal, flavor.

Of Two Madonnas and a Myth

On 3 July 1292 a painted image of the Madonna began to perform miracles of healing in Florence, a fact noted by Giovanni Villani (c. 1270-1348) in his chronicle of Florentine history. The Madonna was painted on a pier of the loggia at the Orsanmichele, the old grain market. Destroyed by a fire that swept through the center of the city in 1304, she was promptly replaced, and replaced yet again in 1347. Such was the effect of her miracles that pilgrims flocked from every corner of Tuscany to worship her, and to leave money in vast quantities for charitable works. A confraternity was founded to sing hymns of praise and manage her affairs, and in the 1350s she was honored by the erection of a lavish marble tabernacle (FIG. 6). Soon afterward the grain market was moved, and the space became entirely hers when the arched openings of the loggia were walled in and the building was consecrated to St. Michael (San Michele in Orto).

Another miracle-making Virgin dwelled in a second shrine at Impruneta, some six miles (9.5 km) southwest of Florence. At Impruneta Our Lady was usually curtained; her powers were only activated when she was carried in ceremonial procession to the city, where, according to the requirements of the occasion, she might appear in church, or on the raised platform (*ringhiera*) in front of the town hall, the Palazzo della Signoria, where she was enthroned among the relics of saints. Our Lady presided at victory celebrations or when delicate political or diplomatic decisions hung in the balance, but her chief role was intercessionary and it was to her that Florentines turned in times of parching drought or just as the Arno was about to overrun its banks.

The Virgins of Orsanmichele and Impruneta concerned power in the form of potential spiritual gifts rendered as answers to prayer. Who made these paintings, when, and whether or not they were beautiful were secondary issues. The point was: did the image work, were the prayers addressed to the holy person thus represented answered?

If some objects might be at the center of spiritual transactions, others had power of another sort, the bearing of witness to the antiquity, continuity, and legitimacy of the city. Take those saints' relics that surrounded the Madonna of Impruneta on her visits to Florence. A relic is either a fragment of a holy person's body or an intimate possession – a lock of hair, a scrap of a habit – or a holy object, such as a sliver of the True Cross. The relic is housed in a reliquary, a container usually made of precious metal, often assuming the form of the object contained within, such as a

6. ANDREA ORCAGNA
Madonna tabernacle,
1352-59. Marble and colored glass.
Orsanmichele, Florence.

Orcagna's tabernacle houses the last of the miraculous images of the Madonna, painted by Bernardo Daddi (active c. 1312-48) in 1347. The fact that healing power could pass successively to new images made after the destruction of the original demonstrates that a given pictorial representation was not worshipped as an end in itself, rather as a spiritual gateway to the Virgin.

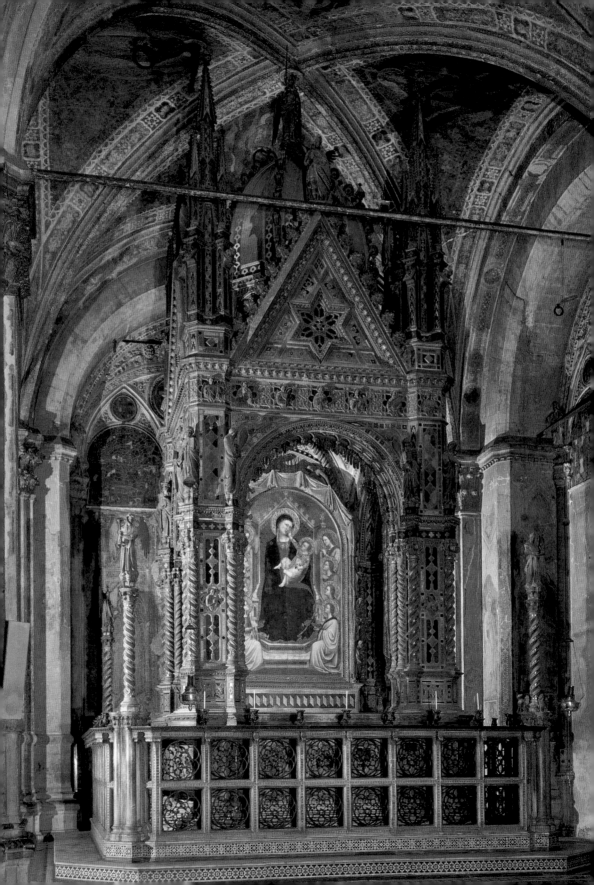

head or an arm. Relics were visible signs of the city's history rather than workers of miracles. The older the relic, and greater the fame of the person from whom it derived, the better. So in Florence the remains of Zenobius (d. AD 423), the city's only home-grown saint, were prized, but as much or more so the remains of John the Baptist, the imported patron saint of the city. While relics were the corporal evidence of the presence of the religious dead, they were also witness to the continually renewed religious life of the city.

The idea of a Florence in the vanguard of the affairs of the peninsula was in the air around 1300. Pope Boniface VIII (ruled 1294-1303) is said to have described the city "which seems to rule the world" as the fifth element of nature, after earth, water, air, and fire. This purported papal flattery is of course reported (possibly invented) by a Florentine. Giovanni Villani writes that he was among the 200,000 pilgrims who flocked to Rome in 1300, and it was then and there that he decided to begin his chronicle, "considering that our city, Florence, daughter and creature of Rome, was on the rise." The time was ripe for consolidating the myth of Florence, and this was the work of many minds over several decades. Put simply, that myth was built on three basic ideas, the Roman origins of the city, its place in the Christian world-view, and its cultural supremacy.

A thirteenth-century chronicle already boasts of the Roman republican origins of Florence, and by the time that the sixteenth-century sculptor Benvenuto Cellini (1500-71) claimed his descent from a lieutenant of Julius Caesar posted in Florence, the idea of Roman origins was a time-worn cliché. If a republic, Florence through time had been a Christian republic. During her history the idea recurs that Florence is the anointed favorite of the Lord, the most likely site of Christian renewal, indeed the New Jerusalem. God was deemed to have been present at the city's origins, responsible for the form of her institutions, and through intermediaries such as the Madonna of Impruneta, a guardian of her well-being.

Florence was steeped in her Roman origins and her Christianity, both playing to full effect when dressed in the rhetoric of cultural supremacy. Tuscan became the common language of Europe, to be succeeded by French only in the sixteenth century. The great Tuscans – Dante Alighieri (1265-1321), author of *La Divina Commedia* (*The Divine Comedy*; c. 1315), Giovanni Boccaccio, master of Latin and the vernacular, Francesco Petrarca (Petrarch; 1304-74), poet and humanist – were central to forging this linguistic supremacy, as were Florentine merchants whose

colonies spanned the known world. But were the literary figures authentic Florentines? Certainly Dante had every claim: born in Florence, though expelled never to return a decade before he began his great poem, *The Divine Comedy*. Boccaccio's case is less clear. He may have been born in Paris, or worse, in Certaldo, like many small towns in Tuscany held in little regard by the Florentines. Whatever the case, he grew up in Naples before moving to Tuscany. As for Petrarch, born in Arezzo, he spent most of his life in France and north Italy, and first set foot in Florence at the age of forty-six. No matter; they were Florentines all, at least by lineage, and in the late fourteenth century the government tried to get their bones returned to their "native" city, not surprisingly to no avail.

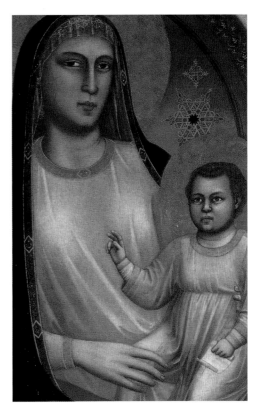

7. GIOTTO DI BONDONE
Ognissanti Madonna,
c. 1306-10 (detail of FIG 1).
Tempera on panel, 10'8" x
6'8¼" (325 x 204 cm).
Uffizi, Florence.

If literary figures were the building blocks of this cultural facade, no less so were the artists. Arguably, priority in the renewal of art around 1300 belongs to Rome and Assisi, but already Boccaccio dubs the true pioneer a Florentine, Giotto di Bondone (c. 1267-1337), the shepherd boy from the Mugello, the rural valley north of Florence, who came to the city and revived the moribund art of painting. Operating the length and breadth of Italy, Giotto produced many works that are now lost, his most striking surviving works being the frescoes in the Arena Chapel in Padua, and the great Ognissanti Madonna (see FIG. 1, page 9, and FIG. 7). Giorgio Vasari (1511-74), the mid-sixteenth-century artist and biographer of the artists, elevated this idea of Florentine supremacy in the visual arts to the canonical status it would enjoy for centuries, beginning the Florentine part of his story with Cimabue (c. 1240-1302?), who was vanquished by Giotto, and ending it with Michelangelo, who surpassed both nature and the antique at a qualitative level upon which no mere mortal could hope to improve. By then the message was clear: better to be Tuscan than Italian, and better yet to be Florentine than Tuscan.

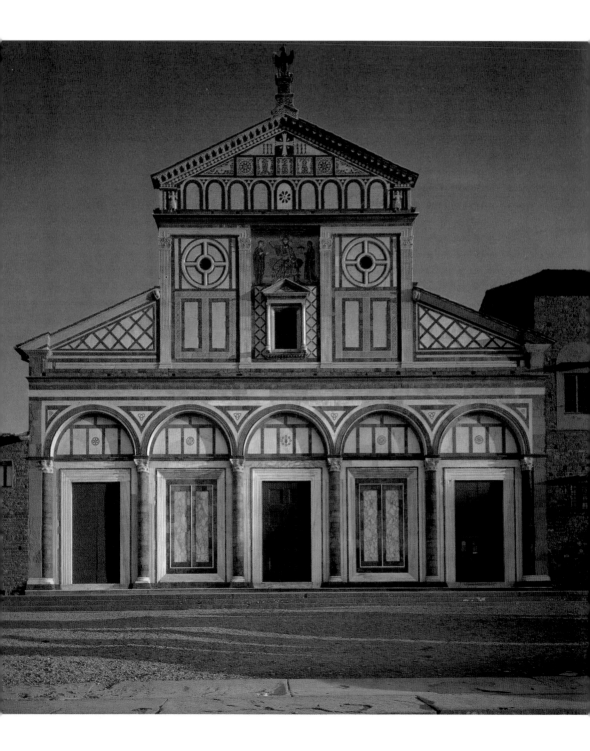

ONE

The City Rises

The city rises: the phrase echoes Giovanni Villani's words, but most of all confirms what the eye sees from any elevated vantage point on the south side of the Arno. The skyline is the result of an extraordinary building boom that occurred during the decades around 1300. Whatever the culture of Florence is about, it rests on this foundation of carved stones made possible by a surging economy based on manufacturing, trade, and banking.

The church of San Miniato is one of the better places to take in the view (FIG. 8). This Romanesque church, built mainly during the eleventh century, sits high on a hill well outside the walls for a good reason. San Miniato was a fourth-century martyr who was beheaded near the Arno. Head in hand, he flew to the hills where he wished to be buried; the place is now the site of one of the loveliest of Florentine churches, pristine in its simple geometrical patterns and color contrasts.

Florence today as seen from San Miniato is a city of more than 600,000 people, its suburbs stretching both east and west along the Arno (FIG. 9). In the early fourteenth century the population was some 90–100,000 people, enclosed within the third set of walls, begun about 1284 and built over half a century. Beyond these last walls lies the wider setting of the city (see map on pages 6-7). It is, like most of the older cities of the world, set in a river valley. The Arno, the life blood of the city, rises in the holy high country of the Casentino, home of several medieval saints and the monastery of La Verna, where in 1224 St. Francis received the stigmata (imprint of the wounds of the crucified Christ).

8. San Miniato al Monte, Florence. 1013; facade c. 1090.

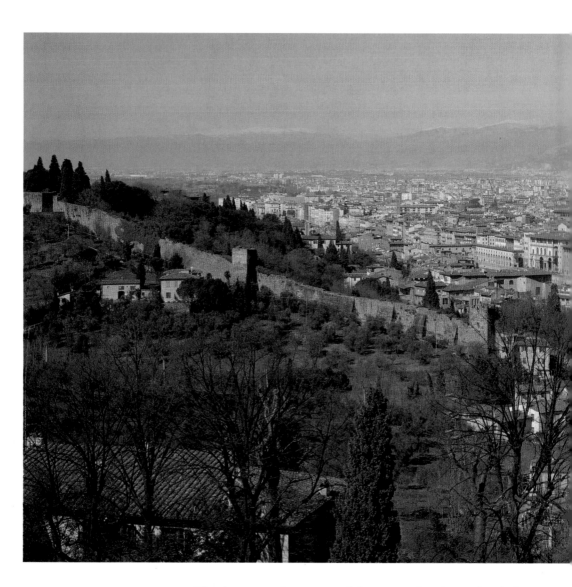

The Arno was the source of the water that drove the cloth industry, but it was a fickle river, in summer a mere stream inadequate to support barge traffic from Pisa on the sea fifty miles (80 km) to the west, but at other times a roaring torrent bringing disastrous floods.

The grain fields upon which life depended were in the lower valley, while grapes and olives grew on the hills. The surrounding countryside, the *contado*, is a reminder that for all its proto-urbanism, the city was an anomaly in a predominantly rural, agricultural society. Chronicles and diaries record the constant uncertainty of the food supply, with famine an occasional visitor. Early on the city's economic relation to the *con-*

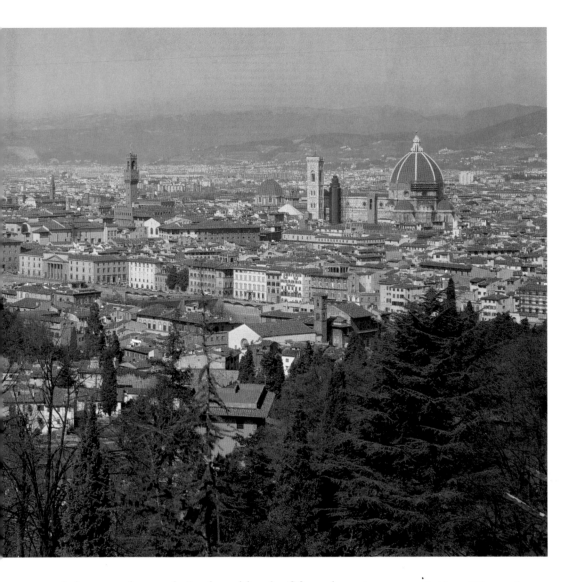

tado began to be regularized, and by the fifteenth century a system of half-and-half crop-sharing between owner and tenant (*mezzadria*) was established.

From the beginning Florence was girdled by walls, the third circle visible in the interesting so-called "Chain Map" (a name derived from the locked chain that serves as a frame) from the 1470s (FIG. 10). These walls had a circumference of some five miles (8 km), enclosing an area of two and a half square miles (6.35 km). The walls were thirty-six feet (11 m) high, punctuated by seventy-three defensive towers and fifteen gates, with a girdle road inside and a moat outside. The work consumed about one-quarter of the city's revenues during the many years of construction.

9. View of Florence from San Miniato al Monte.

An obvious reason for this expenditure is of course security. While most battles, usually skirmishes, took place in rural areas, the possibility of siege always existed. But, beyond pragmatic defensive needs, there was also a largely unarticulated ideology of walls. Inside the walls was a mapped, orderly world, a network of places of ritual and family, friends, and neighbors. It was the site of civilization, as opposed to the culturally formless territory beyond. Land inside the walls was favored by God, and images of the Virgin and the saints on the inner faces of the gates offered safe conduct to those who would venture outside. One touched the gates as an omen of good luck on leaving the city, and diplomatic or military missions exited or entered only under favorable astrological configurations. Apart from those Florentine ambassadors, merchants to the east, or bankers in the Netherlands, it has been suggested that the majority of Florentines never ventured more than fifteen miles (24 km) beyond the gates in a lifetime. Those gates were open only between sunrise and sunset; at night the protective circle was unbroken.

The city within the walls seen from San Miniato today is radically different from the view seven hundred years ago. Except for a short stretch, the walls are gone, torn down in the 1860s for the construction of a broad encircling boulevard, a gate still remain-

10. ANONYMOUS
The so-called "Chain Map" of Florence, 1470s. Woodcut 11½" x 17¼" (29 x 44 cm). Uffizi, Florence.

Somewhere between a map and landscape, this bird's-eye view anticipates later drawings by Leonardo. Note the city walls and the small figure in the lower right-hand corner, busy recording the prospect of the city.

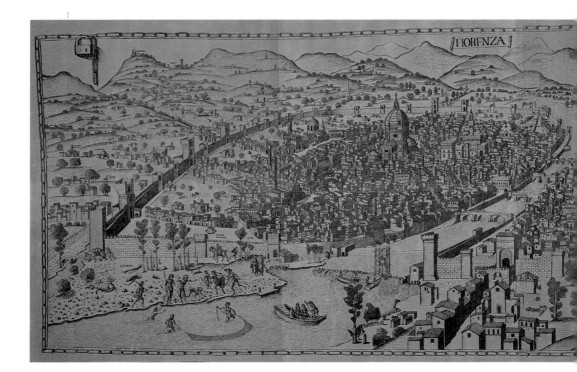

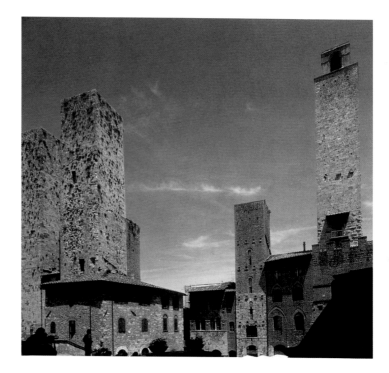

ing here and there. Now, except for a few isolated streets, little of the medieval city survives. The old market, rising on the ruins of the Roman forum, was razed in the 1880s to make way for the wide Piazza della Republica. In the same decades a number of streets were straightened and/or widened, giving the center of the city a more open and regularized appearance than it had originally.

Yet these changes are details compared to the major alteration to the city after 1250. The whole of the thirteenth century, until the triumph of the Guelf party towards the century's close, is a complex story of anarchic internecine feuding and bellicose behavior between the city's old and powerful families. Architecturally this social chaos was reflected in a patchwork of some two hundred towers, many over two hundred feet (60 m) tall, each of which was the core fortress of an extended clan who lived in the houses clustered below; while some of the (truncated) towers survive in Florence, the present skyline of the small nearby town of San Gimignano is more suggestive of how Florence must have looked (FIG. 11). Shortly after 1250 this disorder began to be brought under control, one result of which was a razing of the old towers and a prohibition against building any new ones over ninety feet (27 m) tall. In spite of this, Florence remained a city densely crowded with buildings and people.

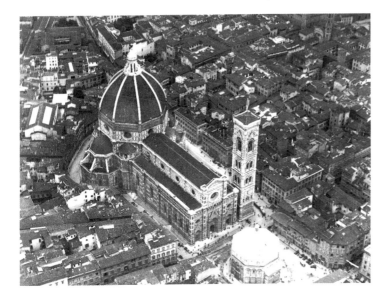

Left

12. The cathedral (Duomo), Baptistery, and campanile, Florence.

The space around the cathedral complex evolved over time: the church of Santa Reparata was razed to make way for the new cathedral (excavations of the former can be visited), a church between it and the Baptistery was destroyed, and finally attention was given to the height of the buildings on the piazza, as seen from the streets opening on to it, and to the uniformity of the palace facades around the cathedral.

The Baptistery and the Duomo

At the geographical and spiritual heart of the city lay the Baptistery, Dante's *il mio bel San Giovanni*, named for John the Baptist, who from the earlier Middle Ages was the patron saint of the city (FIGS 12 and 13). It is a late eleventh- to early twelfth-century building, contemporary with San Miniato, with which it shares a similar geometric design and green and white color scheme. Although built over an earlier Christian Baptistery, it was believed by early Florentines to be the Roman temple of Mars. As early as the twelfth century the building's maintenance was in the hands of the Arte di Calimala, the guild of the finishers and merchants of wool. This is the first of numerous instances in which a guild composed of laymen, as opposed to priests or monks, was charged with the financing and care of the religious edifices of the city. Religious monuments, then, were a civic responsibility.

While Florence had more than fifty parish churches, all children were brought to the Baptistery for what was, in effect, a double baptism, as a Christian and as a Florentine. After 1336 the family entered the portal facing the cathedral through a magnificent set of new bronze doors by Andrea Pisano (c. 1290-1348), whose relief panels represented the life of the Baptist (FIG. 14). The parents knew that their child might be among the 50% of children who died during childhood, and the great mosaic of the *Last Judgment* in the cupola above, executed in the thirteenth and early fourteenth centuries, was a reminder of both the gift and transience of human life.

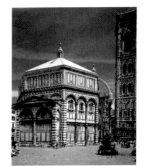

Above

13. Baptistery, Florence, late eleventh-early twelfth centuries.

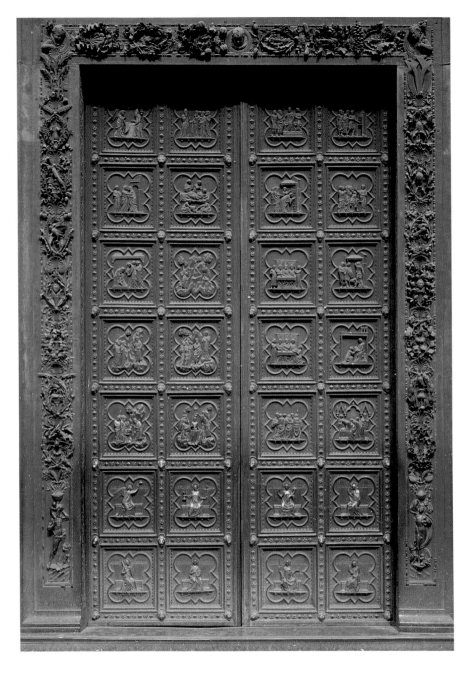

14. ANDREA PISANO
Doors depicting the life of John the Baptist and the cardinal and
theological Virtues, 1330-36. Bronze. Baptistery, Florence.

Bronze doors were not a Renaissance innovation, medieval examples
can be found in other Italian cities; those of Pisa cathedral were probably
the spur to the Florentines' decision to make such a major expenditure.

The Duomo or cathedral (*Domus dei*: house of God) rises opposite the Baptistery, the center for the most important religious observances of the city. It was begun in 1296, intended as the "most beautiful and honorable church in Tuscany," a none-too-oblique reference to the cathedrals of rival cities Siena and Pisa. Planned to be large enough to hold the city's population (but in fact perhaps holding 30,000 people), Santa Maria del Fiore (Mary of the Flower, so named in 1412), stands on the site of the earlier and much smaller church of Santa Reparata. The huge space of the new cathedral accommodated, beyond worship, every sort of transaction and conversation.

Arnolfo di Cambio (c. 1245-c. 1302) was the first of a series of architects who oversaw the building work, which took some one hundred and forty years, a history marked both by cooperation and spirited argument. In 1366-67 the most important decision of all was taken, to have a fourth nave bay and an octagonal choir, the latter feature calling for a dome about 140 feet (42 m) in diameter, the width of the dome of the Pantheon in Rome, but to be far higher off the ground.

Two things are remarkable about the later fourteenth-century stages of the cathedral project. The first is that it continued at all, given the financial depression in Florence, accompanied by the plague – a prelude to the devastating Black Death of 1348 in which about half the population died. There followed severe economic and moral dislocations, but work to the glory of God remained a tenacious first priority.

The second remarkable fact is the sheer audacity of the proposal to raise a dome higher than any ever built, and as wide as the largest dome of antiquity, without a clear plan as to how or whether such a feat could be accomplished. The dream is reflected in a fresco painted in the Spanish Chapel at Santa Maria Novella at the time the decision was taken, but the man who would show how it could be done, Filippo Brunelleschi (1377-1446), was not yet born. At the least the Florentines displayed an iron-willed optimism, at the most an outrageous self-confidence.

The facade of the Duomo was never finished, some sculptures for it by Arnolfo, Donatello (1386-1466) and others, a century later, constituting a beginning. Clearly the first task was to cover the space containing holy things, and to erect a campanile (bell tower). The latter may have been designed in the first instance by Giotto, in emulation of the similarly freestanding campanile at Pisa (known today as the "Leaning Tower").

Baptistery, Duomo, and campanile, with the surrounding space regulated as to the width of streets and to the uniformity of palace

facades; this was the religious center of Florence, a space made possible by civic taxes, whose ultimate source was banking and mercantilism.

The Palazzo della Signoria

Towards the end of the thirteenth century, Florence, like other Tuscan and Umbrian towns, decided to build a new town hall; in the case of Florence in an attempt to outshine that of Siena. The new Palazzo della Signoria (FIG. 15) combined the functions of administrative offices, civic ceremonial center, armory, and residence of the eight priors who constituted the Signoria, the city's main governing body, during their two-month terms of office. The building is decidedly fortress-like in character, though lightened by a tower almost 300 feet (91 m) high, both a symbol of the city's supremacy and the repository of bells that summoned the people for public meetings.

In some respects the outside of the building was as important as the inside. The piazza was created by leveling the houses of the

15. Piazza della Signoria, Florence.

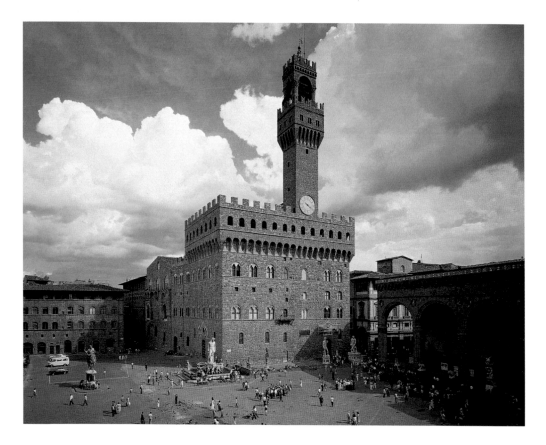

Uberti family, who had been exiled from the city. Soon after the final phase of the building was complete, the raised platform (*ringhiera*) in front was constructed. Diplomatic delegations and famous visitors were received here, their every move scrutinized for fidelity to proper protocol. From 1376 to 1382 the enormous three-arched Loggia della Signoria was erected in order to offer a more magnificent covered stage for ceremony and debate, the proceedings watched over by the relief sculptures of the seven Virtues high above. The great structure was based on the ruins of the Basilica of Constantine in Rome, thought at the time to be a temple of peace. Florence as the second Rome – the message could not have been clearer.

The Character of the City

The Florentines were (and still are) people of the street, always ready for a conversation, an argument, a barbed witticism, engagements that eschewed class distinctions. The highest accolade for a Florentine is to be described as "furbo," an untranslatable word connoting high native intelligence combined with streetwise sense. And as one twentieth-century writer has only half jokingly remarked, for a Florentine the cardinal sin is stupidity; unsentimental pragmatism ruled the streets and their talk.

Religion saturated Florentine life to an extent that few questioned. In addition to Sundays, there were some forty religious holidays. Morning mass for many was the highlight of the day, a place to observe communion but rarely partake of it, to share news, or just plain gossip. Although only 2% of males wore clerical garb, the Franciscans had an order of layman pledged to chastity, prayer, and good works, and confraternities abounded. Itinerant preachers were common, and probably no one gave a second thought to the nunneries at the gates of town, or the penitents' cells on the Ponte (bridge) alle Grazie (the cells were destroyed in the nineteenth century). Some thirteen hundred street tabernacles dotted the city, so that an image of Our Lady available for prayer was rarely more than a few minutes away. Religious festivals abounded, of which the most famous was the Day of the Baptist, 24 June.

Finally, what was the feel of the texture of life in Florence? One can read the contemporary *novelle* (short stories), or the diaries of the time, such as that of the apothecary Luca Landucci (d. 1516), kept between 1450 and 1516. Landucci dwells on the mundane, the fluctuating price of corn, the progress of various building projects. He savors incidents of violence, or the swift and fatal jus-

tice meted out to transgressors. He writes of the unusual – floods, blizzards, lightning strikes – and is fascinated by the macabre, such as the birth of hideously deformed animals and children, bodies thrown in the Arno, desperate suicides, mad defilers of holy images. It seems at times akin to the sensationalism of the modern tabloid, but for him such things are signs of the pleasure and displeasure of God. The supposedly rational air of what we have come to call the Renaissance in fact crackled with superstitions and omens.

Superstition and pragmatism, these qualities were joined in the birth of proto-capitalism, with its attendant functions of borrowing and lending, interest, futures' trading, insurance, in short the driving engine of the quest for profit. These practices were accompanied by a growing sense of the enjoyment of what money could buy, of individual and family honor to be achieved in an increasingly secular world. In practice all this was embodied in lives of action, aggressiveness, and pragmatic risk-taking, which, when combined with the close and competitive crowding of an urban setting, led to more spontaneity in human relations, including a loosening of sexual behavior.

Yet all this happened in a city that still subscribed to traditional Christian values: chastity, a subsistence economy in which usury was discouraged, prayer, value given to contemplation, the forgiveness of sins, and personal abnegation. These traditional values collided with the new practices, and created severe tensions, as revealed by a host of writers from Petrarch onward. At the beginning of the sixteenth century Niccoló Machiavelli (1469-1527) wrote his *Discorsi sopra la prima deca di Titio Livio* (*Discourses on Livy*), in which he contrasted Roman behavior and belief with those of Christianity. For him the Romans led a life of action, courage, assertiveness, and manly behavior, while the Christians were contemplative, passive, submissive, and effete.

In important ways traditional beliefs and new behavior were unreconciled, but a valiant try was made. Greek and Roman thought offered alternative values, often, as in the works of Cicero, argued in an appealing ethical framework. These values were more in tune with evolving Florentine behavior than the values offered by Christianity. The fifteenth-century trend was not to displace Christian values, but to amend them, to achieve a workable fusion, particularly in relation to such issues as the active life, individual honor, and the virtue of material possessions. The continuing exploration of the thought and visual images of people who had lived more than a thousand years earlier changed the intellectual and artistic landscape of Florence.

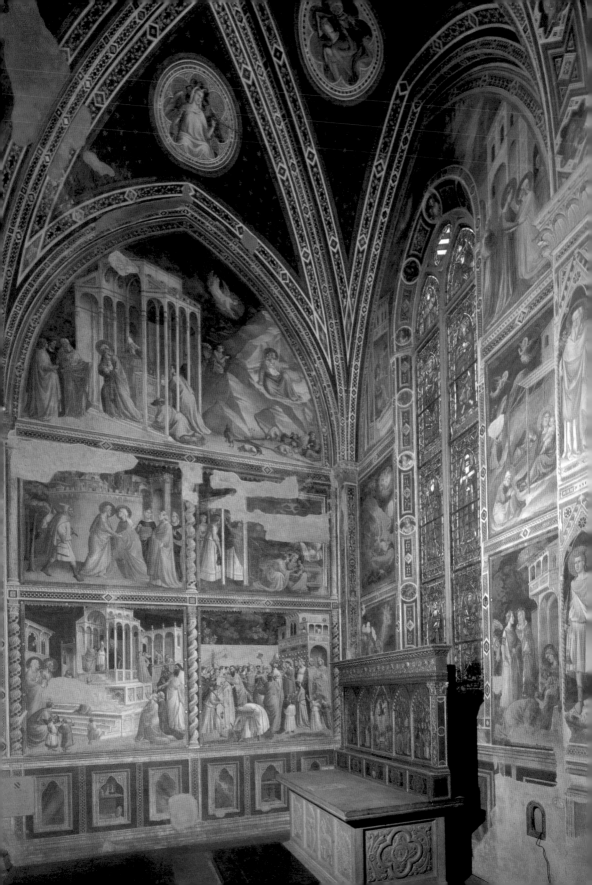

TWO

The Marketplace of Art

16. TADDEO GADDI
The Life of the Virgin,
1328-34. Frescoes and
panel altarpiece. Cappella
Baroncelli, Santa Croce,
Florence.

Fresco is a technique
whereby pigment is applied
to an area of wet plaster,
which when dry bonds the
color and the wall. The
method is called *buon
fresco*, as opposed to *fresco
a secco*, which involves
application of pigment to
a dry surface. The former
method is far more durable,
as it is not susceptible to
flaking.

Fifteenth-century Florence had no umbrella term for the arts in a wider sense (i.e. painting, poetry, dance, etc.), neither was there a word for the more restricted group of the visual arts. "Art" (*arte*) and "artist" (*artista*) were used, but in different senses. "Art" was a designation of a number of activities, usually resulting in a product of some sort, and thus required a second defining word, so "art of wool." "Art" also designated the name of a guild that supervised a given enterprise (for example, *arte di lana*, or wool guild). "Artist," *artista*, referred to a university student of the liberal arts. When Florentines named a producer of what we today call art, they were invariably more specific, speaking of a painter, a goldsmith, an *intarsia* (inlaid wood) worker, a sculptor, and often subdivided these designations, as witness different words used to name different sorts of sculptors. Only in the sixteenth century was some degree of classificatory abstraction achieved when Giorgio Vasari and others saw the unity of architecture, sculpture, and painting to lie in their common parent, *disegno* (literally drawing, indicating both a process and a product, joined to a wider meaning conveyed by our word "design"): so the *arti di disegno*, the arts of design.

Of course fifteenth-century Florentines also on occasion responded to objects in the modern way, finding them precious, beautiful, and worthy of collecting in their own right. But the Florentine's focus was on function; what was a work of art for, how did an altarpiece in a church or a fresco in a domestic setting do its work? To make sense of who produced, who consumed, and by what standards, then the best analogy is the art world of

17. Interior of Santa Croce, Florence, begun 1290s.

The view of the nave differs in one major respect from its fourteenth-century appearance. Originally Santa Croce (and other churches, such as Santa Maria Novella and San Marco) had a wall-like architectural feature across the middle of the nave, called the *ponte* or *tramezzo*. This separated the space of the lay congregation, toward the main entrance, and that of the friars, toward the altar, and mass was performed at separate altars on either side of this screen. In order to foster greater lay participation in the liturgical life of the church, the *tramezzi* were taken down after the middle of the sixteenth century.

today, a set of interconnected constituencies, including artists, buyers, collectors, patrons, dealers, galleries, art photographers, artists' lawyers, writers on art, critics, art historians, and the various papers, journals, and books in which they publish. Pragmatically, an object that circulates within this system is a work of art, its status defined by the system. Roughly speaking the notion of objects circulating in a system composed of various constituencies works for any age, whether or not those objects are called art by the age in question. All that is necessary is to determine the players in the game.

The Florentine "art world" can be viewed in these terms. There were patrons – civic, religious, and private, each with different needs and resources. And there were producers, trained in certain ways, organized professionally, and subject to various controls. While not present in large numbers, there were also writers on art, most influentially artists themselves, whose ideas raised questions about the relations of theory and practice.

Four vignettes of patronage, while not related, suggestively reveal diverse aspects of a complex subject.

A Family Chapel

At the end of the thirteenth century the Franciscan church of Santa Croce was built to accommodate a growing population (FIG. 17). The work was funded in part by the city, with notable assistance from individual families in the form of decoration and endowment of chapels. The east end of the church has a number of these chapels on either side of the choir, each sponsored by old and powerful families with particular allegiance to St. Francis, such as the bankers the Bardi and Peruzzi (FIG. 18). The Baroncelli chapel at the end of the right arm of the transept is closest in features and condition to the original appearance these chapels would have had (FIG. 19).

The principal function of a church is, of course, as a place to celebrate mass, the liturgy in which the incarnation and sacrifice of Christ are commemorated by the miracle of the transformation of the communion wine and bread into the blood and body of Christ. Mass was said each day at the high altar, and in addition the religious community at Santa Croce assembled seven times a day for hymns and prayer. Through the year the church calendar involved celebrations of Christ and the Virgin, and the saints of the church. Because endowing private masses was an increasingly popular act, altars multiplied in Florentine churches, and with them chapels.

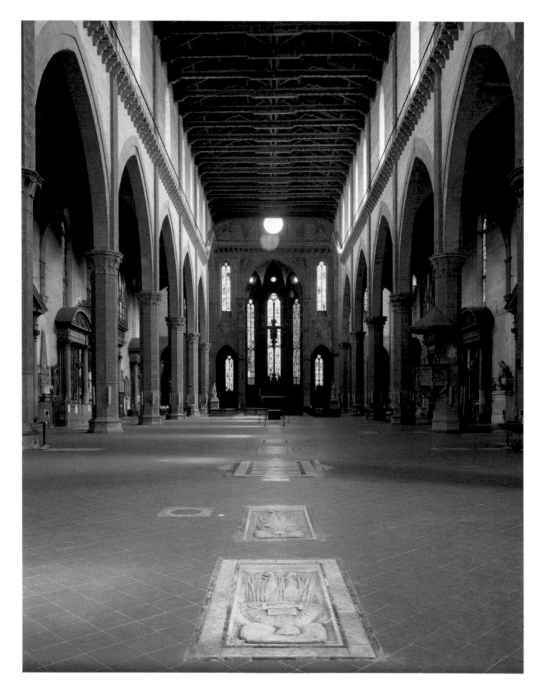

The overriding reason why the Baroncelli sponsored a chapel was as a gesture of piety and devotion that provided a liturgical space, the wherewithal for liturgical celebrations, adornment of that space with art, and tombs. By the twelfth century the Church recognized a "third place," besides Heaven and

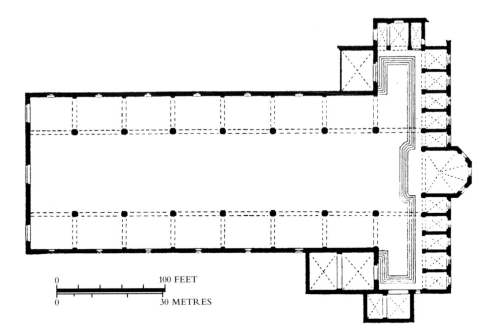

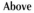

Above

18. Plan of Santa Croce, Florence, begun 1290s.

Hell, where the soul in suffering could atone for earthly sins while awaiting the Last Judgment. Whatever the theology of this third place, called Purgatory, the behavior of the Florentines was simple: they knew they could be in touch with their ancestors and help them, through masses for the dead, and prayer to the Virgin and the saints for intercession. To an extent the reputation of the dead reflected on that of the living, and in an investment-sensitive society there could be no better expenditure than honoring God, one's family, and figuratively making advance payment on one's own salvation.

Hence the fundamental importance of the family chapel (*cappella*), and the need to provide the liturgical accoutrements necessary for the performance of the mass: an altar, a crucifix, a chalice, vestments, altarcloths, manuscripts of the liturgy, candlesticks by which to read, and so on. Because most of their objects were portable and made of precious materials, the majority of them have disappeared.

Beyond these essentials there were usually frescoes, a painted altarpiece, and at times, as at the Baroncelli chapel, a tomb or tombs (FIG. 16, page 35). Each chapel had a single or multiple dedication, often to the patron saint of the donor or his ancestor. The Baroncelli chapel is dedicated to the Virgin, and scenes of her life are frescoed on the walls in superimposed scenes by Taddeo Gaddi (active c. 1322-66), illusionistic spatial boxes that in a sense echo the actual box space of the chapel itself. The altarpiece

Opposite

19. TADDEO GADDI Cappella Baroncelli, 1328-34. Santa Croce, Florence.

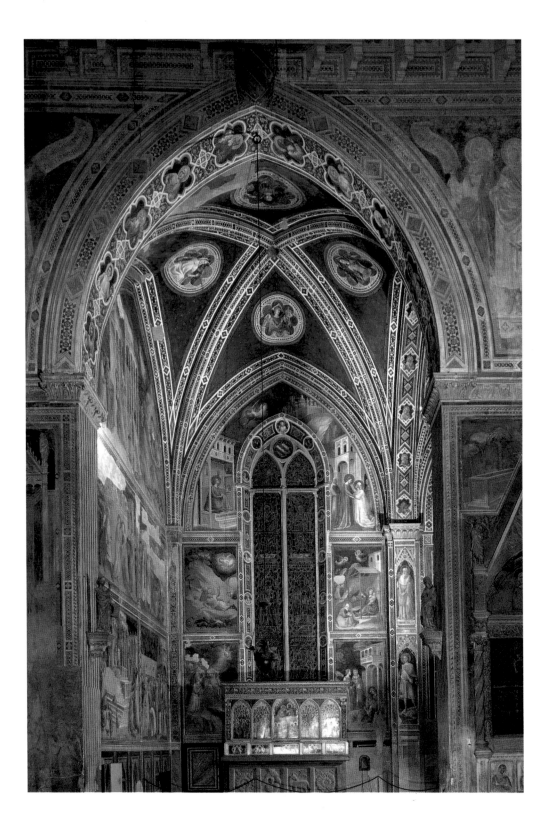

Opposite top

20. FILIPPO BRUNELLESCHI
The Sacrifice of Isaac,
1401-02. Bronze,
21 x 17½" (53.3 x 42 cm).
Museo Nazionale,
Florence.

Opposite below

21. LORENZO GHIBERTI
The Sacrifice of Isaac,
1401-02. Bronze,
21 x 17½" (53.3 x 42 cm).
Museo Nazionale,
Florence.

by Giotto's workshop represents the *Coronation of the Virgin* amid a celestial court.

The tombs in a chapel of course commemorated individuals, but were also a solemn reminder to the living to pray and say masses on behalf of the souls of their deceased forebears. Unfortunately no direct documents survive for the work in the Baroncelli chapel, believed, on the basis of cumulative evidence, to have been carried out between 1328 and 1334. But beyond the tombs, indications of who the donors were could not be clearer. Baroncelli arms and devices occur in no fewer than fourteen places in the chapel, and the names of five members of the family were on the wrought iron gates at the chapel's entrance, now removed. In sum, if a family chapel was a manifestation of piety and devotion, it was also a materialistic proclamation of the lineage and social importance of the family. Piety, honor, and pleasure: in varying mix these lie behind the Florentine family's public expenditures on art and architecture.

The Second Baptistery Doors

The Baptistery had three doorways, and between 1336 and 1452 three magnificent sets of bronze doors were provided; each at first hung on the portal facing the cathedral, but was then moved to make way for its successor.

In 1336, Andrea Pisano finished the first set of doors, which depicted incidents from the life of St. John the Baptist in quatrefoils (a four-leaf clover shape) set within square panels. The importance of the commission can hardly be overestimated, for no less than the patron saint of the city was honored, and in a material roughly ten times the cost of marble.

In 1401, the Arte di Calimala (cloth guild), which had commissioned the first doors, decided upon a second set in the same physical format. Accordingly, a competition was announced to which seven sculptors responded, including Filippo Brunelleschi, the future architect of the cathedral dome, and Lorenzo Ghiberti (1381?-1455). The idea of a competition was nothing new, being the normal Florentine way of assigning public art commissions. The contestants were each asked to do a quatrefoil panel in the form used by Andrea Pisano. Its subject, the Sacrifice of Isaac, is a strong indication that the second set of doors was originally intended to have Old Testament scenes rather than the New Testament ones actually executed.

Of the seven entries, only the panels by Brunelleschi and Ghiberti survive (FIGS 20 and 21). The contestants must have been given

detailed specifications (now lost), for both panels have a naked boy on an altar *all'antica* (in the antique style), an airborne angel in one lobe of the quatrefoil, include two servants and an ass, and have similar landscape elements. Probably there was a directive to include specific references to ancient art, for Brunelleschi's seated servant is in the pose of the famous Hellenistic sculpture *The Thorn Puller*, while Ghiberti's nude Isaac echoes an ancient torso type, even if the specific model does not survive.

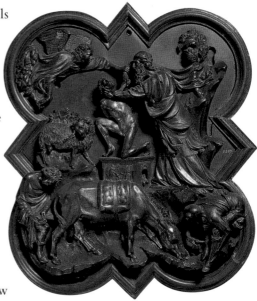

Ghiberti was awarded the commission for the doors, but on what basis is uncertain. Writing in his *Commentaries* a half century later, the sculptor claimed outright victory, while Brunelleschi's 1480s biographer said the contest was a draw, and rather than share the commission, his man withdrew to go to Rome to study the ancient ruins. Whatever the truth, the decision was apparently taken by a committee of thirty-four Florentines, probably in late 1402, for Ghiberti had his contract by March 1403.

The judges may have deliberated about matters of form and style, for the contrast between the two panels seems clear enough. Brunelleschi evinces a brusque realism as Abraham in a violent gesture is an instant away from plunging the knife into his scrawny son's throat. Ghiberti offers a more suave and graceful interpretation, Abraham's bowed body complemented by the curves of drapery, the nude Isaac echoing the same curved configuration. Both figures are in a ballet-like suspension from which no violence will ensue.

Perhaps other factors were at work, even possibly dominant. While Brunelleschi's panel was cast in a number of pieces, Ghiberti's was cast in only two, and required two-thirds of the weight of bronze needed by the former, a significant saving when extrapolated to the cost of materials for the whole door. So, possibly, expense plus a technique seen to be more impervious to damage from the weather tilted the outcome. Whatever exactly was debated, there is no doubt that material and technical considerations were extremely important to a Florentine artist and his patrons.

In the 1430s sculptural
decoration by Donatello,
in the form of stucco reliefs
and bronze doors, were
added, thus mitigating some
of the linear and planar
purity of Brunelleschi's
architecture.

The Patrons and Architects of San Lorenzo

A key moment in the life of the church of San Lorenzo came around 1420, when, under the leadership of Giovanni di Bicci de' Medici (1360-1429), whose parish church it was, a determination was made to both renovate and extend the church, replacing its Romanesque predecessor. Such a decision was not easily taken, given the large sums of money involved and the political moves necessary to tear down houses to open the needed space. Medici leadership was decisive, for the family agreed to a new, essentially freestanding sacristy and a double chapel at the end of the left transept, if other families would take responsibility for the transept chapels.

Open any textbook, and Filippo Brunelleschi is given as the architect of San Lorenzo. Certainly, Brunelleschi's hand and mind are clearly revealed in the old sacristy, beneath whose dome Giovanni di Bicci de' Medici and his wife are buried (FIG. 22). The room's lucid proportions, flat surfaces of white stucco and cool *pietra serena* (a local grey stone) defined in crisp linear details, and a cubical space over which a webbed dome almost floats come together to form a unity that is innovative, indeed the first example of the new architecture.

Beyond the sacristy, in the church itself, the issue of Brunelleschi's involvement becomes far murkier (FIG. 23). It is generally agreed that his direct involvement is confined to the left transept area, although even there he contended in part with renovation of existing structures, and that the main body of the church was built after his death. There is some indication that he left the project as early as 1428 (he died in 1446), and that after a hiatus during the 1430s work was resumed by other architect(s) in 1442 under the sole sponsorship of Cosimo de' Medici.

So, rather than San Lorenzo being the story of a single architect and patron, it is the story of protracted process, which raises several issues. There was no profession of architecture nor were there architects in the modern senses of the words in the fifteenth century. Until Andrea Palladio (1518-80) in the following century, almost every person who designed buildings was trained initially as something else – Brunelleschi, for instance, as a goldsmith. While Brunelleschi was directly involved in construction, others, such as Alberti, were "paper designers," entrusting the execution of their concepts to stonemasons. It is clear that the conceptualization of a building was important, and more than might be imagined, the patron rather than the "architect" received credit for a design. All this implies a dichotomy between design

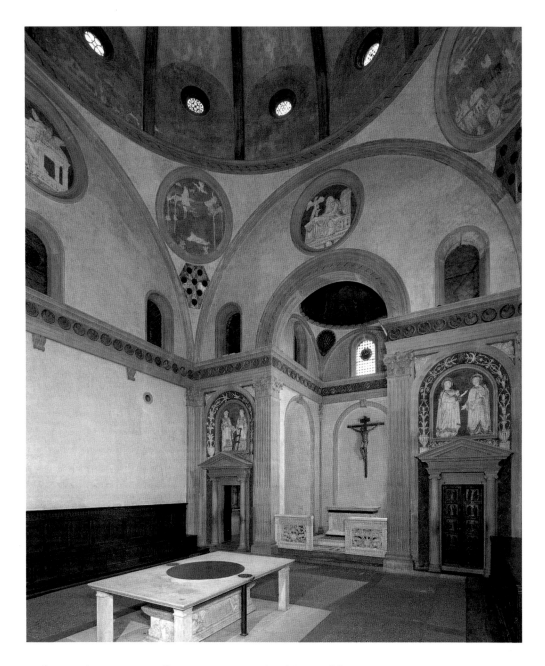

and execution: anyone, after proper apprenticeship, could carve
a stone to measure, but only a lettered man could conceive the
facade for which that stone was needed.

While an architect such as Brunelleschi was a designer as well
as a builder, time may have frustrated even his plans. In the
case of most churches of the fifteenth century and earlier, work
extended over many years, often well beyond the lifetime of

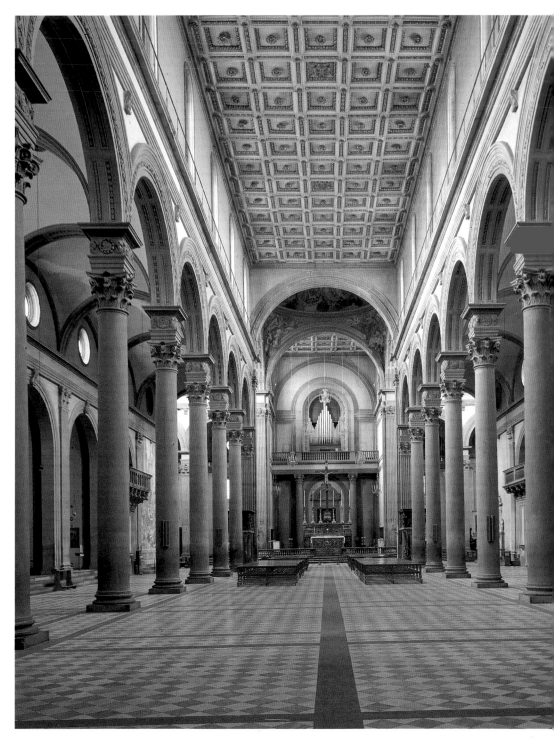

23. FILIPPO BRUNELLESCHI
Nave of San Lorenzo, Florence, 1421-28, by others after 1442.

the architect. Errors could be made in translating design into stone, and the death of an architect allowed his successor and/or patron to make willful alterations. To a degree all these problems beset "Brunelleschi's" churches of San Lorenzo and Santo Spirito. Rather than asking who was the architect of San Lorenzo, it may make more sense to ask about the combination of players involved in a protracted process, about intentions, distortions (willful or otherwise), and the final product in relation to the process. For most buildings of the fifteenth century the equation "controlling mind of the designer equals fulfillment in the product designed" is far too simple. As with so many cases, artistic and otherwise, collaboration, not without friction, was what yielded a result.

A Religious Tabernacle

Florence and environs housed a third miraculous image, at the church of the Annunziata – a painting of the Annunciation thought to be by the hand of an angel, though more likely to be by that of a fourteenth-century mortal. Like Our Lady of Orsanmichele this image possessed healing powers. Over the years thousands of visitors left ex-votos (a gift in fulfillment of a vow, usually a clay or silver relief sculpture of the body part that had been cured, or sometimes an entire effigy made of wax and cloth, such as that given by Lorenzo de' Medici after he survived the assassination attempt known as the Pazzi Conspiracy in 1478). At first these ex-votos were displayed around the image, but later spread throughout the church, and were finally hung from the ceiling, until such time as overcrowding brought the practice to an end. Such was the power possessed by this image that distinguished visitors to Florence were escorted to the Annunziata on their arrival, where there was a private unveiling of the holy image. Only afterwards might they proceed to present their credentials, or go about their business.

For our purposes it is not the image itself that is interesting, but the fact that the Medici family appropriated it to family advantage. This act is embodied in the large marble tabernacle carved by Michelozzo di Bartolommeo (1396-1472) with the assistance of Pagno di Lapo, and erected in 1448 to enshrine the *Annunciation*, on the order of Cosimo de' Medici's son Piero (1418-69; FIG. 24). The Annunziata tabernacle is a magnificent combination of marble and metalwork, its elaborate entablature and cornice resting on four Corinthian columns. The architecture swallows the image of the Annunciation, making it subordinate to the new space in which it has been placed. Piero used Medici iconography

sparingly on the tabernacle, but all knew who had paid for the thirty silver lamps in the shrine, and for what a large inscription proclaims: COSTO FIORINI 4000 ELMARMO ("the marble cost 4000 florins"). While without doubt a pious man, in effect Piero allied the Virgin of the Annunciation with the Medici family, to the clear gain of the latter in terms of family honor and politics. The lines between the secular and sacred were blurred, as they would be until the time of the Council of Trent in the middle of the sixteenth century, during which the dogmas of the church were clarified and systematized.

Learning the Trade and Earning a Living

Art – seen at that time as the specific crafts of painting, goldsmithing, and the like – was a trade like any other. It was assumed that rigorous training over a period of years, not the cultivation of a special gift, was what produced a competent artist. Like as not, an artist was born into a family of artists, or if not, claimed allegiance to a lineage of artists. The Florentine Cennino Cennini (c. 1370-c. 1440), in about 1400, wrote a practical guide to making art entitled *Il Libro dell'Arte* (*The Book of Art*); this begins with his artistic genealogy, which he traces to Agnolo Gaddi (c. 1333-96), to Taddeo Gaddi before him, and finally to Giotto himself, whose heritage Cennino says he keeps alive.

A boy was apprenticed to a master somewhere between the ages of seven and fifteen, and remained with that artist, if all went well, for at least five years. In the *bottega* (artist's workshop) the apprentice began with such manual tasks as sweeping the shop and grinding pigments, all the while practicing drawing with his master as exemplar. The apprentice progressed through all manner of practical skills, such as preparing the plaster coating (*gesso*) on a wood panel to which the pigments are applied; gilding; and using punches to put the decorative patterns on haloes. Finally, he would assist his master in the execution of a work of art, his role confined at first to less demanding parts, such as passages of drapery. Cennini exhorts the apprentice to unstinting dedication, seven days a week, if he is to amount to anything.

Apprenticeship completed, the artist entered his guild, a rite of passage certifying his competence to perform at a professional level. Painters belonged to the guild of apothecaries, sculptors to that of the stoneworkers, goldsmiths to the silk guild. From the fourteenth century on the painters also had a confraternity, the Company of St. Luke, named for the evangelist said to have been the first to paint the Virgin and Child.

Generally, the newly certified artist joined the workshop of an already established master; for instance Paolo Uccello (1397-1475) went to Ghiberti's workshop. Workshops varied from the very specialized (for example, one largely confined to painting marriage chests), to those practicing one art, such as painting, to large workshops that undertook commissions in a variety of media. Andrea del Verrocchio's (1435-88) shop in Florence, active from the late 1460s until the early 1480s, produced sculpture, painting, minor architectural commissions, bronze for casting a bell, painted tournament banners, and undertook the major task of erecting a large gilded ball atop the lantern on Brunelleschi's dome. Leonardo da Vinci was the star of the Verrocchio shop, and while doubtless a multi-faceted genius, might not have developed in the way he did without the broad-based foundation of the Verrocchio workshop. Verrocchio's contemporary, Antonio del Pollaiuolo (c. 1432-98), had a shop that was similarly diversified, its work including liturgical objects, brocaded vestments, and domestic goldsmith work, in addition to sculpture, painting, and prints.

Getting work was always an uncertain business. Artists were not on retainers, nevertheless civic authorities and families did have their favorites. But even favoritism could be uncertain, as when Michelozzo di Bartolommeo displaced Brunelleschi as architect to Cosimo de' Medici. Artists had to make their case, sometimes in the form of flattering letters to a potential patron, at others by entering competitions. While competition is a leitmotif of Florentine artistic practice, it should not overshadow the fact that collaboration was often to the benefit of both parties, as witness the temporary partnership of Michelozzo and Ghiberti, and slightly later, Michelozzo and Donatello. On a more modest level, a modeler in terracotta might employ a painter to color his work, or a sculptor might use another man to make a tabernacle for his Madonna.

While in the fourteenth century there was a small free market in art works, it seems to have been confined to workaday objects of modest quality and price. Dealers emerged in the fifteenth century, usually on a trans-national basis; so, for example, a patron requiring a tapestry of the hunt would approach a man in Bruges, a city that specialized in such work.

Almost all art was, therefore, made to order on commission, and generally involved a written contract between the parties. The subject is usually described, if at all, in a very summary and dry way. This was because the parties might have had a precedent in mind, the artist's or someone else's work,

and reference to it shortcut the ambiguity inherent in a written specification. Alternatively, though few survive, a presentation (or fully worked up) drawing accompanying the contract would fix the general composition, and the figures to be included in the finished work.

The other important matters in a contract were the price, schedule of payments, timetable for delivery, quality of materials used (there were, for instance, three grades of ultramarine blue), and degree of assistant collaboration allowed (for example it could be stipulated that heads were to be by the master's hand alone). Insistence on quality of materials and workmanship, and timely delivery, run through these contracts. The record is replete with exasperation expressed and penalties demanded when agreements or expectations were not fulfilled. On the whole, as is usually the case when there is but one best source for a desired product, the artist had his client over the proverbial barrel.

It is clear, therefore, that the mutual world of patrons and their artists was sufficiently complicated and differentiated in individual cases to preclude any firm conclusions. Nonetheless some tentative ones suggest themselves: the Florentine art object was made to fulfill a purpose, whether devotional, civic, or domestic; objects were not usually thought of as ends in themselves, but rather as implicated in the various rituals of daily life; the providers of these objects were craftsmen, rigorously trained and subject to professional controls, expected to produce a predictable product; and mastery in a social realm, not genius or personal idiosyncrasy, was the order of the day.

Public art was both civic and religious, but in terms of who paid, who supervised the artist, who assessed the product, there was little difference. What interested the Florentine was craftsmanship and quality, and the process of competition which raised the stakes.

Finally, what of style, for instance the modern distinction of Gothic versus Renaissance? The case of the competition reliefs for the Baptistery doors at the least intimates that enthusiasm for such abstract generalities was not characteristic of Florentine thinking. Indeed, ask even the most educated Florentine about Gothic art around 1400, and he would have had no idea what you were talking about. (But since they are ubiquitous in the modern literature, I will from time to time use the terms "Gothic" and "Renaissance," even if they seem anachronistic.)

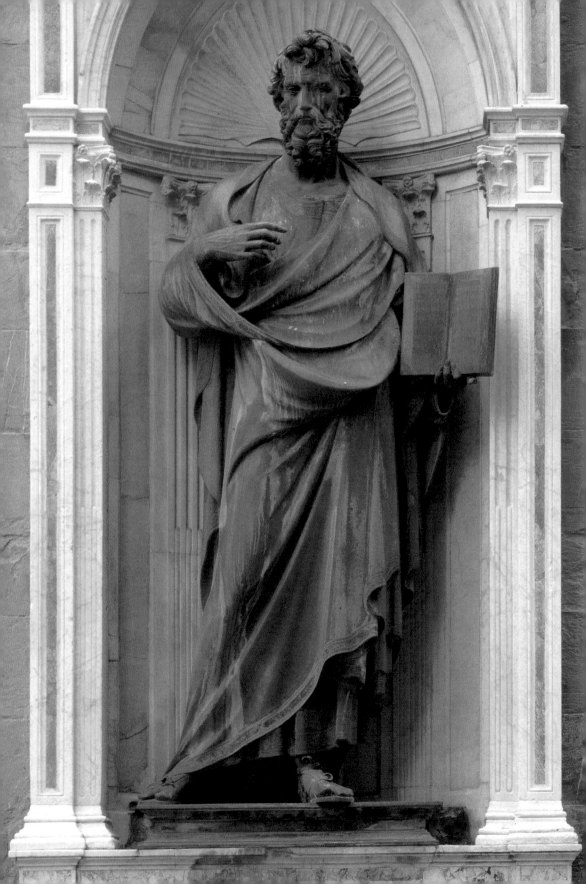

THREE

Speaking Statues

In 1325 the Sienese excavated a Roman copy of a statue of Venus by the fourth-century BC Greek sculptor Lysippus, and proudly mounted it on the communal fountain. Soon feeling that it brought bad luck, they took it down and broke it into pieces, burying them in the territory of the arch-enemy Florence. This incident, reported by Ghiberti and recorded in Sienese documents, attests to the age-old belief that sculpture somehow hovers between flesh and stone, possessing magical powers, and a potential to work both good and evil.

"Speaking" statues, or the association of speech with sculpture (or lack of it) were a commonplace of the period. In the mid-fourteenth century Petrarch wrote of "breathing statues" in which "only the voice is lacking," and in his poetry stone is the most common image after laurel. In Rome at the end of the fifteenth century certain ancient Roman statue fragments supposedly began to speak, and be spoken to; and several decades later a Florentine writer escorting a foreigner around Florence, stopped to speak to Donatello's figure of St. George at the Orsanmichele.

Between about 1410 and 1425 a wholly new public sculpture arose in Florence, whose premises are a compelling physical and psychological presence, figures intended to be "in dialogue" with the people in the streets below. These sculptures seem to possess a larger than life heroism, breaking out from the niche-constricted passivity of sculpture on Gothic cathedral facades, from which they evolved. This radically new sculpture pre-dates any comparable innovations in architecture and painting, and unequivocally constitutes the point of departure for a new art in Florence.

25. LORENZO GHIBERTI
St. Matthew, 1419-22.
Bronze, height 8'10"
(270 cm). Orsanmichele,
Florence.

26. Orsanmichele,
1337-80. Florence.

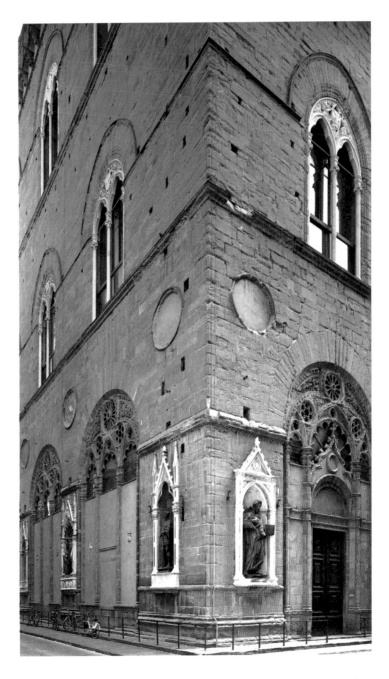

This new sculpture is clustered in three main places, the cathe-
dral facade, the adjacent campanile, and the Orsanmichele (FIG.
26), located roughly mid-way between the cathedral and Palaz-
zo della Signoria. In contrast to the campanile figures, these
over life-sized statues are only a little above eye level, and are there-
fore more directly an integral part of street life.

The Statues of the Orsanmichele

The church of the Orsanmichele was one of the most important intersections of commerce and religion in Florence. The present building was begun in 1337, and from the outset the Signoria decreed that the niches on the exterior piers should be occupied by statues of each guild's patron saint, financed by the guild's members. But by 1400 only three guilds had fulfilled their obligation. In 1406, the buoyant year of the conquest of Pisa, there was a new push to complete the project within a decade, not only to celebrate the guilds themselves, but "for the fame of the country."

If business was one of the religions of Florence, equally the Christian religion was inseparable from business. When the niches were filled with statues, the insignia of a guild above each niche, a visitor to the city would be reminded both of the remarkable individual enterprise of a guild and the economic infrastructure of the guild system, the miracle of early Europe. The Orsanmichele attested to the Lord's special regard for Florence. The niche statues were the guardians of Our Lady inside, while she extended protection to those who revered her, and offered alms to the poor.

The niche sculptures produced soon after 1400 vary considerably in style, and the question already broached in relation to the Baptistery competition comes up again; did people around 1400 think in terms of style, and if so, how?

It might seem that because Lorenzo Ghiberti executed three guild statues, all in the expensive medium of bronze, and each of those for a major guild (the only ones allowed to use that material), he was the preeminent sculptor in the eyes of his contemporaries. While this may for a time have been so, his bronze-working experience, first in the competition piece and then in the first Baptistery doors, gave him a temporary monopoly in that medium. While Ghiberti was executing two bronze sculptures between c. 1412 and 1422, Donatello produced two remarkable marble sculptures that broke with the past, and whose forms moved Ghiberti in his second bronze, the *St. Matthew*, toward a more monumental, classicizing vision. By the earlier 1420s Donatello had, in turn, learned from Ghiberti, and completed his first sculpture in bronze. The story, in short, is of artists both in competition with and learning from one another, and there is not a shred of evidence that their contemporaries put these men or their works into pigeon-holes of contrasting styles.

Lorenzo Ghiberti's *St. John the Baptist*, commissioned by the Arte di Calimala, was probably not the first sculpture begun,

but because it is the benchmark of Florentine style at that moment, it is a useful point of departure (FIG. 27). The statue is dated 1414, indicating completion of the model from which the bronze cast was taken. While Ghiberti had already proved his mettle as a bronzeworker, the over life-size dimensions of the piece made it technically problematic. The nervousness of the guild is reflected in the contractual stipulation that Ghiberti was to be held financially responsible should the casting fail. The worry was legitimate, for casting involves the complex process of getting an even flow of molten metal between the model of the sculpture and an outer shell that encases it.

Stylistically what the guild got must have been much what they expected, for a mellifluous flow of drapery in complementary curves is the hallmark of the Florentine "late Gothic" style, in particular the first panels that Ghiberti made for the Baptistery doors. While *St. John* is a large sculpture, it cannot be called monumental in the sense of presenting an imposing body, for there is scant suggestion of bodily substance beneath the suave crescents of repeated drapery folds: the face is mask-like, hair and beard abstracted through repetition of the drapery patterns in miniature; the figure seems incapable of motion, for an even distribution of weight between the two legs anchors the body; and the hands are limp, almost pneumatic, adding to the impression of stasis. Lest this analysis seem to imply a negative judgment, it is clear that the composition is beautifully unified within the stylistic choices that inform it. Nor is there any indication that the statue was received other than with enthusiasm.

Donatello's *St. Mark* (FIG. 28) for the Arte di Linaiuoli (linen-workers' guild, hence the witticism of the pillow on which the saint stands) was probably begun before the *St. John*. As early as 1409 the guild had ordered a marble block, and in February 1411, a committee was charged to identify an appropriate sculptor. Donatello was selected and told to finish the work

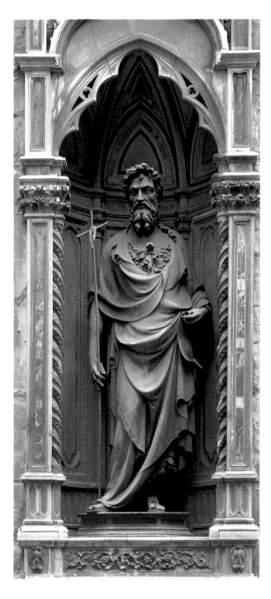

27. LORENZO GHIBERTI
St. John the Baptist,
c. 1412-16 (dated on statue 1414). Bronze, height 8′4″ (255 cm). Orsanmichele, Florence.

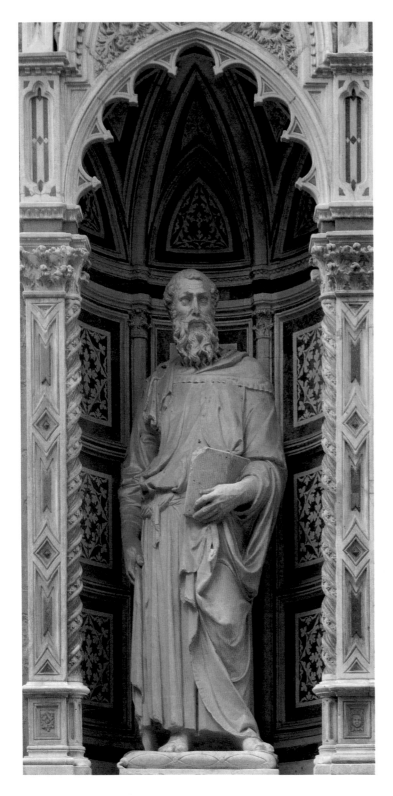

28. DONATELLO
St. Mark, 1411-13. Marble,
height 7'10" (236 cm).
Orsanmichele, Florence.

The seminal place of this
piece in the development
of Florentine sculpture was
long remembered.
Michelangelo is supposed
to have said that if Mark
truly looked like this, then
we would have to believe
every word that he wrote.

by November 1412. In fact he delivered six months late. The question of the exact chronological relationship between Donatello's and Ghiberti's saints seems redundant in view of the radically different conceptions that must preclude any suggestion of either artist influencing the other.

The linen-workers probably expected something along the stylistic lines that Ghiberti produced, but instead received a work that can only be described as an artistic mutation, a figure at once more physically and psychologically compelling than anything produced for centuries. Mark stands with his weight heavily on his right leg, a pose that activates the whole body by tilting the pelvis and shoulders, movement complemented by slight turns of the torso and head. In stunning contrast to Ghiberti's wholly decorative treatment of drapery, Donatello used drapery to reveal the forms and relations of the body beneath it. The right leg is sheathed in stiff vertical folds of drapery that possess the character of the parallel flutings of a column, while the relaxed left leg is defined by a simpler and softer flow of drapery. Throughout, the drapery suggests the quality of flesh and muscle beneath.

The psychological vivacity of the figure cannot be separated from its physical energy. St. Mark gazes into the space of the spectators on the street, forehead furrowed, deep-set eyes intense. Even the hands convey energy, more an extension of the mind than of the body. The record is silent concerning what contemporaries may have thought of this prodigy.

To a modern eye this contrast between Ghiberti and Donatello is the defining moment of the waning Gothic versus the new Renaissance of forms, but the time itself had no such levels of abstraction to deal with the contrast before it, and in fact may have thought in terms of two manifestations of excellence that were simply different, not older and newer, or worse and better. Alberti in his *On Painting* of 1436 includes both Ghiberti and Donatello among the five leading artists of the age. Vasari, writing a century and a half later, saw Donatello as closer to the ancients than any other artist of the time, a man who, while he lived in the fifteenth century, aesthetically belonged with the greatest sixteenth-century artist of them all, Michelangelo. But this same Vasari singled out Ghiberti's *John the Baptist* as "the beginning of the good modern style," and judged Ghiberti's second set of bronze doors for the Baptistery (1425-52) "as the finest masterpiece ever created, in ancient or modern times." Evidently Vasari was not only tolerant of, but generous about, stylistic diversity, and had little propensity to generalize about broad stylistic streams, unless of course to trumpet the superiority of Tuscans to everyone else.

29. NANNI DI BANCO
Four Crowned Saints,
c. 1412-15. Marble, life-size.
Orsanmichele, Florence.

A third sculptor, Nanni di Banco (c. 1381-1421), throws further light on the question, for not only did he work at the Orsanmichele in a manner different from Ghiberti and Donatello, but immediately thereafter changed style as he brought to completion an unfinished project started by others at the cathedral. The *Four Crowned Saints* (FIG. 29), done for the guild of stonecarvers and woodworkers, is undocumented but must date from about the same years as the *St. Mark* and *St. John*, or possibly slightly earlier. The four marble figures, the only multi-figure group at the Orsanmichele in these years, represent four early Christian sculptors who refused to carve an image of Aesculapius (the Roman god of medicine) for the emperor Diocletian, and so were martyred around the year 300. (Parenthetically, the name of the group comes from the confusion of this story with another of four Christian soldiers – "I Quattro Coronati" – who refused to worship in a temple of Aesculapius.)

With great skill Nanni arranged his figures in a shallow semicircle. Whatever his abilities as a sculptor, he had a keen historical sense. These monumental figures are in neither contemporary nor medieval dress, but wear the togas of Roman antiquity. The semicircle of figures would have called to mind Roman grave monuments of similar composition, but at bust length, and Nanni

based his heads on several Roman portrait types. While the figures are ponderous, with none of the potential for movement inherent in Donatello's *St. Mark*, they are more evocative of a distant age, more archaeologically aware, than any of the other sculptures at the Orsanmichele.

In the relief below the niche figures the artisans are dressed in the work clothes of a Florentine workshop, on whose walls hang the tools of the trade (FIG. 30). They are carving a nude figure, apparently a *putto*, and an ornamental architectural member. In a sense the historical patron saints above bless the activity of figures easily read as their Florentine descendants.

About 1414, soon after completion of the *Four Crowned Saints*, Nanni undertook what was to be his last commission, a large relief of the *Assumption of the Virgin* above the Porta della Mandorla, the eastern portal on the north side of the cathedral (FIG. 31). The decoration of the framing elements of the door had been initiated by several sculptors in 1391, and included a few figures in vine tendrils rendered *all'antica* – a female nude of Abundance, a nude of Hercules – that reveal a close study of antique models. Given these forms and Nanni's immediate past experience at the Orsanmichele, it might be expected that the Assumption relief would also be in an antique manner. But Nanni chose rather

30. NANNI DI BANCO *Sculptors in their Workshop*: detail, relief sculpture below niche of the *Four Crowned Saints*, c. 1412-15. Marble. Orsanmichele, Florence.

31. NANNI DI BANCO
*The Assumption of the
Virgin*, c. 1415-21. Marble.
Porta della Mandorla,
Cathedral, Florence.

Nanni was a logical
choice for this particular
commission. His father
had worked on the portal
from 1394 onward, and in
1414 became Capomaestro
(literally "head master") of
the cathedral.

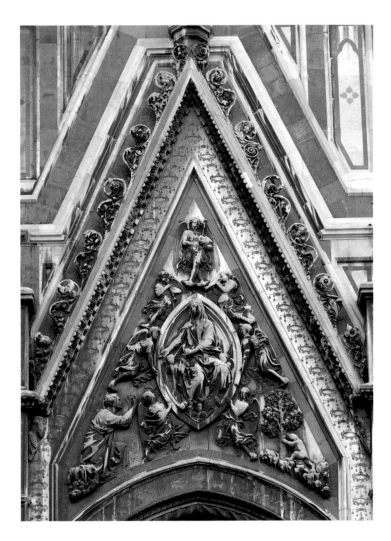

to carve a flowingly robed Madonna surrounded by angels whose
draperies rustle gracefully in the wind, yielding a rhythmic linear
effect more akin to Ghiberti than to Donatello or the earlier Nanni
himself.

He may have made this decision because of a lack of applic-
able antique models, or because Andrea Orcagna's (d. 1638/9)
sculpture of the same subject for the Orsanmichele was a pro-
totype too strong to ignore. But most probably Nanni realized
that the sculptures done to date for the cathedral were in the Goth-
ic style and that to depart from this style could introduce a dis-
cordant note in the cathedral fabric. If this reading is right,
then Nanni (and/or his patrons) thought of style in terms of its
appropriateness to a given subject matter and its setting. What
would do for an Assumption on the cathedral would not be right

for early Christian saints on the Orsanmichele. Such thinking was not isolated, as witness Alberti's decision to complete the facade of Santa Maria Novella in a style wholly responsive to the Gothic forms of the existing work, executed a century and a half earlier.

About 1417, Donatello carved the marble *St. George* for the niche of the armorers' guild at the Orsanmichele (FIG. 32). George is a younger and leaner version of Mark, equally vigilant, clasping his shield with one hand, and holding a metal sword (now missing) in the other. If Mark looks out upon his audience, George seems almost to stare down at a specific something or someone, presumably the menacing dragon who has come to ravage the princess. The urgency of his glance recreates the psychological exchange between sculpted figure and spectator, missing since antiquity, and a forerunner of the unforgettable face of Michelangelo's *David*. While the story of St. George and the Dragon is in the chivalric tradition, here it is interpreted as nothing less than a confrontation in the streets of fifteenth-century Florence.

Ghiberti must have studied Donatello's marbles intently, for their lesson is absorbed in the former's *St. Matthew*, done between 1419 and 1423 for the bankers' guild (FIG. 25, page 51). Like Mark, Matthew looks out upon his audience, but now in the didactic pose of a teacher with his gospel open and hand gesturing toward the Word. Figuratively he is the humanist orator, or more to the point, the itinerant preacher, among whom San Bernardino of Siena (1380-1444) was the most famous in Florence during these years.

While the mellifluous flow of complementary drapery patterns recalls the earlier *St. John*, in contrast to him Matthew assumes an animated pose, his drapery at once decorative and descriptive of the body beneath. This physicality joined to a mental intensity marks Ghiberti's definitive graduation from that elegant if psychologically void style once evocatively described as "the endless melody of Gothic line."

St. Matthew is the most fully documented

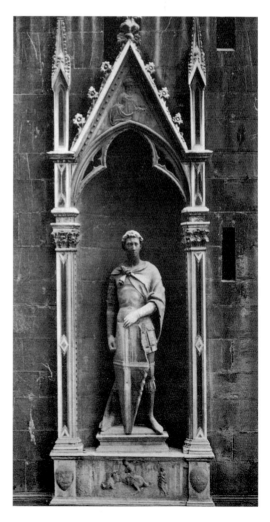

32. DONATELLO
St. George, c. 1415-17.
Marble, height 6'5" (206 cm).
Museo Nazionale,
Florence.

The photograph shows the statue as it was, *in situ* on the Orsanmichele.

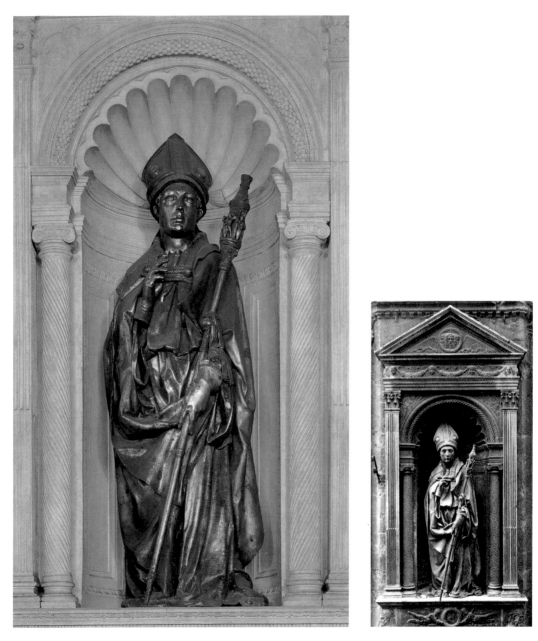

Above left and right

33. DONATELLO

St. Louis of Toulouse, c. 1422-25. Gilded bronze, height 8′8″ (261 cm). Museo di Santa Croce, Florence.

Until recently Andrea del Verrocchio's *Doubting Thomas,* a work carried out intermittently from the mid-1460s until 1483, occupied this niche. From c. 1460 the Guelf party and Mercatanzia (merchant's court) negotiated the sale of the niche to the latter, which was achieved by 1465. Donatello's *St. Louis* was removed to Santa Croce and Verrocchio began his work. The black and white photograph on the right shows the *St. Louis* temporarily restored to its original place at Orsanmichele after World War II.

Orsanmichele sculpture, and interesting insights emerge from that record. The sculpture was to be as large or larger than the *St. John*, and "to be made as beautiful as possible." To read between the lines, it was not only the artists who were in competition with one another, but also the patrons. The costs of materials and technique were on the patrons' minds, for not more than 2,500 pounds (1134 kgs) of bronze were to be used, and the figure was to be cast in either one or two pieces; if two, the head and body were to constitute the separate parts.

Ghiberti made his model during 1419, and the date on the bronze marks the close of his first stage. The subsequent work was not without setback, for the first casting failed, and the sculptor had to begin again. Finally there was the time-consuming work of chasing the cast (finishing the surface). Throughout, as usual for public commissions, the work was overseen by a committee of the guild, which included the young Cosimo de' Medici.

The culmination of the work at the Orsanmichele in the 1410s and 1420s is Donatello's *St. Louis of Toulouse*, the sculptor's first venture in bronze (FIG. 33). It was done in the earlier 1420s for the Guelf party, a conservative political organization whose name recalls the old Guelf party, the only entity other than a guild to sponsor a niche. Occupying the central niche on the street running between the Piazza del Duomo and Piazza della Signoria, every effort was expended to make it the most magnificent combination of sculpture and architectural niche achieved to date.

Louis was the boy-heir to the throne of Naples who was permitted to renounce his succession to enter the service of God, and who subsequently became Bishop of Toulouse; he was canonized in 1317. The message of this exemplar, devotion and humility placed before the exercise of power, could not have been lost on the Florentines and their rulers, who contemplated this lad with his unearthly face and demure gesture of blessing, an image of religious selflessness paradoxically enfolded in the pomp of ecclesiastical garb.

The figure is remarkably three-dimensional in effect, the deep and varied drapery folds arranged both to reflect light and enclose dramatic pockets of shadow. In comparison, the earlier niche figures seem somewhat flat, as if constrained by an invisible sheet of glass dropped in front of them. Here that glass is broken, offering an effect of volumetric billowing rather than compacted mass. To achieve this, Donatello abandoned a cast in one piece in favor of a number of shaped bronze sheets that were screwed together from the rear, a technique that had the added advantage of facilitating the gilding of the sculpture.

The niche is quite as remarkable as the sculpture. It provides a measurable, rational space in which the figure is comfortably accommodated. The major framing element is classical, and the Corinthian pilasters rest on a base bounded by heads on either end, with a central motif of two flying *putti* bearing a wreath derived from ancient sarcophagi. Arches recessed in steps behind the outer frame are supported on two spiral Ionic columns, with a paneled wall and shell apse behind. It is a beautifully proportioned and sophisticated piece of architecture, replete with antique references.

34. The Campanile, Florence, detail showing niches with replicas of the original fifteenth-century prophet figures.

The original sculptures are now in the Museo dell'Opera del Duomo, Florence. The figure of *Lo Zuccone* is second from left.

The niche is undocumented, but there is little evidence to challenge the likelihood that statue and niche are contemporary. The niche is an early example of the new architecture, carried out at the same time as Brunelleschi's work at the old sacristy and the Ospedale degli Innocenti, but, unlike either of those projects, almost archaeologically based in character. Whether Donatello, Brunelleschi or Michelozzo, Donatello's temporary partner in these years, was responsible is disputed. In a city where all the leading artists knew one another and exchanged ideas, even if technical working methods were closely guarded, it is per-

haps not wide of the mark to say that the niche is indeed by Donatello, with a little help from his friends.

Donatello applied the lessons learned from the *St. Louis* to the so-called *Lo Zuccone* ("Pumpkin-head"), perhaps the prophet Habbakuk, high on the campanile (FIGS 34 and 35). Spatial release of the figure from its niche is now transferred to marble. Full draperies spill over the form and largely conceal the body, but no longer in the decorative sense of Ghiberti's *St. John*. These draperies highlight the bald head of a prophet seemingly lost in a trance in which his jaw goes slack and his hand aimlessly fondles his drapery. Amid talk of materials, techniques, contractual obligations, and patrons, what these years saw was a birth of a new and heroic race of men in marble and bronze; *Lo Zuccone* is the embodiment of mystical rapture high above the streets of Florence, and the examination of technical matters cannot begin to explain the individual genius of the man who carved him.

Such was the face of the new art in Florence. It appeared first in sculpture, public in nature, born in an air of competition among artists and patrons, an art involving (in various combinations) continuation of inherited forms, new forms found in the art of antiquity, and the fruits of observation. In the language of the time, these sculpted bodies seemed "to live and breathe," inhabited by vigorous minds and spirits. It cannot be overstressed that this sculptural innovation took place a decade before it happened in painting, in a context unequivocally public and civic.

The Context of the Statues

Why should this artistic revolution occur in this city at this time? The question is of course inherent in what some would call the major issue in the history of art: to what extent the impetus for change in art forms comes from innovation within the discipline and to what extent, if any, change is triggered by external influences.

Nevertheless, a few observations are possible about these years in Florence. It was one of those moments − (Athens in the mid-fifth century BC

and Paris at the beginning of the twentieth century are others) – that are mysteriously blessed by a congregation of artistic genius, an epithet that rightly belongs to Donatello, Brunelleschi, and Masaccio. In the case of Florence, the crucial factor was the economic recovery from the plague, which enabled the allocation of resources to projects other than those of religious and civil buildings. The turn of the century, however, was a perilous time for Florence; the city had almost miraculously escaped defeat by Milan in 1402, and out of that close brush with loss of freedom the Florentines became more keenly aware of their status and responsibility as one of few free republics on the peninsula. The body of literature generated out of that experience, much of it inspired by writings of the ancients, stressed humanity's responsibility for its own destiny, and the need for a liberal education in the interests of a moral life lived in freedom, and the supreme virtues of public service, moderation, and self-control. Ideas like this were in the air of Florence around 1400, not as intellectual baubles, but as articles of faith, and may have had more than a little to do with the poise and confidence of the heroic race of humanity at the Orsanmichele.

On the other hand Giorgio Vasari, writing the life of the Umbrian painter Pietro Perugino (c. 1445/50-1523), attributed Florentine preeminence to three factors: an art of continuous critical appraisal, industriousness and the exercise of good judgment, and a lust for glory and honor. On balance, perhaps both views are correct, and this was an art responsible both to intellectual currents, and to the narrower issues of artistic innovation.

Opposite
35. DONATELLO
Lo Zuccone (Habbakuk?), mid-1420s-early 1430s. Marble, 6'5" (206 cm). Museo dell'Opera del Duomo, Florence.

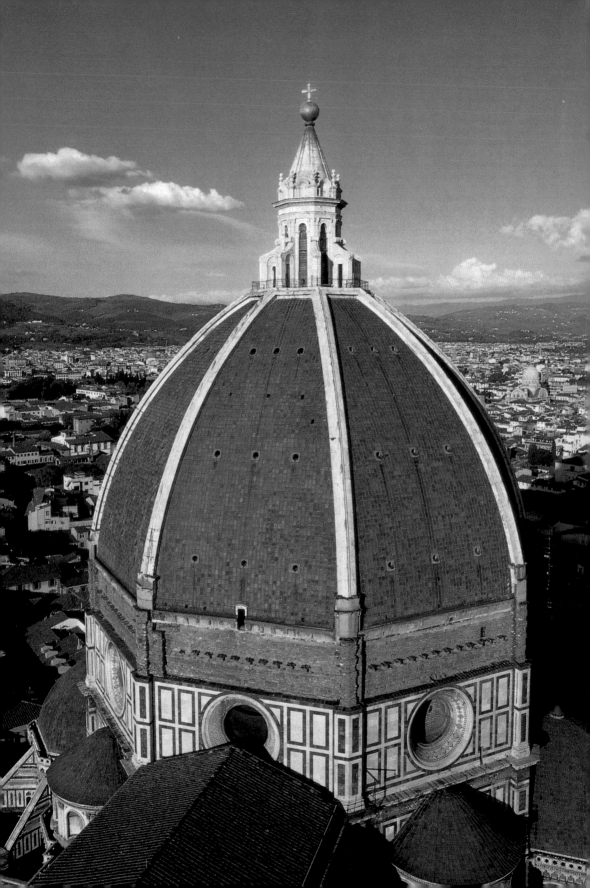

FOUR

In the Shadow of the Dome

I n the dedication of his 1436 treatise *On Painting* to Filippo Brunelleschi, Leon Battista Alberti extravagantly praises Brunelleschi's newly completed cathedral dome, "...vast enough to cover the entire Tuscan population with its shadow..." (FIG. 36). Alberti had been born in 1404, the son of Florentine exiles in Genoa. Trained in Padua in one of the best schools of the age, he attended university at Bologna. While still young he was an avid student of ancient literature, and his interests ran the gamut from philosophy to science. The record would have it that he indeed was a practitioner of the arts, a painter (no paintings have been identified), a sculptor (a self-portrait medal is ascribed to him), and later, an architect. By 1435, he surely knew the major artists of Florence, and his little book grows directly out of that intimacy. In his time he was a unique figure, straddling the worlds of the university intellectual and craftsman of the workshop. It is usually said that Alberti raised the arts to intellectual dignity. Perhaps it is more apt to say that he was the first to bring intellectual work down to the level of the workshop, to the benefit of both.

Alberti was arguably the principal spokesman for a new art based on study of nature and the antique, and it comes as a surprise that he should admire a *Gothic* dome (its pointed profile and exposed ribs are the Gothic features) set upon a church whose basic forms had been in place for half a century (FIG. 37). The dome is, figuratively, the capstone of Florence, the physical feature that gives coherence to the panorama of the city, and toward which major streets lead. If Brunelleschi were a new man working in old

36. FILIPPO BRUNELLESCHI
Dome of Florence
cathedral, 1420-36.

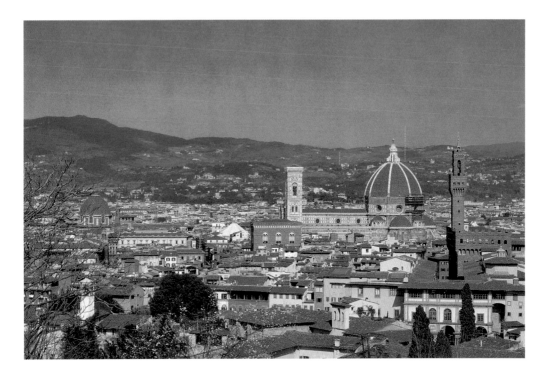

37. View of Florence from the Forte Belvedere.

forms, what he built was unrivaled in size and importance in the architectural history of Florence, and the definition of its meaning essential to the Florentine sense of self.

As the city awaited its new dome around 1400, there is no hint of dissatisfaction with the product of the fourteenth-century building boom. On the contrary; Coluccio Salutati and Leonardo Bruni (c. 1370-1444), the latter to gain fame as an historian and as the second chancellor of the Florentine republic, both wrote around 1403 in praise of their city and its architecture. Even allowing for rhetoric engendered by the Milanese crisis, their words reflect a genuine civic poise and pride. Indeed, Bruni was openly dismissive of the claims of other cities, feeling sorry for them when a comparison is made with Florence.

Competition existed not only among artists and their patrons, but between cities themselves, the spotlight falling upon a city's most important building, the cathedral. In the year of Alberti's dedication in *On Painting*, the Duomo was rededicated by no less a priest than the pope himself, Eugenius IV (r. 1431-47). Brunelleschi had completed his model for the dome in 1418, and jointly with Ghiberti was contracted to construct it in 1420. The sources are rich in tales of bitter rivalry between the two men, but, whatever the truth, Ghiberti dropped out within a few years, and the triumph was Brunelleschi's alone. The history of the dome

has been told in detail many times, and a brief sketch follows. The decisions taken in 1366-67 committed the Florentines to building the largest dome in the world, to be surpassed only by that of St. Peter's a century and a half later. Once the drum had been completed in the 1410s, the success or failure of the project lay in bold engineering solutions. If a pointed dome was aesthetically desirable for the culminating feature of this Gothic cathedral, structurally it was an absolute necessity, for anything approaching a semicircular dome would have invited collapse through the lateral direction of downward forces. The basic form, then, was a given, but apart from daunting questions as to how to raise heavy materials so far off the ground, and above all how to close the dome without the use of centering (a temporary substructure of a vault or dome that supports the bricks/stones until the mortar has set), the 300-foot (91 m) height was beyond the carrying capacity of such a structure, even one made with the stoutest of timbers.

Brunelleschi realized that the dome had to be as light as was possible, so conceived it as a double shell adhering to a skeleton of cross-braced ribs, eight of which are visible on the exterior, with sixteen more concealed between the two shells (FIG. 38). There being at the time no science of statics, the architect had to proceed by trial and error, taking out insurance in the form of such devices as stone and wood chain girdles at the base, and a herringbone pattern of brickwork that would have greater bonding strength than could be achieved by conventional means. Brunelleschi's sources for these various devices and techniques are much discussed; suffice it to say that beyond being possessed of *ingenium*, a natural capacity for original invention, Brunelleschi had intimate familiarity with both Roman and medieval architecture.

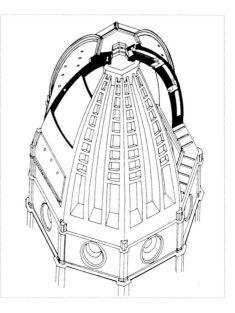

38. Dome of Florence cathedral in section.

The most heated argument concerned how to erect the dome without the use of conventional centering. The record offers one proposal that is as delightful as it is doubtless also fictional, that the Duomo be filled with earth laced with coins, so guaranteeing a free labor force in the form of children to remove the dirt when the job was done. What is not fiction is that Brunelleschi proposed, and had to argue vigorously, that the only way to proceed was by use of scaffolding cantilevered from the inner face of the dome, that is to say

work platforms anchored in the fabric, and moved upward as the work advanced.

This idea, which carried the day, required the invention of new machinery to transport heavy material to the platforms: Brunelleschi was the man for the job. Known as the "New Daedalus" (after the prototypical inventor celebrated in Greek mythology), Brunelleschi was a consummate technologist, his work ranging from a new design for a river boat, to clockmaking, to elaborate mechanized apparatus for staging religious dramas. Whatever else the Florentines thought of their new dome, they must have seen it as an unprecedented miracle of engineering.

Contemporary evaluation of a work of art or architecture other than in general terms is rare during the fifteenth century, so Alberti's 1436 thoughts are particularly valuable. He writes that "Nature, mistress of all things had grown old and weary, and was no longer producing intellects any more than giants on a vast and wonderful scale such as she did in what one might call her youthful and more glorious days." But on returning to Florence from many years in exile, Alberti found artists in no way inferior to the ancients, and realized that the achievement of excellence "lies in our own industry and diligence no less than in the favors of Nature and the times." What Brunelleschi had accomplished was a feat of engineering "that people did not believe possible these days and was probably equally unknown and unimaginable among the ancients." In short, Alberti celebrates Brunelleschi's unprecedented accomplishment, his power to invent without the help of traditional means. The dome stood, then, as a symbol of the new, and the new was the core of the Florentine resurgence. Over thirty years earlier Coluccio Salutati had written that there was no reason, beyond empty glory and the power of antiquity, to prefer the old over the new.

The dome is the heart of Florence, as it was 600 years ago. It would be a mistake, however, to imagine that heart as simply a product of engineering. Such a notion is quickly dispelled by reading Alberti on architecture proper, or his other writings where architecture is introduced as a conceit or metaphor. About 1450, he completed the *De re aedificatoria* (*Ten Books on Architecture*), an outgrowth of his Florentine experience. For Alberti architecture was the highest art, the architect a second Creator, the whole enterprise a religious calling. Alberti was passionately concerned with the civic nature of architecture, the appropriateness of buildings to various levels of society, above all with the proper siting of a city's public buildings. The well-maintained "temple" (Alberti's constant word for a church) is of course the greatest ornament

of the city, and should be at the highest point of elevation. If the topography of Florence did not permit literal observance of that injunction, the soaring dome of the Duomo was a climactic substitute.

The Duomo is the central metaphor of Alberti's *Della tranquillità dell'anima* (*On the Tranquility of the Soul*), written in the early 1440s. The essay explores tranquility and its acquisition, how it is achieved in adverse circumstances, and how inner turmoil is subdued. The Duomo is the image of the soul's tranquillity, for its diverse and potentially conflicting parts are a harmonious concord of opposites. These thoughts, in this Gothic building, at a time when a wholly new architecture from the hand of Brunelleschi was rising elsewhere in the city – how could Alberti think in this way? The answer is dependent on his idea of *concinnitas*, the idea that parts of a whole which are different in form must be brought together to form a coherent and harmonious whole. *Concinnitas*, for Alberti, was nothing less than a law of nature, and when applied in a building yields dignity, charm, authenticity, and value.

The harmonization of parts rather than commitment to a particular style was what mattered to Alberti. Hence his praise for the Duomo, and his own work on the Gothic facade of Santa Maria Novella, which created an ensemble that respected the tradition of some of the oldest architecture in the city.

Brunelleschi's Other Projects

In 1436, Alberti's writings on architecture and his own work as an architect lay in the future. The dome was just completed, over a decade and half of work, during which Brunelleschi was also occupied with other projects, where, unconstrained by preexisting buildings, he forged a wholly new style. There was the old sacristy at San Lorenzo, and in 1419 the beginning of the Ospedale degli Innocenti (hospital of the innocents, an institution for abandoned children) for the silk guild (FIGS 39 and 40). In comparison to older hospitals such as Santa Maria Nuova, the plan was more rationally ordered, but the most striking feature is the entrance loggia. Earlier hospitals had similar entrance porches, usually with polygonal columns rising from a low base, the general effect displaying little sensitivity to proportional harmony (FIG. 41). In contrast, Brunelleschi's new version of this traditional architectural type is a simple statement of lucid proportions that yields a sense of delicacy and lightness, understood at a glance by the spectator.

The new style is usually described as Early Renaissance, or

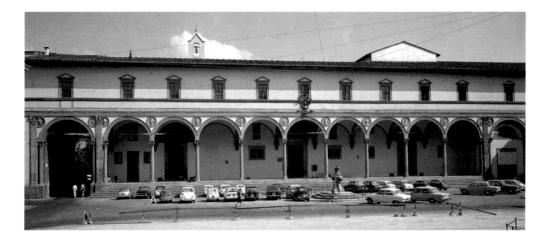

74 *In the Shadow of the Dome*

Above left
39. FILIPPO BRUNELLESCHI
Ospedale degli Innocenti,
Florence, c. 1419-1440s.

The Innocenti loggia is
one of three that frame the
Piazza dell'Annunziata.
The other two are decades
later in date.

Below left
40. FILIPPO BRUNELLESCHI
Loggia of the Ospedale
degli Innocenti, Florence,
1419-1440s.

Right
41. Loggia of the Ospedale
di San Matteo, Florence,
1384.

The building now houses
the Fine Arts Academy.

classical, but in fact any obvious connection with specific Greek
or Roman buildings is absent. To be sure, Brunelleschi reinstat-
ed the ancient order (meaning a column and its parts, the base
on which it stands, and the load which it supports, all accord-
ing to a system of ratios, the Greek temple being the purest
manifestation); but this is only a general borrowing, and the
specific details of the building seem to derive instead from Tus-
can Romanesque intermediaries, such as the Baptistery and San
Miniato.

A sure sense of proportions, not an archaeological relation
to ancient models, forms the basis of the new architecture. A cube
ten *braccia* on each side (a Florentine unit of measure equivalent
to about 23 inches or 58 cm) is the basic unit of the loggia, repeat-
ed nine times. The height of the columns (including the blocks
above them) equals the diameter of the semicircular arches. A
hemispherical vault rests on each cube, supported visually on
the wall by brackets. Materials offer a simple contrast of gray stone
and white wall surfaces, the moldings appear etched on rather than
modeled, yielding a pristine lightness undisturbed by gratuitous
decoration (the terracotta roundels of infants in swaddling cloths
and the frescoes are later in date).

The Augustinian church of Santo Spirito is on the south
side of the Arno. Designed by Brunelleschi in the late 1420s or
early 1430s, only one column had been erected by the archi-
tect's death in 1446. Today the church is austerely simple on the
exterior, with plain side walls and an unadorned facade that fronts

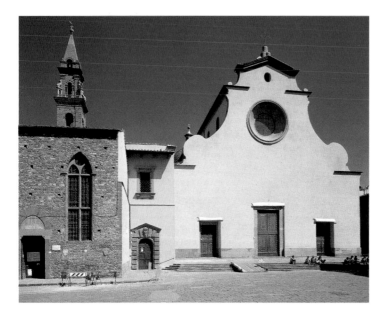

Left
42. Facade of the church
of Santo Spirito, Florence.

on one of the most characteristic Florentine neighborhood squares
(FIG. 42). Originally the setting was to have been far grander, with
the nave rotated 180 degrees so that the facade would face onto
a large piazza leading to the bank of the Arno.

The interior of Santo Spirito is perhaps the most satisfying
covered space in all of Florentine architecture (FIG. 43). The effect
is similar to the less complex forms of the Ospedale degli Inno-
centi, lucid, light in feeling, simple, built from repeated units,
using stone and stucco that eschews color, and above all with
an immediately comprehensible set of restful proportions. Plan
(FIG. 44) and elevation reveal the scheme. The square formed by
the crossing (of nave and transepts) provides the module on which
the church is based. The width of the nave is equal to the sides
of the crossing square, while the widths of the aisles, and of the
nave arches, are both one half of the side of the crossing square,
yielding square aisle bays one-quarter the area of the crossing square.
In elevation the height of the nave arcade is equal to the height of
the wall above. In short the proportions are irreducibly simple
– 1:1, 1:2. One walks through a cluster of proportionate, repeat-
ed units, at any given spot looking from one space through fram-
ing columns into other spaces, an effect that would have been
enhanced by the apparent original intention to wrap the nave
columns around the entrance end of the church (FIG. 45). The emo-
tional atmosphere is cool and rational, the space a place for con-
templation.

Santo Spirito and San Lorenzo implied a new aesthetic for

Right
43. FILIPPO BRUNELLESCHI
Santo Spirito, Florence,
planned late 1420s-early
1430s, begun mid-1440s.

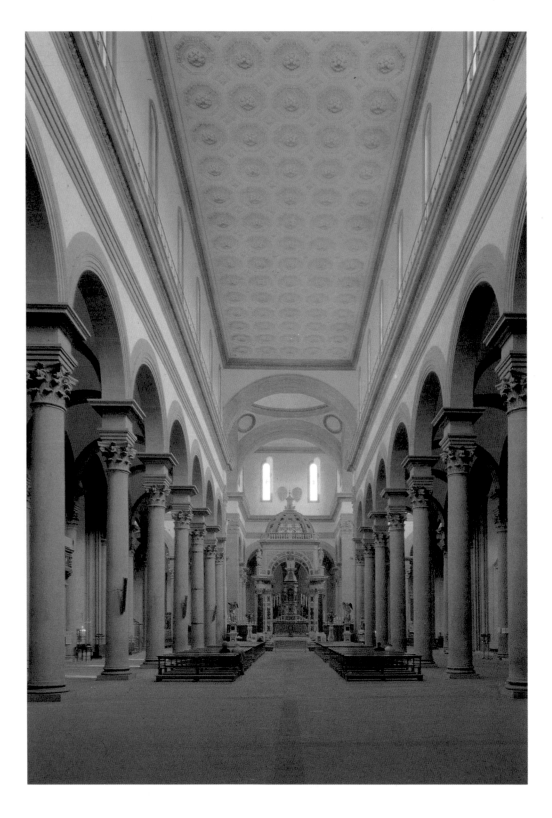

This is a reconstruction of Brunelleschi's original intention, which involved a more sculptural conception of masses than appears in his earlier works, here embodied in the curved walls of the side chapels, which appear on the exterior as an undulation of the wall of the church.

Right
45. Santo Spirito, Florence, view through columns at crossing of nave and transept.

the relation between architecture and painting, for Brunelleschi's concept literally and figuratively left no space for the frescoes so characteristic of earlier Florentine churches, frescoes which while wonderful in themselves inevitably tend to dissipate the architectural unity of a building. The new alternative was the relatively small panel altarpiece, a number of which are still in place at Santo Spirito.

Architectural Patronage

In 1442, Cosimo de' Medici had assumed the financial responsibility for the completion of San Lorenzo, an act that was a departure from the civic patronage of buildings. In the light of such munificence it is not therefore surprising to find that the third richest man in Florence, the landowner and banker Giovanni Rucellai, committed to a similar act of generosity in his quarter of the city, the completion of the facade of the church of Santa Maria Novella (FIG. 46). One of the most important Dominican houses in Italy, the complex housed the popes on their visits to Florence, and was the site of the prestigious Council of Florence, which in the 1430s attempted unsuccessfully to unite the western and eastern churches. The facade had been begun in the last years of the thirteenth century but was only completed to the level of the arched tomb niches when the work stopped, leaving the rest bare brickwork.

One might wonder why Giovanni Rucellai in the later 1450s agreed to finance the facade of Santa Maria Novella. Piero de' Medici's commission for the tabernacle for the miraculous image at the Annunziata, and another similar one at San Miniato in 1448,

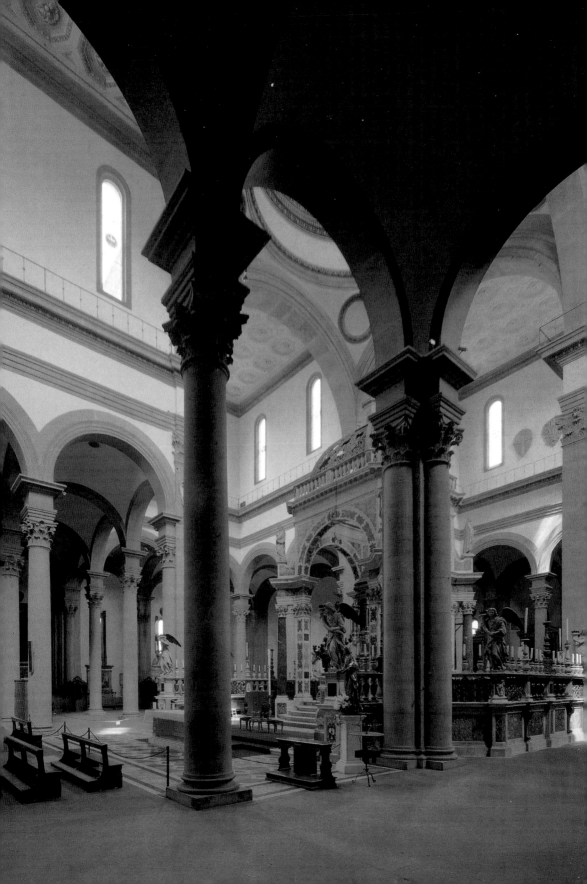

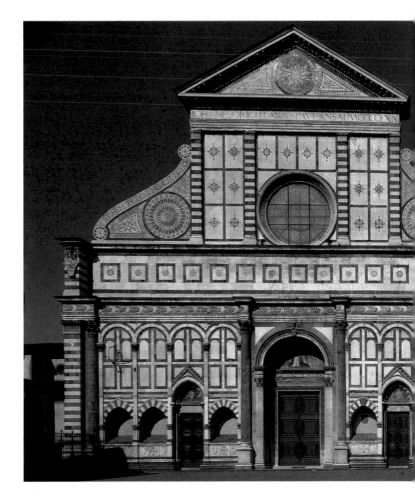

joined his family name to holy objects, in an act of piety and familial celebration. Rucellai's motivation was similar. His own burial chapel has an inscription expressing his pious hope that his good works may merit his salvation, and at Santa Maria Novella a large Latin inscription under the pediment translates as GIOVANNI RUCELLAI SON OF PAOLO 1470, and the frieze below the lower cornice carries the Rucellai device of ships with billowing sails, an allusion to the fickle winds of Fortune, which may be harnessed to man's benefit by a well-trimmed sail.

The facade of Santa Maria Novella was almost certainly designed by Alberti. Though he had little idea how to carve a stone, let alone raise a dome, his architectural learning was immense, based on the examination of ruins, and study of *De Architectura* (*Ten Books on Architecture*) by Vitruvius (Marcus Vitruvius Pollo; active 1st century BC), the only treatise on the subject to survive from antiquity, a learning cast in a broader matrix of social

46. LEON BATTISTA ALBERTI
Facade of Santa Maria
Novella, Florence, 1456-78
(dedicatory inscription
1470).

thought, above all inspired by Cicero. In contrast to Brunelleschi, Alberti always assigned the execution of his projects to others.

The buildings for which Alberti is best known are San Francesco (the so-called Tempio Malatestiano) at Rimini, begun before Santa Maria Novella, and Sant' Andrea at Mantua, which capture the monumentality and gravity of ancient Roman buildings. Not so Santa Maria Novella, unless one chooses to emphasize certain individual parts, such as the monumental portal or the pediment. The effect is of pattern and flatness, a lucid geometry of forms executed in two hues of stone. The facade is overtly inspired by the Baptistery and the facade of San Miniato. To be sure, the design is in part dependent on the pre-existing work, but with various options available, Alberti chose to echo the famous Romanesque buildings of Florence – *concinnitas*, on a city-wide basis.

The ground floor of the facade builds upon the earlier work, the verticals implied by the pointed arches picked up by the

four vertical sections and giant columns to each side of the arched monumental entrance. This verticality is then countered (the harmonization of opposites) by a broad horizontal band decorated with a motif of squares, which serves at once as an attic to the lower storey, and a base for the upper. The upper storey, built around the circular rose window typical of Gothic facades, echoes a Roman temple facade, its four pilasters carrying an entablature (with the inscription) crowned by a pediment. To the sides are two volutes, or counter-curves, used here for the first time to mask the dissonance between the height of the nave and the much lower side aisle shed roofs, a use repeated by others over the centuries. Finally, unlike San Miniato, the facade as a whole possesses a proportional inevitability, in the sense that no dimension can be changed without doing violence to the whole. Unsurprisingly the scheme is surpassingly simple – a square set on two squares below, proportions that determine the subdivisions of the facade.

Rucellai lived to see the completion of his project, and must have been well pleased. He wrote that spending money had given him more pleasure than earning it, above all money invested in building. The patron and his architect were a pair of architectural fanatics.

Secular Projects

Giovanni Rucellai also built a palace; the houses of Florence generally were called *palazzi* – palaces – but true palaces in our sense of the word only began to be built in the second third of the fifteenth century. From the thirteenth century onward, Florentine houses are quite conservative, usually three or four stories, with either one or three doors, and windows one above the other. Staid and austere, these houses indicate the proprietor's social standing, but without ostentatious display. This sort of house continued to be built in the fifteenth century, cheek by jowl with its neighbors, crowded on narrow streets where little light falls on them (FIG. 47).

After the mid-1440s, a building boom in palaces began, which can only be described as a status contest among such leading families as the Medici, Rucellai, Pitti, and Strozzi. The preferred word used by the humanists for fine architecture is "magnificence," which had crucially to do with an architecture appropriate to the dignity and social standing of the owner. Magnificence was an easy word to toss about, but a problematic concept when it came to architectural practice. How in a free republic was the virtue of

an owner to be projected to the less fortunate without inciting envy? The palace facade had much to convey, and it had to be done right.

Roman ruins had comparatively little to tell Florentines about how to make their palaces, but ancient literature was filled with food for thought. Within living memory Christian strictures against money-lending and undue profit had concerned Florentines; palaces were of course the fruit of just such dubious monetary gains. It was then that Florentines turned to the ancients for an amended set of values.

Aristotle in the *Nichomachean Ethics* had reassuring words on wealth, believing that money well spent brings greatness and prestige. Pliny the Younger applied such ideas specifically to architecture, writing that splendid building should be justified by the public life of a patrician. Cicero concurred, adding that a man's house should reflect both his dignity and the volume of his social activity. Alberti in the *Ten Books on Architecture* reiterates the idea that the character of a palace should have centrally to do with a man's social standing. He held that some architecture is for everyone, some for common folk, and some for those

47. Renaissance houses in the Via de' Bardi, Florence.

at the top of society. He is foursquare in asserting that in a city only a few men stand out, and theirs is the claim to highest magnificence. For these, wealth is the true sign of God's favor. Other contemporary writers, such as Leonardo Bruni, Poggio Bracciolini (1380-1459), and Matteo Palmieri (1406-75), argued that not only is wealth not a luxury, it is the prerequisite for the exercise of virtue in an active, civic-oriented life. The wheel had come half circle from wealth being a sin to it being a moral virtue. No wonder that Florentine patricians carefully considered their public posture as expressed in buildings.

The palace, which typically represented an investment of one-half to two-thirds of a man's financial worth, was first of all an embodiment of family propaganda, the tradition and continuity of lineage. The family accommodated in a palace was almost always an extended family, not a small nuclear family in the modern sense. New or renovated palaces were built on or near ancestral sites, and in wills every effort was made to see that a palace did not pass out of family hands.

About 1445, Cosimo de' Medici began to build a new family palace (FIG. 48), a few doors toward the center of town from a cluster of older family houses (now destroyed). Cosimo's position was particularly sensitive, for by this time he was the *de facto* power behind the trappings of republican government. At the most he could afford to be seen politically as *primus inter pares* (first among equals) but had carefully to avoid any suggestion that he was a citizen with unique privileges and powers. His caution is reflected in his commission to Brunelleschi to design a new palace, a design that turned out to be too grand and so was rejected, to the reported rage of the architect. Cosimo then called upon Michelozzo di Bartolommeo, the one-time collaborator of Ghiberti and Donatello. Michelozzo's building differed in several respects from the building we see today, which, in the seventeenth century, was lengthened northward (the photograph is taken from the south) by the addition of one portal and seven window bays, and a loggia on the corner where business was conducted was walled in. The pedimented windows on the ground floor were added in the early sixteenth century.

The building, restored by the mind's eye to its original form, has one centered portal leading through to an inner courtyard, and three floors, each slightly lower than the floor below it. The facade stonework progresses from rusticated (rough-cut heavy blocks) on the ground floor, to smoother-cut stone above, with thin cornices separating the floors, on which delicate mullioned windows rest; a massive cornice closes the composition.

48. MICHELOZZO DI
BARTOLOMMEO
Palazzo Medici, Florence,
after 1444-1450s.

The core of the palace
is an arcaded courtyard,
appropriate for ceremony
and display, while the rear
block opened on a garden.
The formal courtyard
differentiates a fifteenth-
century palace from its
predecessors; in the latter
the interior open space was
little more than a wide light
shaft, usually with a well at
the bottom. The palace is
now known as the Palazzo
Medici-Riccardi.

The humanists' "magnificence" does not seem quite an apt description. The building is large, has a vertical fortified look, and is more than anything a sober expression of solidity and strength. Inescapably, the north facade of the first block of the Palazzo della Signoria is the direct ancestor of the facade of the Palazzo Medici, a daring and risky association if, indeed, intended, for Cosimo in his palace was the controlling power behind the legitimate power vested in the Signoria (FIG. 49).

Despite Cosimo's care not to distance himself from the citizenry, his new palace apparently came under attack. In 1453-56 one Timoteo Maffei·wrote a spirited defense of Cosimo the builder, rationalizing that the palace was not built to suit Cosimo's needs, but to adorn a great city.

Since 1428, Giovanni Rucellai had been acquiring properties piecemeal, which formed the complex of his family's house. By the early 1450s he began a consolidation by commissioning Bernardo Rossellino (1409-64) to design and build a central courtyard. Several years later he decided to construct a facade, a mask of power and virtue to front the irregular earlier archi-

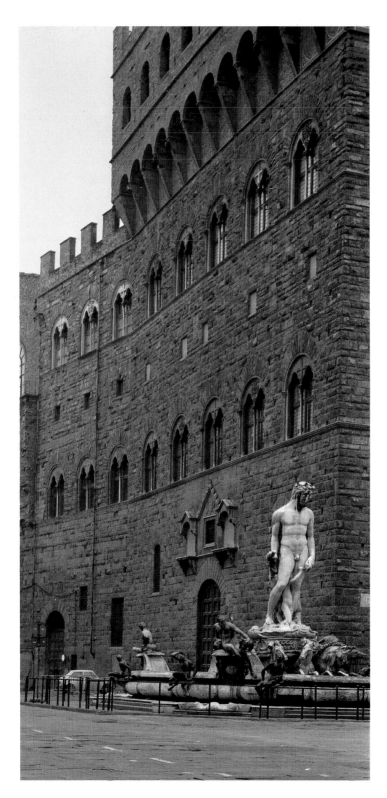

49. North facade of the Palazzo della Signoria, Florence, begun c. 1300.

This photograph shows the original (north-facing) principal facade of the palace, the bulk of the building on the right, which when taken in isolation makes its relationship to fifteenth-century palaces much clearer.

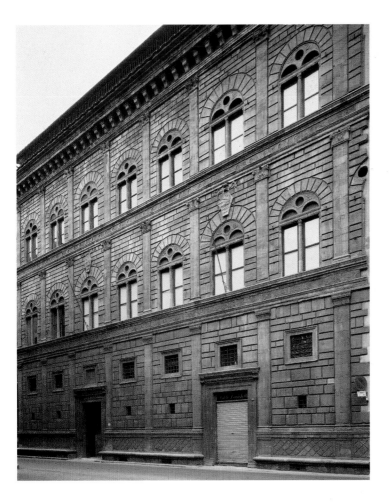

50. Leon Battista Alberti(?)
Facade of the Palazzo
Rucellai, Florence, 1455
or after.

Note, in particular, the
ragged, unfinished masonry
on the right end of the
facade.

tecture (FIG. 50). The facade was probably built to a design by
Alberti. The original idea seems to have been a facade five bays
wide, its one portal opening on Rossellino's courtyard. With
the acquisition of further property Rucellai extended the palace
to the right, only to break it jaggedly off when further property to
complete the expansion proved unavailable.

The form of Rucellai's facade echoes the Palazzo Medici –
three floors, delicate windows resting on the cornices that sep-
arate the floors, all capped by a heavy cornice. However, the
Rucellai palace is smaller and more elegant, with smooth-finished
blocks replacing rusticated stone, and the facade composed by
pilasters in three different classical orders, one above the other.
This inventive way to give the horizontality of the building a bal-
ancing vertical emphasis was never used again in Florence. The
reason was probably ideological rather than stylistic. Florence was
the daughter of Rome, but specifically republican Rome. An edu-

cated Florentine would have known that such a use of architectural orders was an imperial motif, employed, for instance, at the Colosseum, or more to the point, as a feature of the Septizonium (destroyed in the sixteenth century), which was believed to be part of the facade of the imperial palaces on the Palatine Hill in Rome. Possibly it was thought that Rucellai and his architect had crossed the line of propriety in implying a comparison between a Florentine banker and a Roman emperor.

The Rucellai palace fronts onto a small, irregularly shaped piazza, sufficiently cramped that it could be said that fifteenth-century Florentine buildings seem more space-occupying than space-enhancing. Small as it is, this space was an extension of the palace. A loggia was built in the 1450s, to be replaced by a second one a decade later (FIG. 51). Such loggias (there were about twenty in 1470), while sometimes used for business, were the site of family display and festivity, such as wedding feasts. Soon after Rucellai's loggia was built, the fashion seems to have passed

51. ANONYMOUS
Loggia Rucellai, Florence, mid-1460s. (The building is now used as a commercial antique gallery.)

out of style as family life withdrew from public view into the privacy of interior courtyards and gardens.

The story of palaces might well end here, but for one poignant and socially revealing coda. The cornerstone of the Palazzo Strozzi, a building larger than either the Medici or Rucellai palaces, was laid with much fanfare in 1489 (FIG. 52). Filippo Strozzi (1428-91) was the scion of an old and prominent Florentine family whose male members had been exiled since 1434. Filippo had made his commercial fortune in Naples, and when at long last he was allowed to return to Florence, there was much need and little time to leave the physical mark of his family on the city. To compete openly with the great families could be risky, so Filippo seems to have cleverly enlisted Lorenzo de' Medici to support the idea that the erection of a magnificent new palace would do honor to the city.

52. BENEDETTO DA MAIANO(?) AND IL CRONACA (cornice, 1530s)
Palazzo Strozzi, Florence, begun 1489.

Wide-angle photography and earlier depictions give little sense of the massive structure, which, because of the narrowness of the streets, is almost impossible to see as a unified whole.

Filippo Strozzi died when his palace was barely begun, but the family carried it to completion. It was a jewel in the crown of the city, but to what gain in amenable living for the Strozzi? The record has it that Filippo's son and his family lived in a few rooms on the *piano nobile* (the floor with the largest rooms, in this case the floor above ground level), while the rest of the palace was either empty or used for storage. Such was the private price paid for proclaiming to the public through architecture one's social standing and virtue.

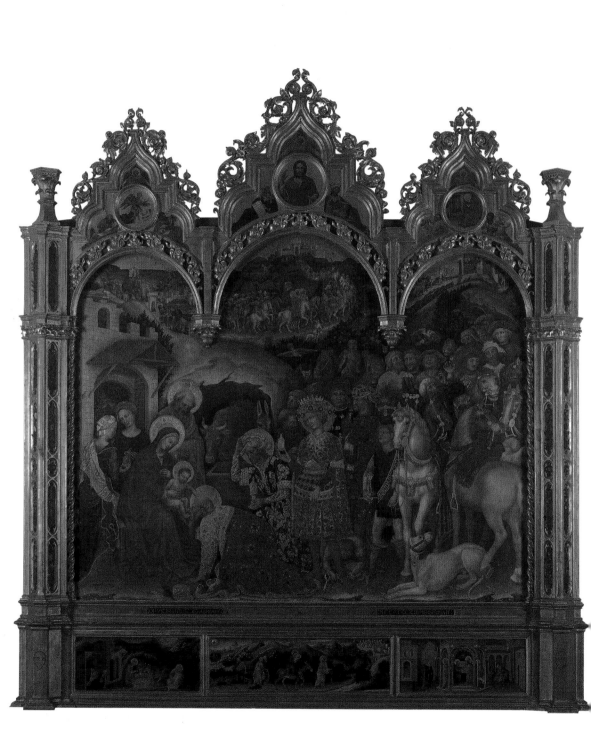

The World Seen Through a Window

For all their love of the written word, the Florentines were unreceptive to science, an attitude that goes back in part to Petrarch's view that the sciences fail to impart wisdom. There were, however, two major exceptions to this lack of interest: optics and perspective. Given that artists from Giotto onward became increasingly interested in depicting tangible forms in illusionistic space, inevitably optical science and artistic practice to an extent converged. So one finds seminal pages on perspective in Alberti's *On Painting*, writing on optics in Ghiberti's *Commentaries*, works solely on perspective by Piero della Francesca (early 1420s-1492; a Tuscan painter who worked in Florence in 1439, but left his greatest works in Arezzo and elsewhere), and finally notebook pages by Leonardo written at the end of the century, which reveal the most complex thoughts to date on the subject.

53. GENTILE DA FABRIANO
The Adoration of the Magi, 1423. Tempera on panel, 9'3" x 9'10" (307 x 325 cm). Uffizi, Florence.

Earlier arguments that Gentile's was an aristocratic style, as opposed to the burgher style of his contemporary Masaccio, do not survive scrutiny of the social positions of their patrons, respectively the Strozzi and Brancacci.

The Illusion of Space

Toward the close of the fifteenth century Leonardo da Vinci began assembling notes for a treatise on painting. Painting for Leonardo could only succeed when conducted according to clear principles, of which the most important was the ordering power of mathematics. He compared painting to philosophy, in that both were concerned with looking beyond appearances to underlying structure and movement. Leonardo saw painters as potentially God-like, surrogate creators, who, through the hand guided by eye and mind, could take possession of the universe. Beyond its traditional purposes painting had a powerful role, the generation of new

knowledge, a role in which it might exceed the possibilities of the written word.

Such ideas are light years away from the artistic world of 1400, when Cennino Cennini's practical manual offered advice from one craftsperson to like-minded colleagues on how to do things in a traditional, time-tested way. If, then, in 1400 painting was a craft practiced by the socially humble, a century later it was practice guided by theory, and theory led artists into the previously closed circle of masters of intellectual inquiry.

Alberti had written his *De Pictura* (*On Painting*) in Latin in 1435, and promptly translated it into Italian for the artists of Florence. He was aware that he was treating art "in a wholly new way," for his book is neither a manual, nor is it a history of art or artists, for which the Roman Pliny's *Historia naturalis* (*Natural History*) would have been the obvious model. Rather, it is a book about the status and principles of painting, an art structured according to Euclidean geometry. The content of that art was uplifting narrative, which Alberti called *historia*, only successfully achieved by men virtuous in character and learned in both mathematics and letters. Cleverly, Alberti closely associated painting with two of the liberal arts (geometry and rhetoric), so implicitly elevating its intellectual status. By recounting the importance of painting to the princes and leading citizens of antiquity, he implied that beyond intellectual recognition artists were owed an improved place in society. *On Painting* is an original work, based upon ancient models of writing, notably categories of rhetoric.

In the context of the mid-1430s Alberti's book is a curiosity for several reasons. While perhaps 80%-90% of painting at that time was Christian in subject matter, not only does Alberti refrain from discussion of Christian art, but he takes subjects from ancient literature as his main examples. And he addresses painting, at that time certainly the least innovative of the arts. With a few exceptions, notably Masaccio, painting was a conservative endeavor carried on by such minor contemporaries as Niccolò di Pietro Gerini, Lorenzo di Niccolò, Bicci di Lorenzo, Mariotto di Nardo, Giovanni da Ponte, and others who are household names only to scholarly specialists. That Alberti must have recognized this situation is clear from his dedication of the book to Brunelleschi the architect, and the mention therein of three sculptors – Donatello, Lorenzo Ghiberti, and Luca della Robbia (c. 1400-82) – and a deceased painter, Masaccio. The dedication seems implicitly an exhortation to the painters to reenergize their art on the dual basis of the study of antiquity and of the men named in the dedication, all but

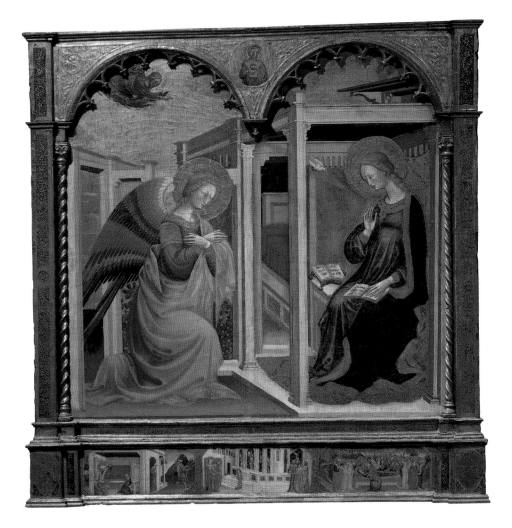

one of whom worked in media other than painting.

The *Annunciation* by Bicci di Lorenzo (1373-1452) and assistants of around 1430 is representative of a wide class of paintings done at the time (FIG. 54). An altarpiece whose purpose was to stimulate devotion and instruct the faithful, it is not a picture of something so much as a fusion of imagery and a richly carved wood architecture united in a holy object. The subject matter is clear, the Annunciation in the central panel, the Virgin's ancestor David playing the harp above, and three predella (the painted base of an altarpiece) scenes illustrating the important events of the Virgin's life. Lest the message be lost on anyone, the artist relies on verbal inscriptions, beginning with the greetings of the Virgin and Gabriel inscribed on their haloes.

In color and play of flowing line the altarpiece continues those

54. BICCI DI LORENZO
AND ASSISTANTS
The Annunciation, c. 1430.
Tempera on panel, 64^1/$_2$ x
54^1/$_2$" (164.4 x 144.7 cm).
Walters Art Gallery,
Baltimore.

fourteenth-century traditions that culminate in the pervasive style of the early fifteenth century, usually referred to as International Gothic. The play of color and line tend to a decorative flatness, while the fantastic stage-like setting shows a restless desire for spatial illusionism. A close reading of Alberti's book in juxtaposition to this painting and many others like it reveals no similarity of outlook. Whatever Alberti is writing about, it does not concern the mainstream painting of his day, but something else, an art of painting desired, but as yet only fleetingly glimpsed.

In thinking about illusionistic space, it is unlikely that Alberti sharply distinguished painting from pictorial relief sculpture. He would have observed the growth of interest in the depiction of space as Ghiberti progressed from the earlier to the later panels of his first set of Baptistery doors, the different box-like space of Nanni di Banco's sculptors' workshop beneath the *Four Crowned Saints* at the Orsanmichele (see FIG. 30, page 59), and, above all, the new marble relief technique invented by Donatello, *rilievo schiacciato*, literally "squashed relief." Donatello apparently first used it in his relief of *St. George slaying the Dragon* (c. 1417; FIG. 55) beneath the statue of St. George (see FIG. 32, page 61). The highest relief is used for the saint and his horse, but even that projection is shallow. The building, trees, and clouds behind are almost paper-thin, as if etched rather than carved onto the marble. It is as close as one can get in sculpture to the atmospheric effects of painting, and anticipates rather than follows any comparable accomplishment in painting.

That accomplishment in painting was first achieved by Masaccio (Maso di Ser Giovanni di Mone; 1401-28) in the mid-1420s in his frescoes in the Brancacci chapel in the Carmine, the church of the Carmelite order, on the south side of the Arno. Here Masaccio, together with Masolino da Panicale (1383-1440s), frescoed events from the life of St. Peter. As Donatello's *St. Mark* seems an artistic mutation, so does Masaccio's share of the work, until one ponders its relationship to sculpture. In *The Tribute Money* the graven figures of the Orsanmichele are transposed to painting (FIG. 56). The central group in the fresco is an expanded adaptation of the semicircle of Nanni's *Four Crowned Saints* (see FIG. 29, page 57), like them toga-clad figures who conduct their business in dignified solemnity. They stand in a sparse landscape, illuminated by a light that is the fictive extension of the actual light that enters through a window to the right of the fresco. The receding lines of the building, which converge in the head of Christ, lead the eye to the mountain range beyond which forms become less distinct and colors diminish in intensity, allowing the spectator to imagine a vastness of scale not possible were these forms closely described.

If Lorenzo's painting has little to do with Alberti's thought, then Masaccio's *Tribute Money* has much to do with it. The *Tribute Money* anticipates Alberti's notion of *historia*, a term that he does not closely define, but, in the context of the examples he employs, is a narrative painting with morally illuminating overtones. Alberti would have a *historia* display variety, but at the same

55. DONATELLO
Relief sculpture of *St George and the Dragon*, c. 1417. Marble, 15³/₈ x 47¹/₄" (38.2 x 108.5 cm). Museo Nazionale, Florence.

A similar *schiacciato* relief, representing *Christ Delivering the Keys to St. Peter*, may have been a part of the lost altarpiece of Masaccio's Brancacci chapel.

Following pages
56. MASACCIO
The Tribute Money, mid-1420s. Fresco. Cappella Brancacci, Santa Maria del Carmine, Florence.

The Expulsion from the Garden can be seen on the pillar to the left.

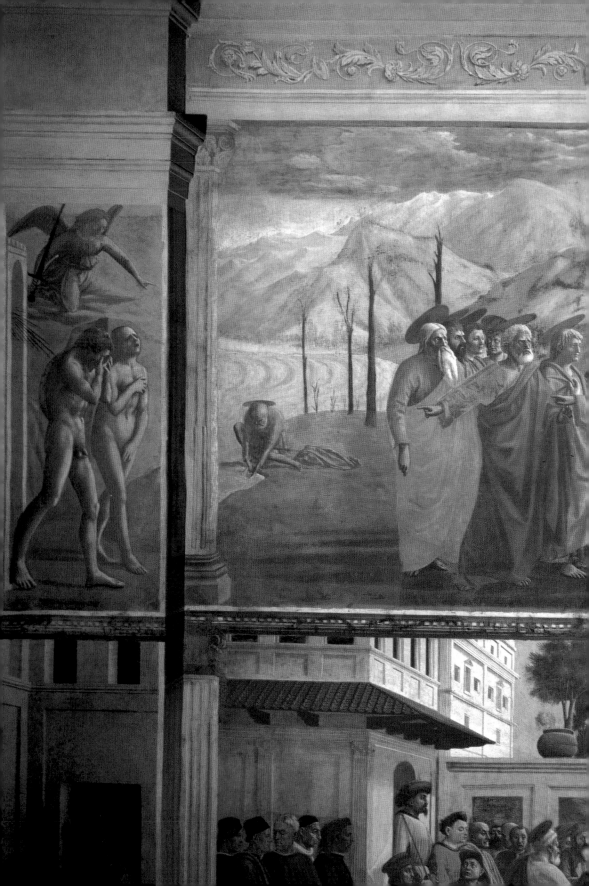

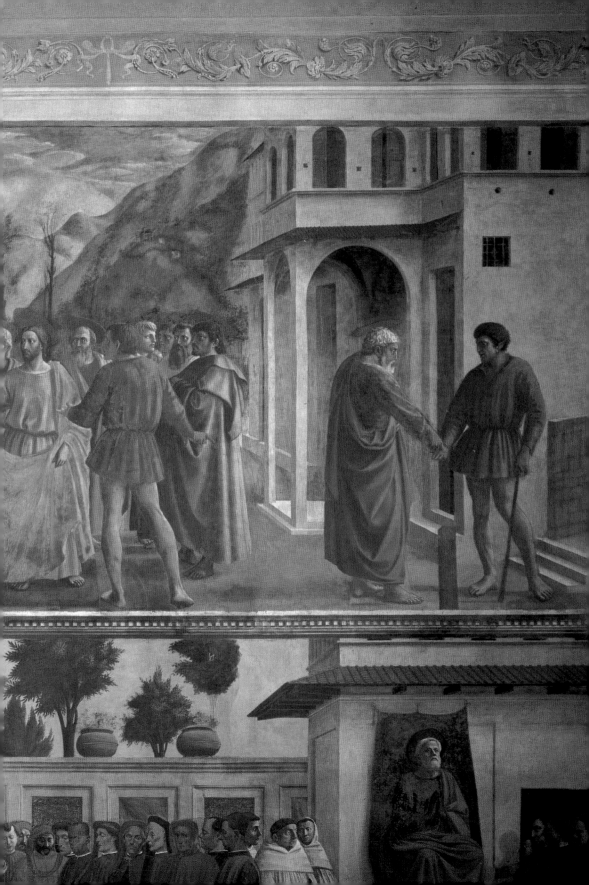

time be "restrained and full of dignity and modesty." The *historia* should be economical in its use of figures, whose job in the painting is to convey emotions through movements of the body, in order to achieve an affecting emotional response on the part of the spectator, who may "mourn with the mourners, laugh with those who laugh, and grieve with the grief-stricken." In the interest of verisimilitude Alberti urges that faces be painted as if they were sculpted, and that sculpture rather than painting is the best model for the novice painter. Finally, a *historia* will only succeed if it is based on careful forethought embodied in drawing.

The example of the "proto-Albertian" *Tribute Money*, whose character is unthinkable without the sculptural innovations that lie behind it, suggests clearly that Alberti's ideas came out of the circle of men named in his dedication. In one respect, in particular, the conundrum of Alberti the synthesizer of workshop practice versus Alberti the original theorist is crucial – his views on the construction of pictorial space.

The Development of Perspective

Linear perspective allows an illusion of three-dimensional space to be represented on a two-dimensional surface. Take the example of the straight set of railroad tracks running across a plain. If one views a section of track from directly above, one sees what experience confirms to be the case, that the two rails are a constant distance apart and so absolutely parallel, and the cross ties (or sleepers) on which the rails are mounted are also parallel and a constant distance apart. If however one now stands between the rails and looks down them towards the horizon, what is

57. ANONYMOUS
Ideal City, late fifteenth century. Oil on panel, 48¹/₃ x 81¹/₄" (124 x 234 cm). Staatliche Gemaldegalerie, Berlin.

There are several of these "cityscapes," not all by the same hand, dating from the last third of the century. Their meaning is debated, their relationship to the tradition of theatrical set design being possibly the most promising line of inquiry.

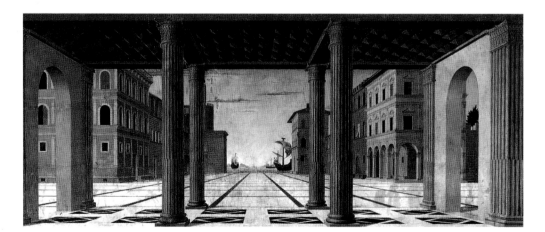

58. DONATELLO
The Feast of Herod,
mid-1420s. Bronze,
23¹/₂ x 23¹/₂" (60 x 60 cm).
Baptistery, Siena.

The receding lines
(orthogonals) do not
precisely converge at
a centric point, though
this may be explained
by variations caused by
conversion of the model
to a bronze cast, or more
probably in the chasing
of the bronze cast.

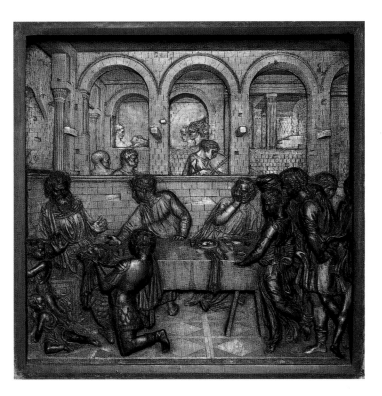

seen is an optical illusion, namely that the tracks narrow and converge at a point on the horizon. This mind/eye paradox is familiar to any schoolchild, and underlies the thinking by which the
space within a later fifteenth-century panel of an *Ideal City* is constructed (FIG. 57). Multiply the two rails to many evenly spaced
lines which converge at a common horizon point, and conceive the "cross ties" as being spaced so that two "rails" and
any two "ties" uniting them form a square, and one has a grid
which describes the space of the piazza represented in the painting. The crucial point to be made is that the grid allows any object
in the fictive space to be placed in proper scale relation to any
other object. For example, if the distance between two receding lines (called orthogonals) taken from the bottom edge of
the painting is said to represent two feet, then any other horizontal line between those same two receding and converging lines
also represents two feet.

How did this formula develop? The modern story of perspective is usually told in five simple chapters. The first involves
fourteenth-century experiments in spatial illusionism, particularly in Siena before the outbreak of plague in 1348. These bold efforts
held to the idea of lines receding to a central axis, but not yet
to a point. The second concerns two lost paintings by Brunelleschi,

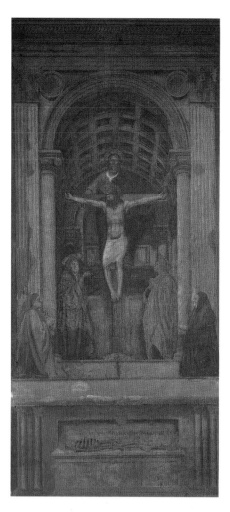

variously dated 1413-23, one a view of the Baptistery taken from just inside the central portal of the Duomo, the other of the Palazzo della Signoria and its piazza, taken from the point where the Via dei Calzaiuoli enters the piazza. Both panels, since they depicted squares with their buildings, consisted of straight lines and the angular relations of those lines. Whatever these so-called demonstrations looked like in detail, it is agreed they were rendered in systematic perspective and, crucially, to scale. It is debated whether these panels were achieved by measured ground plans combined with measured elevations of the buildings, copying from images reflected in a mirror, or possibly viewed through some sort of grid such as threads stretched at right angles to each other from the inner edges of a frame, or some combination of such devices.

There is also debate concerning the purpose(s) served by these demonstrations. They may have been an accompaniment to thinking on optics, and/or were tools by which the architect might better understand his trade. The least likely possibility is that they were originally intended as a means of constructing an imaginary illusionistic space.

The third chapter of the story occurred around the years 1423-27, when Donatello and Masaccio created two elaborate imaginary spaces. Donatello's *Feast of Herod*, a bronze relief for the baptismal font of the baptistery in Siena, embodies an unprecedented emotional intensity, the foreground filled with figures, some shuddering in horror as the severed head of the Baptist is presented to Herod (FIG. 58). The drama unfolds in a complex set of spaces, one behind the other, united by orthogonals that converge on a single point, or more accurately a very small area. The frame is figuratively that of a window, through which a fictitious world is seen.

Masaccio's contemporaneous *Trinity* (God the Father, the Holy Ghost in the form of a white dove, and the crucified Christ) is a total illusion of a chapel purporting to open off the left aisle of Santa Maria Novella (FIG. 59), its architectural forms as classical in motif as those of the St. Louis niche at the Orsanmichele, on which Donatello was working in the same years (see FIG. 33, page 62). Two donors kneel to either side outside the chapel,

59. MASACCIO
The Trinity, 1425. Fresco.
Santa Maria Novella,
Florence.

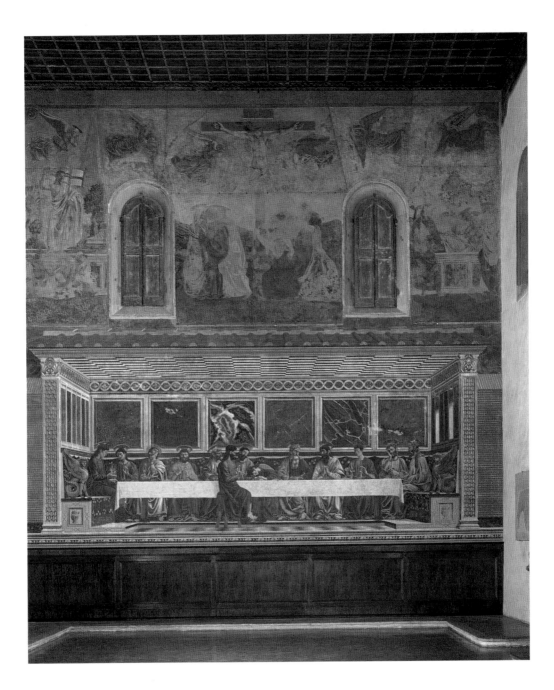

60. ANDREA DEL CASTAGNO
*The Last Suppe*r, c. 1445-50. Fresco, Sant'Apollonia, Florence.

The tradition of "opening out" the end wall of a refectory (dining hall) with a representation of the
Last Supper, figuratively the head table of the religious community, stretches from Taddeo Gaddi
in the mid-fourteenth century, through a number of fifteenth-century painters, including Castagno,
Ghirlandaio, and, most memorably, Leonardo at Santa Maria delle Grazie in Milan.

while within the figures of the Virgin and St. John flank the crucified Christ. God the Father rises behind, and while he is in the picture plane close to the surface of the fresco, incongruously he also appears to stand on a ledge or tomb affixed to the back wall. This is a major spatial inconsistency, but is apparently deliberate. While the chapel as a whole is calculated to offer a coherent optical illusion to a viewer standing beneath the nave arcade, the iconic image of the Trinity itself is a truth for all times and all places, and so is exempt from being described from a particular point of view. While illusionistic, and therefore mundane, paradoxically the space must also be understood as a heavenly chapel. We can no more enter it than can the donors who pray. Their space and our space is of a particular place and time, its nature recalled to us below where, between fictive colonettes of an altar table, lies a skeleton beneath the inscription, "I was once what you are, and am what one day you will be."

Whether there was a common theory behind the *Herod* and *Trinity*, and whether the same procedure was used in laying out their respective spaces, and what these, in turn, may have had to do with Brunelleschi's demonstrations continues to be debated. It is not disputed that these two works of art were seminal to the fourth chapter of the perspective story, Alberti's step-by-step instruction in Book I of *On Painting* on how to construct what has come to be called one-point linear perspective.

The last chapter of the story concerns the influence of Alberti's prescription upon subsequent practice. Understandably, this is a short chapter, for artists rarely adhered to the letter of what Alberti had written.

Such is the canonical story of the discovery of perspective, but there is much reason to suspect that it is an anachronistic modern invention, for the simple fact that no one in the fifteenth and sixteenth centuries told the story. To be sure, there were exceptional instances in which illusionistic space was intended as an extension of an actual space, as in Andrea del Castagno's *Last Supper*, painted on the end wall of a refectory (FIG. 60), or the feigned cupola of Andrea Mantegna (1431-1506) in the Camera degli Sposi in the Ducal palace, Mantua. But no one then used such modern phrases as "fictive space," "illusionistic space," "perspectival space." Vasari, though writing later, speaks of perspective in terms of objects rather than the space they occupy – a foreshortened body or an architectural member. Objects were the concrete reality of the time, and had primacy over the void that contained them; it is possible that space without objects was meaningless as an entity, outside of cosmological deliberations.

The Uses of Perspective

The altarpiece was a background before which a priest performed the mass in a church, and served as a stimulus to devotion. As it developed in the fourteenth century, the altarpiece often took the form of a multi-compartmentalized image called a polyptych; its individual images set in a carved and gilded architectural frame. Giovanni del Biondo's (active 1356-99) 1379 altarpiece for the Rinuccini chapel in Santa Croce is a fine example (FIG. 61). The central and largest compartment represents the Madonna and Child surrounded by the Virtues, flanked from left to right by SS. Francis, John the Baptist, John the Evangelist, and Mary Magdalene. Above the lower tier are smaller half-length figures of saints, and above them doctors of the Church (SS. Gregory, Ambrose, Augustine and Jerome, the four great saints of the early Church), flanking the Crucifixion. The predella represents an event of the life of each of the four principal saints. The altarpiece is figuratively a picture gallery of holy characters.

Several simple points should be made about this arrangement. There is a hierarchy of importance expressed through size: the four largest figures of saints are central to Florentine veneration in gen-

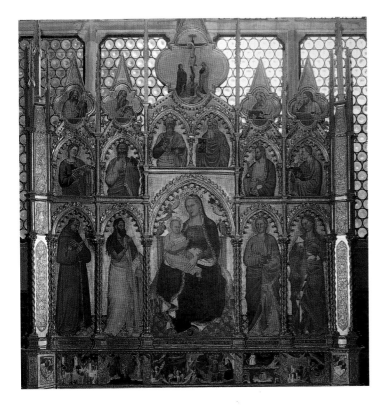

61. GIOVANNI DEL BIONDO
Rinuccini Polyptych, 1379.
Tempera on panel.
Rinuccini chapel, Santa
Croce, Florence.

eral, and that of Santa Croce in particular. The selection of saints for inclusion in an altarpiece was never random, but had to do in some combination with a consideration of a city's particular saints, those of a monastic order, saints particularly venerated at a given church, and those important to an individual, such as the name saint of the patron of a chapel or altarpiece. Whatever the selection of holy persons, they are placed in individual compartments against flat gold surfaces. Their arrangement makes it easy for a worshipper *in absentia* to contemplate them by recalling their placement in the overall pattern. This sort of visual memorization was popular in the later Middle Ages, and continued into the fifteenth century.

At some point, possibly as early as 1426 in a dismantled altarpiece by Masaccio whose central panel is a Madonna and Child, now in London, the polyptych was challenged by a new form, usually square in format, in which the Madonna and saints were placed in a unified space without compartmental divisions, and with the figures in consistent scale, the so-called *sacra conversazione* (holy conversation). Linear perspective allowed an optically illusionistic mode of organization in place of the flat compartments. Further, the protagonists of the altarpiece moved from a

62. Fra Angelico
San Marco Altarpiece,
1438-40. Tempera on
panel, 86½ x 89½″ (220
x 227 cm). San Marco,
Florence.

The murky and discordant garden in the background is the lamentable result of a botched early cleaning of the painting.

63. DOMENICO VENEZIANO
St. Lucy Altarpiece,
c. 1445-47. Tempera on
panel, 82 x 84″ (209 x
216 cm). Uffizi, Florence.

mute line-up of autonomous characters toward psychological inte-
gration in a shared experience.

In a series of altarpieces executed in the 1430s the friar Fra
Angelico (c. 1400-55) developed the *sacra conversazione*, culmi-
nating in the San Marco Altarpiece of 1438-40, commissioned
by the Medici family (FIG. 62). The Madonna and Child are
seated upon a classicizing throne hung with a cloth of honor; they
are flanked by four angels on each side, and, standing from left
to right, SS. Lawrence, John the Evangelist, Mark, Dominic, Fran-
cis, and Peter Martyr, a selection pertinent both to the city and
the Dominican order, of which San Marco was the newest house.
SS. Cosmas and Damian kneel in the foreground, physician-saints
who were the patron saints of the Medici. The scene is an epiphany,
or manifestation, in the sense that curtains have been parted to
reveal the miraculous gathering. The kneeling saints establish the
foreground space, while two diagonals of standing saints along
with the receding lines of the richly decorated carpet funnel
the eye to the climactic image of the Virgin and Child. It is in
most respects an Albertian picture, down to the detail of St. Cos-
mas in the left foreground, who looks directly at the spectator
while gesturing toward the Madonna. He is Alberti's recommended
interlocutor, who invites the spectator's empathetic response. If

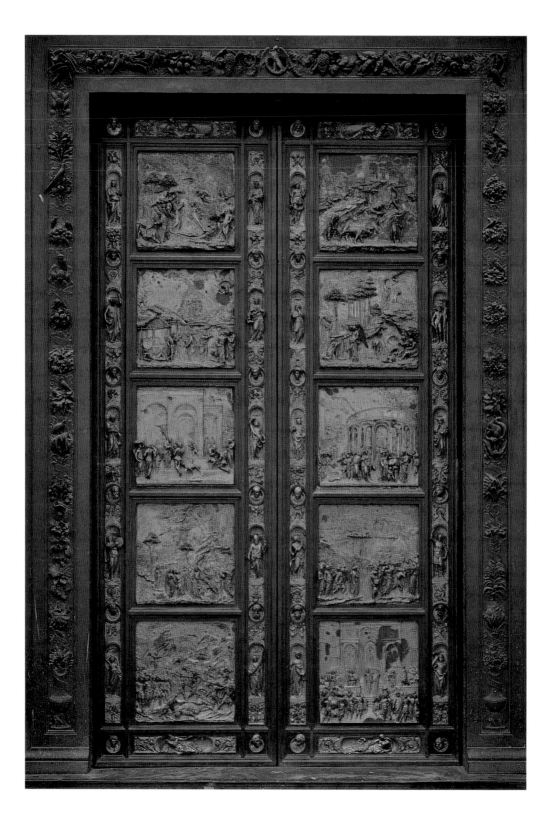

The World Seen Through a Window

perspective is an optical device, here it is more, drawing us to the emotional heart of the picture.

Around 1445, Domenico Veneziano (d. 1461) painted the St. Lucy Altarpiece, a work indebted to Fra Angelico, but with fewer figures (FIG. 63). The Madonna and Child are enthroned in an open loggia, part of a fanciful architecture, understood if one imagines what a ground plan of the building would look like. They are flanked in the foreground by SS. Francis, John the Baptist, Zenobius, and Lucy. The pointing Baptist is the Albertian interlocutor, and again perspective is used to draw us to the psychological center. The perspective construction appears to be accurate in Albertian terms, but in fact is not quite so. Each figure is emphasized by a semicircle or segment of a circle which functions on the surface of the painting to draw attention to the head under it, but it has been demonstrated that an accurate Albertian perspective construction would result in the arches being considerably higher than they in fact are, so diluting the connection between the heads and the circular forms by which they are emphasized. If Masaccio in the *Trinity* was inconsistent in his perspectival construction in the interests of sound theology, Domenico seems to have departed from "proper" usage to insure a tighter, more coherent compositional effect. The result is an altarpiece that had wide-ranging influence.

The question of the relation of perspective space and narrative in art is a question about the relations of space and time. We assume that a represented fictive space will contain narrative events understood to be happening simultaneously. For instance, a picture may show several events, say a friar preaching, a man leading a train of donkeys across a square, a fishmonger purveying his wares. We do not necessarily assume that these events have any narrative connection with one another, but because they occupy a common space, we assume they are happening at the same time. This was not at all the assumption of the fifteenth-century artist. He inherited, and continued to exploit through the century, a tradition of sequential or continuous narrative, the representation in one compositional field of the sequence of a story spread out in time. Masaccio's *Tribute Money* (see FIG. 56, page 95) is just such an example. The Gospel of St. Matthew recounts how Christ and the apostles approached the town of Capernaum, only to be stopped by a tax collector demanding a toll. The band being without money, Christ commanded Peter to go to the shore of the lake and extract a coin from the mouth of a fish. This miraculous act accomplished, Peter paid the tax collector.

Masaccio's fresco at first glance seems a story unfolding at a

64. LORENZO GHIBERTI "Gates of Paradise," 1425-52. Gilded bronze. Baptistery, Florence.

These doors are the culmination of Ghiberti's career, and were almost immediately recognized as an incomparable work. Guided by humanist advisers, Ghiberti brilliantly converted verbal ideas into a fusion of clear narrative and lucid space. Over recent decades the gilded panels have been cleaned, the originals preserved in the Opera del Duomo.

65. LORENZO GHIBERTI
The Story of Isaac, panel
from the "Gates of
Paradise." Gilded bronze,
31¼ x 31¼" (87 x 87 cm).
Baptistery, Florence.

single moment, but when the story is understood it can be read sequentially. The central group represents the request of the tax collector and Christ's charge to Peter, to the left the next incident, in which Peter pulls the coin from the mouth of the fish, and on the right the final incident, when Peter pays the tax collector. The rectangular format of the fresco comfortably accommodates the three major events in the foreground space.

If, however, the format precluded the necessary foreground space, there was another solution. Quite simply, the artist could place them in a background defined and compartmentalized by means of linear perspective. This is what Donatello did in the *Feast of Herod* (see FIG. 58, page 99), where events leading up to the presentation of the head of the Baptist to Herod are presented

in the spatial cells in the background. In deepest space the head is presented by the executioners, in middle space a procession bears the head to the banquet hall. Ghiberti, in the Isaac panel of his second set of doors for the Baptistery, the so-called "Gates of Paradise" (1425-52), offers a more elaborate version of this sort of spatial narrative compartmentalization (FIG. 64). The space is ample and coherent, the many figures in comfortable scale relationship with the architecture. The first reaction, as with the *Tribute Money*, is to assume that various narrative events are occurring simultaneously. But in fact the central event of the story, Jacob's blessing of Isaac, is narrated in seven separate moments, with the chief protagonists – Jacob, Isaac, Rebecca, and Esau – each represented several times (FIG. 65).

Rather than being aberrations, these examples represent a ubiquitous approach to sequential narrative, occurring later in famous fresco cycles by a number of artists. Space, then, is the passive host to the life of dramas. The space is static, the story cinematic. Rather than merely a medieval survival, as has been claimed, sequential narrative in a unified space is also, arguably, modern, as witness experiments in theater, opera, and cinema.

Perspective altered for theological reasons, for compositional reasons, to accommodate continuous narrative – the case begins to build that whatever fifteenth-century perspective was, it was not primarily a tool to counterfeit the way the "real" world was seen.

Add to these doubts the obvious, that perspective was but one more tool in the artist's collection of expressive devices, at times used for visually playful ends rather than to define a "correct" illusion of space. Paolo Uccello was a notorious student of perspective, so much so that a century later Vasari could tell the charming tale of the artist lying in bed with his wife, uttering adoring words about his *dolce prospettiva*, or "sweet perspective." Uccello's attributed drawings – of a *mazzocchio* (wooden frame of a man's headdress) or a chalice leave no doubt why he was suspected of an obsession (FIG. 66). But when it came to paintings, it was another story. Despite the perspectival virtuosity displayed in the three scenes of the *Battle of San Romano* (probably done for Cosimo de' Medici, c. 1440) – horses seen in foreshortening, lances wittily laid upon the ground as if they were orthogonals – who would believe that this world of enameled wooden horses and silver-armored knights before a tapestry-like landscape is anything other than

66. PAOLO UCCELLO(?) Perspective drawing of a chalice, 1430s (?). Pen on white paper, 11¼ x 9½″ (29 x 24.5 cm). Gabinetto dei Disegni e delle Stampe, Uffizi, Florence.

It is not certain whether the perspective drawings attributed to Uccello are in fact by him. But at the least they seem to be faithful reflections of his work.

Above
67. PAOLO UCCELLO
The Battle of San Romano,
c. 1440. Tempera on panel,
6' x 10'7" (181 x 322 cm).
Uffizi, Florence.

The date of this work is
much disputed. There are
companion panels in Paris
and London.

Left

68. Paolo Uccello
*The Flood, and the
Recession of the Flood,*
c. 1447. Fresco. Chiostro
Verde, Santa Maria
Novella, Florence.

The exact subject of this
fresco remains enigmatic.
Noah's Ark is represented
twice, on the left on its
long side as the waters rise,
on the right with Noah
receiving the dove. The
identity of the imposing
man standing in the right
foreground is unclear, but
he is unlikely to be Noah.

a chivalric fantasy, or that perspective is anything but an opti-
cal conceit (FIG. 67)?

Uccello's *Flood* in the Chiostro Verde (Green Cloister) of
Santa Maria Novella, done around 1447, could not be more dif-
ferent (FIG. 68). Violent and bestial chaos attends the rising of the
waters around Noah's Ark, the headlong plunge of perspective
raising the emotional temperature of a world turned upside down,
lashed by wind and lightning. Perspective is the vehicle for a
disorienting emotionalism, in this, perhaps the strangest and most
visionary fresco of the fifteenth century. Uccello was not unique
in exploiting the expressive possibilities of linear perspective,
for to twentieth-century eyes the fascination of a figure such as
Fra Filippo Lippi (1406-69) resides centrally in his calculated
spatial ambiguities.

"The world seen through a window" – the phrase is a mod-
ern formulation. What Alberti actually wrote well into the
first book of *On Painting* was: "First of all, on the surface which
I am going to paint, I draw a rectangle of whatever size I want,
which I regard as an open window through which the subject
to be painted is seen..." The "open window" may be merely a
loose analogy, or may imply a world view in which an observ-
er stands in a new, subjective relationship to the space of the
cosmos he inhabits. Perhaps the eye contemplates a space which
is now infinite in extension. No writing before 1600, and little
before modern times, claims that linear perspective is other
than a technical device, albeit one based on Euclidean geome-
try, the only body of knowledge inherited from classical antiq-
uity whose truth is uncontested. It was left to the modern age
to speculate that perspective is a master metaphor, bearing pro-
found philosophical baggage.

Clearly fifteenth-century artists were resilient when it came
to adapting their styles to particular tasks at hand. Nanni di Banco
could use a neo-Roman style for his martyrs at the Orsanmichele,
only to turn immediately to a Gothic style in completing a por-
tal sculpture at the Duomo. For Uccello, on the one hand, per-
spective is a toy in a game of chivalric fantasy, on the other a
riveting device in evocation of cataclysmic power.

In 1459, at the behest of Piero de' Medici, Benozzo Goz-
zoli (1420-97) frescoed the small chapel in the new Palazzo Medici
(FIGS 69 and 70). The subject is the Procession of the Magi who
come to worship the Madonna and Child, depicted in a free-
standing altarpiece, a copy after Fra Filippo Lippi. Gozzoli's direct
inspiration is the 1423 altarpiece of the *Adoration of the Magi* by
Gentile da Fabriano (1370-1427), done slightly earlier than the

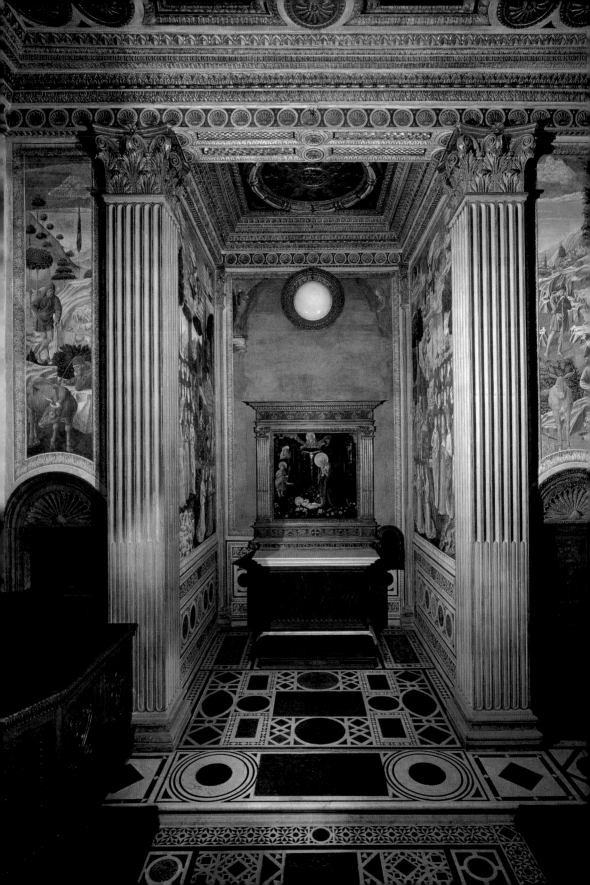

Brancacci chapel (FIG. 53, page 91). Festive and unabashedly aristocratic, Gentile's procession of the kings is rich in caparisoned horses, luxurious brocades, and exotic animals, all rendered in bright colors and with profuse use of tooled gold. Gozzoli, no doubt at Piero's direction, revived a style that is exquisite and private in nature, not appropriate for the frescoed public spaces of a burgher city. Gentile's vision spills onto Gozzoli's walls, an adaptation that preserves the flatness of the walls. The procession is replete with portraits, including members of the Medici family, and the representation of the cypresses and villas of the background evoke the hills above Florence where this gentry took its summer retreat.

Just six years later Gozzoli frescoed scenes of the life of St. Augustine at the church of the same name in San Gimignano. The scene of *St. Augustine Entrusted to his Tutor* could hardly differ more from the Medici chapel, being a complex cityscape with a deep perspective, the evident premise that the wall is to be painted away rather than affirmed. The change is not explained by the artist's stylistic evolution, but by the different location (FIG. 71). The fourteenth century had established that narrative fresco cycles in church chapels should consist of a series of fictive spatial boxes in which the stories unfold, an idea affirmed by Masaccio and Masolino at the Brancacci chapel, and successive artists. In adopting this mode, Gozzoli did not need to be instructed by the patron: both knew the rules of the game.

If artists adapted their means to the tasks at hand, patrons were no less flexible in their taste. The year after Piero commissioned

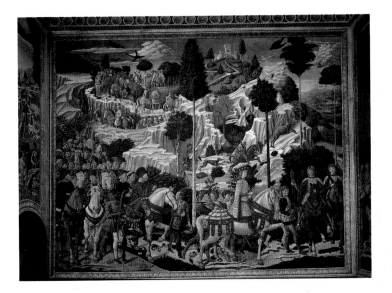

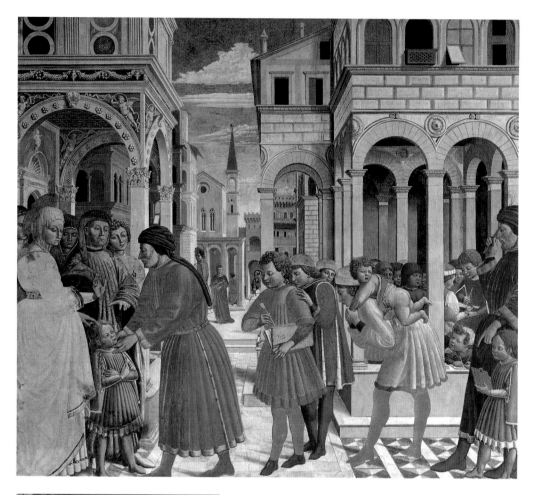

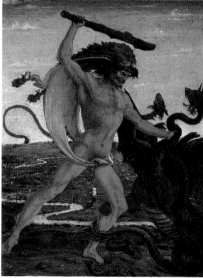

Above
71. BENOZZO GOZZOLI
St. Augustine Entrusted to his Tutor, 1465. Fresco.
San Agostino, San Gimignano.

Left
72. ANTONIO DEL POLLAIUOLO
Hercules and the Hydra, after 1460. Oil on panel,
6³/₄ x 4³/₄" (16 x 10.5 cm). Uffizi, Florence.

Pollaiuolo was an innovator in the representation of the
male nude in action, remarkably in his engraving of
The Battle of the Ten Nudes. He and Andrea Mantegna
pioneered the art of engraving in Italy, a medium that
was a logical extension of the goldsmith's training.

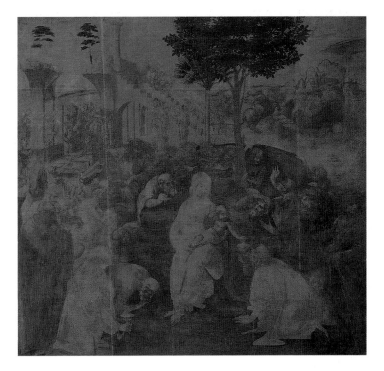

73. Leonardo da Vinci
*The Adoration of the
Magi*, 1481-82,
Brown underpaint,
8′ x 8′1″ (243 x 246 cm).
Uffizi, Florence.

his little chapel, he ordered a different sort of subject for a spacious room in the palace, three large canvases depicting the Labors of Hercules. They were commissioned from Antonio del Pollaiuolo, and although lost, are thought to be reflected closely, if not copied, in two small surviving panels by the artist (FIG. 72). Pollaiuolo's struggling angular nudes, with taut, wiry limbs, are placed before views of the Arno valley. Their subject is mythological, the style probably then viewed as neo-pagan. Gozzoli and Pollaiuolo could hardly differ more in style, but Piero knew that different purposes and different settings not only invited, but demanded, varying artistic responses.

This chapter began with Leonardo, and ends with him. A precocious draughtsman, he was hardly a precocious painter. He only hit his stride with his unfinished *Adoration of the Magi*, abandoned when he left for Milan in 1481-82 (FIG. 73). In many respects this work visually anticipates the remarkable thoughts on painting which Leonardo only began to write down in the 1490s. This painting and these thoughts heralded a new role for painting as a vehicle of scientific investigation by which a new body of knowledge could be generated; but that new role was to unfold in north Italy and Germany, not in Florence.

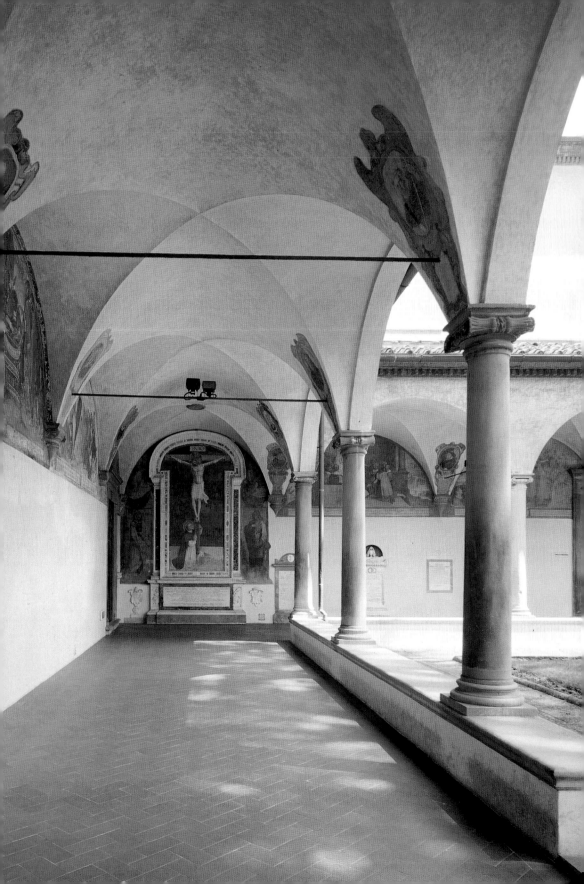

Home Economics

Florence had two sorts of homes. The first was the house of the extended family. The second, less obvious, was the religious house, monastery, or nunnery, in which another sort of family dwelled, its members often resident for a lifetime. Arguably these two different kinds of families vary only in degree, for both had domestic rituals, and both used art for devotional and didactic ends.

Alberti aptly compared the monastery to a fortress. Like a fortress, a monastery is a walled enclave that controls who may enter and leave, and it is a collective of persons whose individuality is subordinated to an unquestioned common purpose. Other fifteenth-century writers found in monastic life the clarity of organization that should pertain in an ideal city.

The Monastery of San Marco

On 6 January 1443, the Feast of the Epiphany, a procession led by Pope Eugenius IV (ruled 1431-47) came to San Marco to rededicate the complex of church and monastery. The goal of the procession was Fra Angelico's altarpiece on the high altar, which represents Christ the King with the orb of the world in his hand, before whom the temporal kings proffered their submission. The money for the rebuilding of San Marco had been provided by Cosimo de' Medici, whose generosity, according to his biographer Vespasiano de' Bisticci, was motivated by atonement for his dubious financial dealings.

The property had been transferred to the Dominicans in 1436

74. MICHELOZZO DI
BARTOLOMMEO
First cloister, San Marco,
c. 1438. Florence.

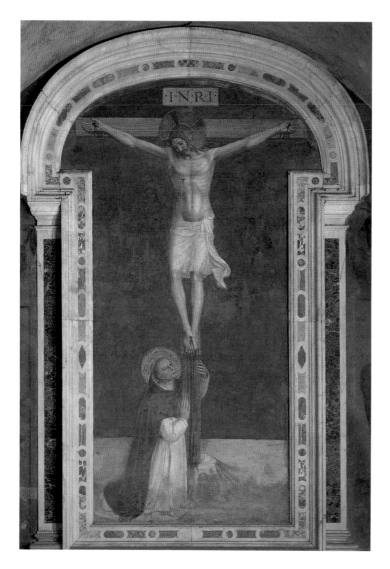

75. FRA ANGELICO
*Christ on the Cross Adored
by St. Dominic*, after 1442.
Fresco. First cloister of San
Marco, Florence.

from an order that had fallen on hard times. Michelozzo di Bartolommeo, soon to build the Palazzo Medici, was chosen as the architect, while Fra Angelico, the painter-friar whose community was San Domenico at Fiesole, frescoed the new fabric between 1438 and 1452.

The Dominicans of San Marco were reform-minded friars who sought to return to the ideals of their founder, above all the renewal of the vow of poverty. The friars dedicated themselves to prayer and pastoral work, rather than the scholarly activities carried out at some of their sister houses, in spare surroundings stripped of everything not essential to the devotional life. As individuals and as a corporate body their devotions were to the

Virgin Mary, and to Christ, teacher and companion in the spiritual guest. Life in the monastery followed a daily ritual. The "Hours" were strictly observed, specified times of both day and night for participation in the mass, singing of hymns, chanting of psalms, and reading from the Bible.

The first cloister at San Marco was a semi-public place (FIG. 74), from which opened a chapter room where business was conducted, and a hospice for visitors. The cloister frescoes enjoined friar and visitor alike to observe the purposes and decorum of the place. The end of the corridor of the first cloister leading from the outer entrance is frescoed with a lone, weeping St. Dominic who embraces the blood-drenched foot of the Cross (FIG. 75). Lunettes above the doors show Christ in his tomb as the Man of Sorrows, St. Thomas with open book, and St. Peter Martyr, who with index finger to lip commands silence. The chapter room off the north corridor of the cloister served for the reception of visitors, initiation of novitiates, house business, and such

76. FRA ANGELICO
Crucifixion with Saints,
1441-42. Fresco. Chapter
Room, San Marco,
Florence.

ceremonies as the washing of the feet. Its space is dominated by a *Crucifixion* in a lunette-shaped field, more a communion of saints from all ages than a historic narrative (FIG. 76). From the left are SS. Cosmas and Damian, the Medici patrons, San Lorenzo, the name saint of Cosimo's brother and patron of their church, St. Mark, and John the Baptist. Bishops and monastic saints are on the right, led by St. Dominic at the foot of the cross. The space is stripped of all possible distractions, an image for meditative contemplation.

The floor above is the private world of the friars' cells, which became accessible to public view only when the monastery was suppressed in the nineteenth century. The fresco of the *Annunciation* is at the top of the stairs, that miracle of Incarnation by which the story of salvation began, proclaiming a truth to every friar as he passed by each day (FIG. 77). The individual cells are ranged along three corridors; those above the hospice were intended for the novitiates, and each has a starkly simple image of the crucified Christ with St. Dominic in prayer. Taken as a whole Fra Angelico's frescoes for the novitiates illustrate a thirteenth-century text, *De modo orandi* (*The Way of Prayer*) that describes the nine ways of prayer employed by St. Dominic. Like all the cell frescoes, these were meant as visual stimuli to supplement and

77. FRA ANGELICO
The Annunciation, after 1450. Fresco. Corridor, San Marco, Florence.

This fresco and one in the east corridor (where the monks may have said matins) of the Madonna and Saints were apparently among the last painted. It seems that at first the focus of devotion was solely in the monks' cells, and only later involved the communal space of the corridors.

78. FRA ANGELICO AND
ASSISTANTS
The Mocking of Christ,
1440s. Fresco. Cell 7,
San Marco, Florence.

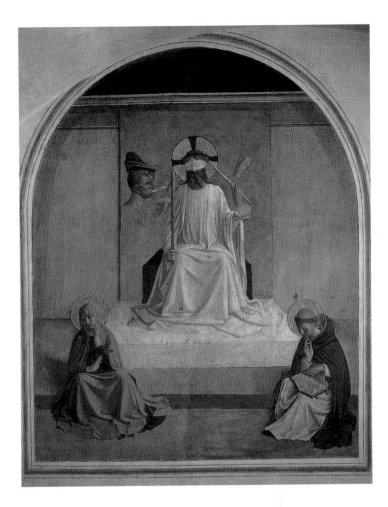

indeed to supplant the written word.

The east corridor housed the cells of the regular friars, each
provided with a fresco of an event from the life of Christ or
the Virgin Mary. For instance Cell 7 has *The Mocking of Christ,*
in which the blindfolded Christ is beaten and spat upon by
symbolic heads and hands (FIG. 78). The seated Virgin and St.
Dominic contemplate the meaning of this violence, as the cell's
inhabitant is called upon to do in his own imitation of Christ.
Through these frescoes the friars carried not only the words of
the gospels in their heads, but the imprint of memorized holy
images.

The north corridor was given in part to the lay brothers of
San Marco, of whom the most famous was the patron, Cosimo
de' Medici. He had a double cell in which private mass could
be said, adorned with a fresco of the *Adoration of the Magi,* by
Benozzo Gozzoli(?), a not surprising choice of subject given

the family's support of the important Confraternity of the Magi. A cell dedicated to a particular layman (Cosimo's son Piero had the same privilege at the Annunziata) was rare, as was a chapel in a private palace, which required papal dispensation. But the Medici were no ordinary citizens.

The Domestic Environment

It is but a matter of degree to go from a monastic home to a secular one. Beyond its existence as a building a house – *casa* – was an important idea, the blood lineage of a family whose honored forebears were remembered in masses for the dead. The family was the core unit of social cohesion and continuity. The house was the tangible symbol of the family name, and the things within that house were not disposable, but preserved across the generations. While around 1400 the Florentine house apparently had little in it beyond necessities, by 1500 the space had begun to fill with things, a number of them not merely non-utilitarian, but luxuries. While this change can be attributed to a number of factors, probably the most important were the slowing down of business investment and the exemption of personal possessions from taxation. The emergence of what one economic historian has called "the empire of things" is surely one of the leading characteristics of this remarkable age. Unfortunately no fifteenth-century Florentine house exists in its original interior state, but a few generalizations can be made about the fourteenth-century house, whose characteristics carried over into the next century (FIG. 79). They were generally three or four storeys, the ground-level floor was given over to shops and/or storage. The next floor, the *piano nobile*, had larger rooms where guests were entertained. Living quarters were laid out without corridors, reducing privacy. There was usually an interior courtyard, at first mainly a light-well, not the larger festive space that would evolve later.

The Palazzo Datini in Prato (a few miles outside Florence) and the Palazzo Davizzi (now Davanzati) in Florence give some idea of how fourteenth-century interiors must have looked. The major rooms were frescoed in imitation of textile or tapestry hangings, offering both abstract patterns and landscape elements. A room at the Palazzo Davanzati has scenes from the thirteenth-century romance the *Castelaine de Vergi*, a story about the trials of chastity and fidelity (FIG. 80) that is an exhortation to virtue.

That sort of message was directed mainly at women and chil-

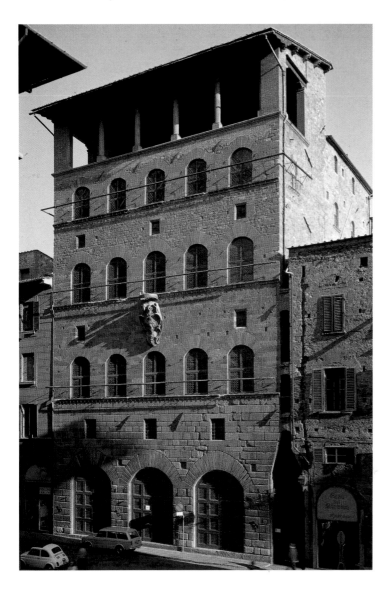

79. Palazzo Davanzati, mid-fourteenth century(?). Florence.

The loggia at the top is a later addition.

dren. Francesco da Barberino, writing on women in 1314-16, allowed that only those of the upper classes need read and write, or those bound for a convent (predominantly, it seems, also from the upper classes). A woman should cultivate bashfulness, rarely appear in public, and speak in the presence of men only when spoken to. There is some evidence to suggest that in succeeding decades more emphasis was put on female literacy, that women constituted a significant minority of the group of Florentines who were literate.

It is clear that the husband's place was as an agent in public life, as opposed to the wife's role managing the private space

Following pages
80. ANONYMOUS
Bedroom in the Palazzo Davanzati, 1390s. Fresco. Florence.

81. DOMENICO VENEZIANO
Madonna and Child,
c. 1432-37. Tempera on
panel, 33³/₄ x 24¹/₄″
(86 x 61.5 cm). Berenson
Collection, Florence.

of the household. While it is always risky to take a particular written passage as representative of a general situation, Alberti's words in *Della Famiglia* (*On the Family*), probably written in the early 1430s, are extremely revealing. They concern a groom's introduction of his bride to the affairs of her new household:

After my wife had been settled in my house a few days, and after her first pangs of longing for her mother and family had begun to fade, I took her by the hand and showed her around the whole house…At the end there were no household goods of which my wife had not learned both the place and purpose. Then we returned to my room and having locked the door, I showed her my treasures, silver, tapestry, garments, jewels, and where each thing had its place…

Only my books and records and those of my ancestors did I determine to keep well sealed both then and thereafter. These my wife not only could not read, she could not even lay hands on them. I kept my records and at all times not in the sleeve of my dress, but locked up in order in my study, almost like sacred and religious objects.

(Trans. Watkins.)

Of the various businesses of Florence, marriage was one of the most important, for improvement or decline in family alliances had financial, social, and political repercussions. Because marriage was too important to leave to the vagaries of romantic love, it was arranged between families. The prerequisite of the marriage was the dowry provided by the bride's family, consisting of a trousseau and a sum of money, often paid on the installment plan, the amount a direct reflection of the families' social standing. The groom's family in practice, though not required to do so, usually countered with a second trousseau (for a bride's clothes were the sign of her husband's affluence) and household furnishings.

If a woman's place in the framework of the law was bleak by modern standards, there is the tantalizing and much less docu-

mented question of a woman's life in an area untouched by legal documents. Many arranged marriages resulted in deep caring and love between the partners. The groom's female relatives gave rings to the bride, an invitation to a new world of friendship. But many aspects of how a woman lived her daily life, whom she saw, what she did, and what she read, are shrouded in silence.

The furnishings of the house were some combination of dowry and things provided by the groom, mainly the latter. Often the young couple first lived under the groom's father's roof, so these things were added to what was already there. As the quotation suggests, interior space was in part a matter of gender, – a man's suite of rooms was his inner sanctum, while the woman was responsible for the household as a whole. The respective roles of husband and wife in deciding what was needed for the household, how these things were chosen, what they were to look like, and so forth are unknown.

82. LUCA DELLA ROBBIA *Madonna and Child* (*Madonna of the Apple*), c. 1460. Enameled terracotta, 27⅝ x 20½" (70 x 52 cm). Museo Nazionale, Florence.

This may have been a Medici commission.

Christian images had an important place in the Florentine home. Early in the century the Dominican Giovanni Dominici (1357-1419) encouraged parents to instill good religious behavior in their children by means of pictures, statues, and toys. At an early age a child could adore the baby Jesus and his Mother, and as a girl grew her character would be formed by contemplation of female saints. Dominici even recommended a play altar where a child (presumably male) could imitate a priest.

Images of the Virgin and Christ were ubiquitous in the Florentine home, in some houses placed in every room, and Domenico Veneziano's *Madonna and Child* of the 1440s (FIG. 81), or Luca della Robbia's glazed terracotta of the same subject, with milky flesh against a blue sky (FIG. 82), are typical of the better examples. Many clay reliefs (a specialty of the Donatello shop), small marble reliefs, and modest works in pressed metal were intended for domestic consumption.

The *cassone* – a wooden chest for the storage of clothing – was an essential piece of furniture, often produced in matched pairs (FIG. 83). Vasari writes about this fashion, which by his time,

83. APOLLONIO DI GIOVANNI
Panel of a tournament on a *cassone*, c. 1450-65.
Tempera on panel, 40 x 78″ (103 x 203 cm).
National Gallery, London.

84. APOLLONIO DI GIOVANNI
AND MARCO DEL BUONO
GIAMBERTI
The Story of Esther,
c. 1450-55. Tempera on
panel, 17½ x 55⅛"
(44.4 x 140.6 cm).
Metropolitan Museum
of Art, New York.

Front panel from a *cassone*.

he says, was outmoded: "The citizens of those times used to have large wooden chests like sarcophagi in their rooms. And all had their chests painted with stories on the front...mostly fables from Ovid and other poets, or stories told by Greek and Roman historians, and in addition hunts, jousts, and tales of love..."

The *cassone* was often made on the occasion of a marriage. A continuous narrative unfolds across the oblong front panel, illusionistic space usually sacrificed to a decorative surface. The ends of the chest are painted with supplementary scenes or family coats of arms, while the inside of the lid was adorned with scenes of love, or at times feigned luxury cloth, a reference to the clothing kept inside.

The decoration would represent a memorable event at the time of the marriage, such as a joust or battle, or festivities accompanying the wedding itself. But if there is a broad theme characteristic of the genre, it is scenes which extoll the virtue, fidelity, or chastity of women. A *cassone* panel of the great Old Testament exemplar Esther was painted c. 1450-65 in the workshop of Apollonio di Giovanni and Marco del Buono Giamberti (active c. 1450-65), who specialized in furniture painting (FIG. 84). The narrative unfolds from left to right in a contemporary Florentine setting, with a palace evocative of the new Palazzo Medici, and a loggia of the sort Giovanni Rucellai built (see FIG. 51, page 88).

85. DOMENICO GHIRLANDAIO
The Birth of the Virgin, 1486-90. Fresco. Choir, Santa Maria Novella, Florence.

One of a large set of frescoes in the choir of Santa Maria Novella depicting the life of the Virgin and John the Baptist, painted by Domenico Ghirlandaio for Giovanni Tornabuoni, one of the wealthiest men in Florence. The young woman dressed in festive clothing with four attendants is his daughter Ludovica. These scenes are filled with contemporary portraits.

The panel is highly decorative, rich in gold, but beyond that a didactic message to the young bride to ponder a virtuous biblical role model.

While, as already remarked, no fifteenth-century domestic interior survives intact in Florence, numerous paintings, such as Domenico Ghirlandaio's (1449-94) 1486-90 fresco of the *Birth of the Virgin*, suggest how they must have looked (FIG. 85). An *intarsia* (inlaid wood) wainscoting is set in the wall below a sculpted frieze. Such woodwork often framed inset paintings, so called *spalliere* (*spalle* means shoulders, at the height of which painted panels were mounted). *Spalliere* differ from *cassoni* in being larger, and rather than emphasizing decorative flatness, are conceived as spatial boxes akin to the frescoes in the fifteenth-century chapel. Like the *cassoni*, *spalliere* have a similar range of subjects, often with the same obliquely didactic message.

Four panels illustrating the story of Nastagio degli Onesti from Boccaccio's *Decameron* were commissioned in 1481-82 from San-

86. SANDRO BOTTICELLI
AND ASSISTANTS
Nastagio in the Wood,
1482-83. Tempera on
panel, 32¹/₂″ x 6′3″ (83 x
183 cm). Prado, Madrid.

First of four *spalliera*
paintings with episodes
from Boccaccio's tale
of Nastagio degli Onesti
(*Decameron* 5.8).

dro Botticelli (1445-1510) by Antonio Pucci on the occasion of the
marriage of his son to a woman of the Bini family. Since Boc-
caccio's story culminates in a wedding, the choice of subject is
wholly appropriate, if somewhat gruesome in the telling. In
the panel illustrated, Nastagio, smitten by his unrequited love for
the daughter of Paolo Traversari, retires for solace to the woods
at Chiassi, outside his hometown of Ravenna (FIG. 86). Wandering
in the wood, he comes upon the extraordinary apparition of a
woman pursued by a knight on horseback accompanied by fierce
dogs. The knight is a suicide, the woman dead of remorse, both
of them condemned to eternal suffering. In the second panel, the
knight rips out the woman's heart and organs and feeds them
to the dogs, but the woman rises again and flees toward the
sea. The third panel shows Nastagio, who holds a banquet for his
beloved on the site of the apparition, to reveal the fate that might
befall her if she refused his hand in marriage. She then sends
her maid to him with a note accepting his proposal of mar-
riage. The last panel is the happy ending, or perhaps the accep-
tance of an offer that could not be refused, the wedding feast
in which the Onesti and Traversari are united in marriage. Such
was the mail-fisted admonition concerning a woman's obedience
to her husband.

A birth, most particularly of a boy (a girl had to be provided
with a dowry), was a happy event, for what was regarded as a
woman's chief function in life had been achieved. She was imme-
diately visited by her female relatives, as shown in Ghirlandaio's
fresco, who often bore gifts of sweetmeats. A work of art com-
memorating the event was the *desco da parto* (birth tray). These
trays were polygonal or circular in shape, and were often paint-
ed on both sides. The subjects varied, the Triumph of Love (from
Petrarch), the Fountain of Youth, or simply the celebration of the
birth itself with appropriate fanfare (FIG. 87). If the time of birth
was celebration, it was also a time of thanksgiving and forebod-
ing. One in ten Florentine women died in childbirth, and many
babies died before reaching their first birthday.

Portraits adorned the rooms of the house, until about mid-
century profile portraits, whose ultimate inspiration was ancient
coins. Today it is rare for the identity of a sitter or the provenance
of such a portrait to be known. The functions of portraits were
various – propagandistic, commemorative of events such as a mar-
riage, expressions of status and pride – but above all commem-
orative acts of family piety. Throughout the fifteenth century por-
traits, both posthumous and of the living, were included in both
frescoes and altarpieces; on a least two occasions Ghirlandaio

87. ANONYMOUS
Birth tray depicting a
birth scene, c. 1435-40.
Tempera on panel,
diameter 22¹/₈" (56 cm).
Gemäldegalerie, Berlin-
Dahlem.

This painting, behind
which lie the styles of
Masaccio and Domenico
Veneziano, is of high
quality.

represented deceased persons as if alive (FIGS 88 and 89). Floren-
tine portraits until those of Leonardo cannot be said to reveal
much of the inner life of the sitter. Rather, they are emblems
of status, and female profile portraits show this most clearly
(FIG. 90). They represent highly idealized women concordant with
contemporary notions of beauty; porcelain complexions, plucked
eyebrows, and stylized coiffures, their clothes and jewels announc-
ing not their autonomous status but that of the men to whom
they were married.

It was otherwise with a portrait type that emerged in the 1450s,
the male marble bust based on the naturalism of Roman repub-
lican portraits. In the case of the marble bust of Matteo Palmieri,
by Antonio Rossellino (1427-79), the antique context was wider

88. DOMENICO GHIRLANDAIO
Old Man with a Child, c. 1480.
Tempera on panel, 24³/₈ x 18¹/₈″
(61 x 45.4 cm). Louvre, Paris.

89. DOMENICO GHIRLANDAIO
Head of a Man, c. 1480.
Silverpoint and white on
pink paper. 9⁷/₈ x 8¹/₂″
(28.2 x 9.9 cm). Print Room,
Nationalmuseum, Stockholm.

Death masks (one of
Brunelleschi survives) and
drawings taken on the
deathbed at times served
as models for painted portraits.
Here the coldness of death
served as the basis for the vital
and intimate portrait in FIG. 88.

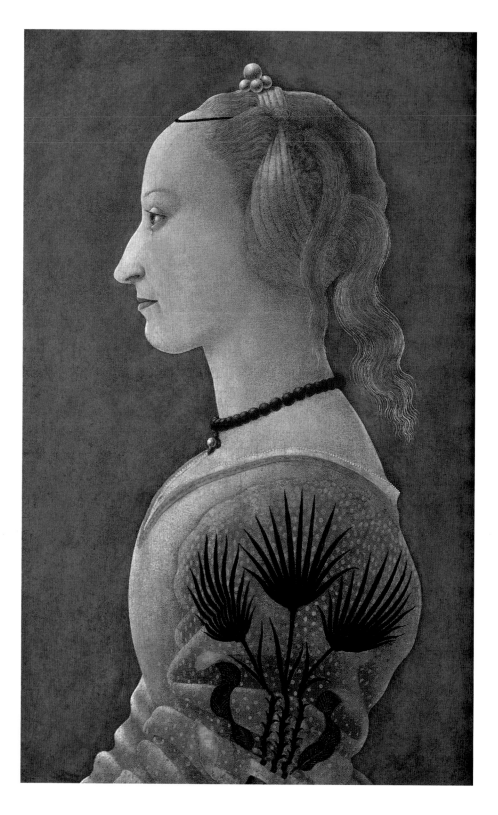

than simple formal influence (FIG. 91); the bust was set up above the door of Palmieri's house (which explains its weathered appearance), following the practice that Pliny had recommended to Roman patricians.

The Florentine house was filled with many other things: woodcuts of religious subjects, utilitarian objects such as pottery, with foliage tendrils, at times with rampant animals amongst them, being a popular decoration for the latter (FIG. 92). With the invention of printing, books entered the home, few in number for they were expensive. Most interesting were printed books still decorated with hand illuminations, a bridge between the worlds of the manuscript and printed book.

Early humanists and artists had begun to collect antiquities ranging from coins to sculpture. Such objects were also collected by amateurs, to be enjoyed in themselves, but also as symbols of their owner's intellectual aspirations, and, as such, statements about levels of family culture and prestige. Closely related to such collecting was the rise in the later fifteenth century of art in the modern sense of the word, an object not requiring any functional justification. Bertoldo di Giovanni's (c. 1420-96) late 1470s bronze relief of a battle, a reconstruction of a Roman sarcophagus in Pisa, was probably an overmantel sculpture whose primary intent was to delight its owner, Lorenzo de' Medici, and his guests (FIG. 93).

The Florentine's eye and mind were not solely on the city within the walls, as a miniature from a manuscript of Virgil's *Georgics* suggests (FIG. 94). The *Georgics* was the most famous writing on agriculture to survive from antiquity. It is easy to forget that agriculture was the base of Florentine economy; a Florentine saying ran "Only animals live in the country," and Alberti fulminated about cheating peasants (in fact it was the peasants who regularly lost out), but Alberti also reflected on the relative advantages of raising children in the city and country, allowing that in the latter one can "find peace, contentment and a free way of pursuing life and health."

Whatever the ambivalence of Florentine attitudes, by the

fourteenth century the countryside was sufficiently peaceful to allow pleasurable country living, and by the later fifteenth century the villa had become a popular second home. One such was Lorenzo de' Medici's Poggio a Caiano (FIG. 95) begun in 1487 on land acquired from the Rucellai. Poggio was a retreat for hunting and fishing, a landscape mythologized in Lorenzo's own poetry, in which Ambra is not just a stream that runs by the property, but comes alive as the nymph of the place. The building was only partly finished in Lorenzo's time, but the porch is his, a temple front in the Roman manner, its terracotta frieze a celebration of both the rural calendar and the progress of civilization from chaos to the Golden Age of Lorenzo.

No fifteenth-century Florentine villa survives with its interior decoration wholly intact, but the importance of such com-

Above

92. Two-handled jug with blue cobalt relief decoration, Florence, fifteenth century. Clay, height 9³/₄" (25 cm). Museo Nazionale, Florence.

The decoration on Tuscan pottery progressed from rudimentary colored shapes in the fourteenth century, to animated design of the sort illustrated here, finally to give way to decoration imitative of paintings produced north and east of Tuscany.

Right

93. BERTOLDO DI GIOVANNI *Battle Scene*, c. 1479. Bronze, 16 x 39" (43 x 99 cm). Museo Nazionale, Florence.

Bertoldo also executed several bronze statuettes intended as collectors' items, early examples of a genre that found its full flowering in northern Italy.

Above
94. APOLLONIO DI GIOVANNI (attrib.)
Detail of an illustrated page from Virgil's *Georgics*, c. 1450-60.
Manuscript illumination, 6¾" x 3¼" (17.2 x 8.4 cm).
Biblioteca Riccardiana, Florence.

95. GIOVANNI D'UTENS
View of Poggio a Caiano,
late sixteenth century.
Fresco. Museo di Firenze
Com'Era, Florence.

missions is suggested by the caliber of artists who undertook them – Castagno, Botticelli, Perugino, Ghirlandaio, Filippino Lippi, Pollaiuolo. The themes ranged from the *Famous Men and Women* by Andrea del Castagno at the Villa Carducci (FIG. 96), to Botticelli's representation of Lorenzo Tornabuoni with four of the liberal arts, and his bride with Venus and the Graces, for the Villa Tornabuoni.

By the 1490s, private domestic space in the wealthiest homes was a true example of the "magnificence" that humanists had called for in architecture, but few patrons, in fact, dared to flaunt. But the 1490s were also a time of wrenching change, when the Medici were expelled from the city, and for a time the fiery prophet Girolamo Savonarola (1452-98) was the voice behind a government that aspired to be a theocracy (a government under God). Carnival song gave way to religious hymns, and the rich dress in elegant portraits surrendered to the dull and modest attire of the streets. The bonfires of the vanities that flared up in 1497 and 1498 consumed paintings, sculptures, cosmetics, books, musical instruments, and games, and many of the artefacts and assumptions of a brilliant age were reduced to ashes.

Right and below

96. ANDREA DEL CASTAGNO
Famous Men and Women, Villa Carducci,
late 1440s. Fresco, transferred to canvas,
Uffizi, Florence.

This fresco comes from the Villa Carducci, on the
outskirts of Florence. The set of *famosi* includes
warrior-statesmen, virtuous women, and writers:
Pippo Spano, Farinata degli Uberti, Niccolò
Accaiuoli; the Cumaen Sibyl, Queen Esther;
Queen Tomyris (shown right); Dante, Petrarch,
and Boccaccio. They were accompanied by a
fresco of the Madonna and Child flanked by
Adam and Eve, discovered in 1948-49, and still
in situ. The illustration below shows the frescoes
as they were installed at the Museo Castagno
Sant'Apollonia, before their removal to the Uffizi.

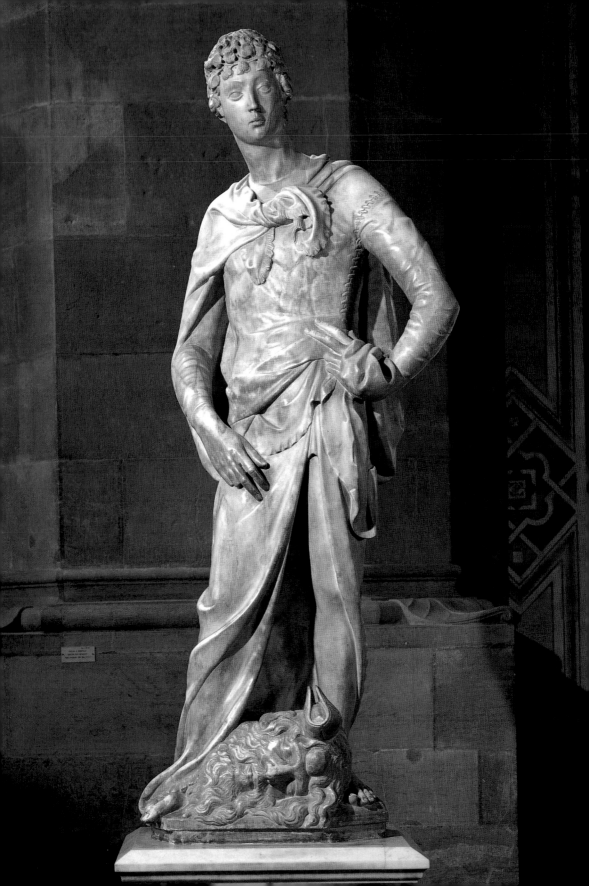

The "Gods" of Florence

he most devastating flood in living memory swept through Florence in 1333 (FIG. 98) and carried much of the past away, including an ancient equestrian statue of Mars that stood at the head of the Ponte Vecchio.

Appropriate to a military outpost, the war god Mars was patron of the Roman town, and in 1333 few if any doubted that the Baptistery had originally been his temple. As the old statue slipped beneath the waters so ended, or so it might seem, the contest between Roman and Christian Florence. But no, paganism was in the mother's milk of the city, the old gods at propitious moments reappearing to assume their roles in the new religion.

Originally it seems there were two Florences, pagan and Christian. The first was the Roman town north of the Arno founded under Caesar, the second on the south bank and two or three centuries younger, stretching from San Miniato down to the Christian burial ground at Santa Felicita. Slowly the spirituality of the second town permeated the first, and the original Baptistery of St. John rose in the sixth or seventh century, in what was to become the holy center of the city.

And two Florences there continued to be. In the early fourteenth century Dante wrote his *Divine Comedy*, the great poem of a journey to salvation brought to life by vivid encounters with pagans who had sinned, and having sinned, are one with us. From Dante on it seemed that the denizens of the pagan and Christian worlds simply could not live without one another, even if at times their encounters seem like family squabbles.

97. DONATELLO
David, 1408-16. Marble,
height 6'3" (191 cm).
Museo Nazionale,
Florence.

One of those squabbles broke out early in the fifteenth century. Fra Giovanni Dominici, encountered earlier as an advocate of art for the instruction of children in piety, preached in the Duomo against the pagan poets, in whom he saw the potential for spiritual ruin. Coluccio Salutati, himself no stranger to the ideals of monasticism, chose to differ, and propounded the Christian merits of Hercules, and the possible virtue of infusing the ethical thought of such men as Plato, Cicero, Seneca, and Marcus Aurelius into the teachings of Christ and the fathers of the church.

The two men were representative of groups that could be called the Ancients and Moderns, to use anachronistic terms. The Ancients were steeped in traditional canonical Christian thought, the Moderns new men, who paradoxically used their fresh encounters with thought older than Christianity itself to forge amended values for a changing society.

Needless to say, this sort of debate had little to do with the religious behavior of an average Florentine, behavior both inherited and largely unexamined. He or she was more interested in the avarice and carnal transgressions of clergy of the sort ridiculed by Boccaccio than in the fine points of theology or what the lettered should or should not read. The man for the street Florentines was Antonino (Antonino Pierozzi; 1389-1459), later to be sainted, a Dominican who with great reluctance, and then only entering the city with bare feet, became their archbishop

98. Photograph of the flood in Florence of November 1966, which may help one imagine the devastation of 1333.

in 1446. Antonino wrote a *Summa Theologica* (theological encyclopedia), later published in four large volumes. But probably few knew that, let alone read his words. The Antonino they knew and loved was a pragmatist dedicated to pastoral activity, and the reform of the clergy and religious houses of the city.

It has been argued that Antonino's time as archbishop (1446-59) was one of spiritual crisis, which was reflected in art. But this is dangerous territory. The gaunt, desiccated wooden sculpture of *Mary Magdalene* by Donatello (FIG. 99) is one of a number of works of art adduced as a visual symptom of this crisis, but then he had already displayed this ascetic style in a statue carved in one of the more confident years, 1438. Domenico Veneziano's

St. Lucy Altarpiece (see FIG. 63, page 105), with its leathery and wiry Baptist contrasting with the idealization of Lucy, suggests another line of argument, that the representation of an ascetic saint required an austere style and is not necessarily indicative of either personal or societal distress.

It is true that Donatello's last works from the 1460s, including remarkable bronze reliefs of the Passion of Christ, have a hallucinatory effect only matched by Paolo Uccello's *Flood* (see FIG. 68, page 111). In the *Lamentation over the Dead Christ* an immensely old, bearded Christ is mourned by hysterical figures, some of whom tear at their hair like ancient Maenads, while specterlike nude horsemen float by in the background (FIG. 100). The scene is rudely and arbitrarily cropped, as if it were taken by a street photographer. These reliefs are mounted in two pulpits in the nave of San Lorenzo, but whether that was their intended location is debated. Rather than being the touchstone of an age, these reliefs are perhaps better thought of as the work of a great artist, who having set the standards for his contemporaries, in a last gesture passed beyond them into a uniquely personal vision.

In general religious art in the third quarter of the century is resolutely naturalistic and unencumbered by obscure meanings. So might be described Benozzo Gozzoli's scenes of the life of St. Augustine at San Gimignano, Fra Filipo Lippi's frescoes at Prato, or that most elegant collaboration of architect, sculptors, and painters in the chapel of the Cardinal of Portugal in San Miniato.

Above
99. DONATELLO
Mary Magdalene, mid-1450s. Painted wood, height 74" (188 cm). Museo dell'Opera del Duomo, Florence.

Wooden statues of this sort were usually painted. While not a common technique in Florence itself, it was one favored in Tuscany, and particularly Umbria.

Left
100. DONATELLO
Lamentation over the Dead Christ, c. 1465. Bronze. San Lorenzo, Florence.

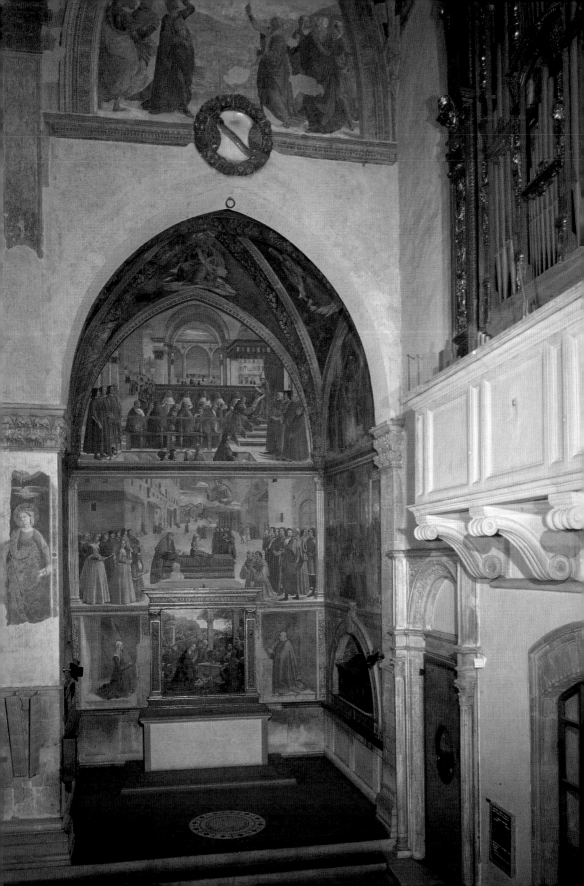

The Sassetti Chapel in Santa Trinità

Similar artistic assumptions pervade the family burial chapel of Francesco Sassetti in Santa Trinità (FIG. 101); it was frescoed in 1480-85 by Domenico Ghirlandaio, who also did the altarpiece, its two tombs carved by a sculptor whose identity is disputed. While Sassetti was no ordinary man, and the chapel is of the highest artistic quality, the thought that informs the ensemble is close to the norm of Florentine burgher sensibility in these years.

Francesco Sassetti, born in 1421, had made his fortune in Geneva, and had risen to become director of the Medici bank in 1469. He had cultivated the tastes of an amateur humanist, supporting humanist undertakings, and amassing a significant collection of manuscripts and coins. His personal life in the 1470s was touched by both sorrow and hope, for he had lost his young son Teodoro, only to be blessed with the birth of Teodoro II in 1478-79. In gratitude for this "rebirth," he apparently made a vow of thanksgiving, of which the chapel is the result. The moment was also a difficult time for Florence, for the Pazzi Conspiracy against the Medici had taken the life of Giuliano de' Medici in 1478, an event that was followed by two years of serious conflict with the papacy.

The iconography of the chapel is seemingly straightforward, with a double dedication to St. Francis, Sassetti's name saint, and to the Nativity, a poignant reminder of the birth of a new child. The panel of the *Adoration of the Shepherds* is on the altar (FIG. 102), while the narrative of the life of St. Francis is frescoed on the walls in the traditional manner. The style is one of naturalism, filled with distinctive portraits of contemporaries and recognizable land- and cityscapes. A fascination with things *all'antica* is joined to this naturalism, in the altarpiece the sarcophagus and ruins replete with invented classical inscriptions, and in the sculptured decoration of the carved tombs and adjacent monochrome paintings based on ancient coins.

The *Vision of Augustus* is frescoed above the entrance arch of the chapel, the emperor believed by some at the time to have been the founder of Florence. His vision was of a savior who would succeed the imperial regime, and the site of the new regime according to Florentine thought, being the New Jerusalem that was Florence itself. The upper fresco on the altar wall represents the *Confirmation of the Franciscan Order by Pope Honorius III* (FIG. 103). This event takes place beyond a wall behind the rank of foreground figures, not in Rome as the story would have it, but in an immediately recognizable Piazza della Signoria with the

101. DOMENICO GHIRLANDAIO Cappella Sassetti, 1482-86. Santa Trinità, Florence.

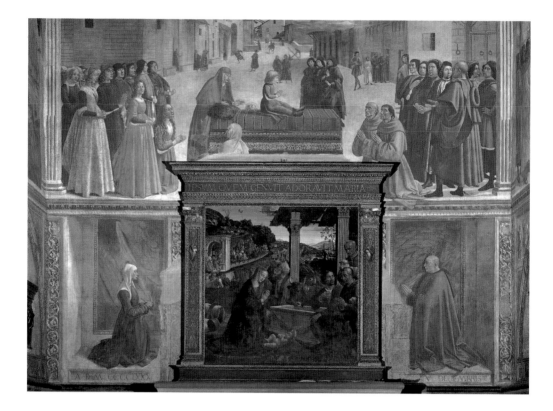

102. DOMENICO
GHIRLANDAIO
*Adoration of the
Shepherds*, 1483-85
(dated 1485). Panel.
Cappella Sassetti,
Santa Trinità, Florence.

Ghirlandaio's altarpiece
is heavily indebted to
the stark naturalism of
the northerner Hugo
van der Goes, whose
large altarpiece (now in
the Uffizi), commissioned
by Tommaso Portinari
for the high altar of San
Egidio, had recently
arrived in Florence.
The portraits of the
donors, Sassetti and
his wife, are frescoed on
the wall on either side
of the altarpiece.

Loggia della Signoria in the background. A preparatory draw-
ing reveals that the scene was at first to be set in a church inte-
rior, so some major re-thinking took place. In accord with the
Vision of Augustus and the recently resolved conflict with the papa-
cy, the revised version offers the piazza as the Florentine equiv-
alent of the Capitoline in Rome, the loggia echoing the deep
arched openings of the Basilica of Constantine.

The autobiographical fingerprints of Sassetti and the drive to
localize the story run throughout the chapel. The scene of *Fran-
cis Renouncing his Patrimony* is set in Geneva, where, far from
renouncing anything, Sassetti made his money. The background
of the Stigmatization of St. Francis shows La Verna and Pisa, where
the Arno runs into the sea. The fresco immediately above the altar-
piece represents the posthumous miracle of *St. Francis Resusci-
tating the Roman Notary's Son*, an event that took place in the Piaz-
za San Marco in Rome, but in the fresco is located in the Piazza
Santa Trinità in Florence.

This last scene is unusual in Franciscan iconography, and is
substituted for the more usual *Apparition at Arles*. It is filled with
contemporary portraits, including Francesco's sons with their
wives and fiancées. The central image of a live boy on a bier

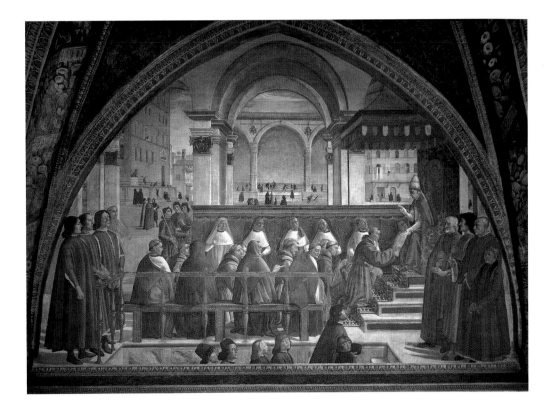

for the dead surely refers to the newborn Teodoro II.

The *Confirmation of the Order* is a most remarkable manipulation of the ostensible subject, which is relegated to a footnote in the scene. The prominent foreground figures, who have nothing to do with the historical event, include Lorenzo de' Medici, on the right, flanked by Antonio Pucci, a loyal Medici follower, and the balding Francesco Sassetti. Three of Sassetti's sons stand on the left. In the center Lorenzo's young sons ascend the stair, accompanied by their tutors, led by Angelo Poliziano (1454-94). Whatever the Franciscan overtones of the scene, its central message celebrates Sassetti's good fortune to live in a golden age under the protection of Lorenzo and his family, to whom he owed both his fortune and his honor.

It would be an error to understand the chapel as a secularization of sacred matters, for the Florentines' sense of their religion lay in enacting it as devout and empathetic participants, whether in procession, mystery plays, or presence in the narrative of a fresco. Any viewer of this private chapel in a fully public place would have understood this without giving it a second thought.

Lorenzo's loyalty to Sassetti was generous, given that these

103. DOMENICO GHIRLANDAIO *Confirmation of the Franciscan Order by Pope Honorius III*, 1482-86. Fresco. Cappella Sassetti, Santa Trinità, Florence.

years saw the collapse of the Medici banks from Milan to London. Whatever the combination of economic and political circumstances, the second half of the century witnessed a growing retreat of Florentine life into the private sphere, the civic spirit of the city with its accompanying architectural and artistic projects increasingly only a memory. A republic was giving way to an imperium under Medici domination, accompanied by a cultural shift toward an elite literary and philosophical culture that had less and less to do with the religious beliefs and behavior of ordinary people.

Marsilio Ficino and the New Florentine Pantheon

The cultural linchpin of this new elite was the scholar Marsilio Ficino (1433-99), son of Cosimo de' Medici's personal physician. Ficino was a devout man and a brilliant linguist. After a religious crisis of some sort in the 1450s, he emerged with a devotion to Plato as against what he saw as the prevailing false doctrine of Aristotelianism. The goal of this self-described doctor of souls became the harmonization of Christian and pagan thought in a new religious doctrine and pious philosophy. Ficino believed that behind apparently diverse appearances and streams of thought lay a concealed wisdom, and behind competing claims a common truth.

Cosimo gave Ficino a house and all the known dialogues of Plato to translate from Greek into Latin, a task completed in draft by 1468-69. In the latter year Ficino began his *Theologica Platonica* (*Platonic Theology*), and in 1473-74 wrote *De christiane religio* (*Concerning the Christian Religion*), books in which he worked out his philosophy of the simultaneity of light, divinity, beauty, love, and the soul. By now a priest, Ficino attempted to fuse pagan theology, Neo-Platonism, and the Judeo-Christian tradition.

Ficino's stress on the word and decoding of apparently contradictory messages meant that only those gifted in words and the conundrums of allegory could hope to know what he was writing about. For this reason the most advanced thought in Florence was destined to be an affair of the salon, not of the streets. And it was to be in the streets in a few short years that the major crisis of Florence was to unfold.

Classical mythology imbued with Christian virtue was a staple of Ficino's thought, and such mythology became a popular subject in Florentine painting and sculpture in the last decades of the century. While a number of attempts have been made to link the complexities of Ficinian doctrine to specific visual images,

it seems most often that allusive, evocative general parallels were involved. Already Salutati had Christianized Hercules, and such overtones probably clung to the Hercules scenes by Antonio del Pollaiuolo (FIG. 104). Other works, such as the various mythologies of Sandro Botticelli, invite and have received erudite interpretations. There were indeed various "divinities" particular to Florence – Christ, the Virgin Mary, the saints; the question arises as to whether Venus, Mars, Minerva, and Pan can be added to this figurative "pantheon," and if so, who embraced it in this expanded form.

104. Antonio del Pollaiuolo *Hercules and the Hydra*, after 1460 (detail of FIG. 72, page 114). Oil on panel 6¾ x 4¾" (16 x 10.5 cm). Uffizi, Florence.

Florence inherited from the Neo-Platonists of late antiquity the notion of myth as an allegorical vehicle for dealing with deep theological and psychological truths, thus circumventing the belief that mythic events had any historical truth, and the embarrassment of explaining the often preposterous behavior of the gods. Myth for Ficino and his circle was the road to concealed wisdom, a road map read by decoding allegorical intricacies. The pagan gods, then, were believable to a learned circle, not as a substitute for Christ, the Virgin, and the saints, but as a complement to them.

Botticelli's Primavera

The loose association between intellectual thought and visual images is suggested by Sandro Botticelli's *Primavera* (*Spring*), probably painted in the early 1480s for one of the old Medici houses in the Via Larga (FIG. 105). The painting has generated as much interpretation as any picture of the Renaissance, save perhaps Leonardo's *Mona Lisa*. These interpretations range from a what-you-see-is-what-you-get paganism to recondite proposals of complex meanings centered in Neo-Platonism.

There is agreement concerning the various literary sources: the ancients – Ovid, Horace, Seneca – and Botticelli's contemporary Angelo Poliziano (1454-94). It follows, then, that the picture does not illustrate one literary text, though it is possible, as has been argued, that there could have been a written program for the subject matter. On the other hand, it could also be the genial eclecticism of a poetic freehand invention. Here scholars sharply differ. Vasari described the painting as "Venus as a symbol of Spring, being adorned by the Graces." While hardly an inclusive explanation, it seems that basically Vasari was right.

105. SANDRO BOTTICELLI
Primavera (*Spring*), early
1480s. Tempera on wood,
6′8″ x 10′4″ (203 x 314 cm).
Uffizi, Florence.

Spring, according to the Roman rustic calendar, unfolds from right to left, beginning where Zephyr, the wind deity of early spring, seizes the nymph Chloris, who metamorphoses into the flower-clad Flora. Venus, with Cupid and his flame-tipped arrow of love above, welcomes us to her bower with a specific rhetorical gesture of greeting, while the Graces dance around to the side. Mercury, the god of May and so also of the end of spring, idly dispels the last remaining clouds with his caduceus (herald's staff) as he turns away to look toward summer. Venus' bower, clad in the freshness of spring, is the garden of love presided over by its generative deity.

The panel, more than ten feet (3 m) wide, projects a mood of aristocratic elegance. The figures float above the greensward against a tapestry-like background of fruit trees, faces idealized

according to the prevailing conventions of female beauty, and diaphanous garments wrought in exquisite linear patterns. The costumes are not archaeological, but old-fashioned. The feel of the visual language is hardly Latin, rather the Italian vernacular of Dante's Earthly Paradise, Petrarch's sonnets, and the sort of sensibility that informs Poliziano's *Stanze per la Giostra del Magnifico Giuliano* (*Stanzas for the joust of Giuliano the Magnificent*) or Lorenzo's own poetry and essay on his sonnets. The picture is generally in the tradition of the decoration of the Palazzo Davanzati, Gentile's *Adoration of the Magi*, Uccello's battle scenes, and Gozzoli's chapel – vernacular, the stuff of medieval romances. *In situ* the painting was probably a *spalliera* set in a wall, perhaps in the wedding chamber of Lorenzo di Pierfrancesco de' Medici and his new bride. At the least it is an invocation of the realm of love to which Venus welcomes us, assuredly an intimate and private place.

Is it a Neo-Platonic picture? Probably not (although others argue otherwise), if one means by that an illustration of some arcane written program that does not survive. On the other hand, love is at the center of the thought of Ficino and his circle. For them Venus is the embodiment of every virtue, her liberality and magnanimity extending to the fertile earth. It has been suggested, but also disputed, that the figures are portraits of actual persons, albeit in idealized form. Whatever the case, to view this picture, and read it in tandem with the poetry of Poliziano and Lorenzo, is to enter a mental landscape filled with vibrant asso-

106. Luca Signorelli
The Realm of Pan,
c. 1490. Panel, 6'4$^{1}/_{2}$"
x 8'5" (194 x 257 cm).
Formerly Staatliche
Museen, Berlin
(destroyed 1945).

ciations, both elegiac and nostalgic.

Vasari writes that Luca Signorelli's (1445/50-1523) so-called *Realm of Pan* (FIG. 106) was painted for Lorenzo de' Medici and therefore before his death in the spring of 1492, an unprovable assertion but one without strong reasons to doubt. Pan was the god of Arcadia, a deity of field and forest, shepherds, flocks, and animals, and so also the god of the cycle of the seasons. According to Ovid he pursued the nymph Syrinx, only to be frustrated when she metamorphosed into reeds, from which to console himself he carved musical pipes.

The painting, in composition conceived as a pagan *sacra conversazione*, represents Pan seated with country folk who play the pipes, among them old shepherds, and idealized nudes, perhaps nymphs of the place. No wholly satisfactory interpretation has been advanced, but the conditions for an interpretation are much as pertain for the *Primavera*: several possible literary sources, uncertainty about the function of the painting in its original setting, the question as to whether contemporary portraits were included, and the place of picture on a spectrum running from a precise program to poetic evocation. Lorenzo and his fellow poets mythologized the countryside around Florence by populating it with gods and nymphs. In the case of Pan, his was the land around the Medici villa at Fiesole, whose dependent peasants were characterized as shepherds. As with all mythologies of these years, given the nuanced climate of Florentine thought, the *Realm of Pan* may have deliberately invited layered readings by highly educated viewers.

Florence and Savonarola

Whatever the case, more than a little of that climate shifted with the death of Lorenzo de' Medici on 8 April 1492. Lorenzo was succeeded by his son Piero, a man of limited political judgment. On 14 August 1494 Charles VIII (1470-98) of France and his army invaded Italy, a prize he had coveted for a decade. His target was Naples, and stupidly Piero made an alliance with that city. The price Florence had to pay to the French was surrender of Pisa and Livorno, and the fortified outposts of Florentine territory on which her very security depended. By mid-autumn Piero and his allies were expelled from the city, and a new government ruled Florence for four turmoil-filled years. As Cosimo and Lorenzo had for decades been the power behind the republic, so now the Ferrarese Dominican Girolamo Savonarola fulfilled the same function from his cell at San Marco.

Such radical political change emerged from the confluence of various events and currents of thought, a profound social and political crisis, a strain of millenarianism (the coming of a thousand-year reign of peace under the rule of Christ) preached by many as the year 1500 approached, and not least, the emergence of a charismatic leader who proposed that the fallen political order should be replaced by a new one based on the old idea of Florence as the Lord's Elect Nation.

In 1491, Savonarola characterized his host city as a place of turpitude and blood, and a den of robbers. With the death of Lorenzo and the unfolding of subsequent political events, Savonarola's preaching reached the city in the form of huge audiences in the Duomo, and his message was one of the great reversals in the history of political rhetoric. At first Savonarola was the prophet of doom and repentance, seizing upon the arrival of Charles as the scourge of the Lord, the new Flood, the new Cyrus with sword of vengeance in hand. But with the Medici expelled and the French

107. ANONYMOUS
The Execution of Savonarola,
1498 or after. Panel.
San Marco, Florence.

This was presumably done shortly after May 1498, though there is no firm evidence for this. The execution is eerily conceived as a casual occurrence among strollers, while in fact the record reports that the piazza was jammed with onlookers.

108. FILIPPINO LIPPI
The Vision of St. Bernard,
c. 1485-90. Tempera on
panel, 6'10" x 6'5" (210
x 195 cm). Church of the
Badia, Florence.

threat past, his message changed. A purged Florence was once
again the chosen city of the Lord, destined for a new and more
glorious age to be marked by lasting peace.

Under Savonarola Florence experienced a sustained spiritu-
al severity. The reign could not last long, for the combined
hostility of the papacy, the Franciscans, and dispossessed fami-
lies led to the friar's downfall. In June 1497, Savonarola was excom-
municated for preaching pernicious doctrine and for disobey-
ing papal orders concerning the administration of San Marco.
Commanded not to preach, as a man driven by divine purpose he
did in fact preach to a huge crowd during Lent of 1498. From then
on the situation deteriorated, culminating in the hanging on 28
May of Savonarola and two of his fellow friars (FIG. 107), after

which their bodies were burned and the ashes ignominiously dumped into the Arno.

The effect of this profound turmoil on art is hard to gauge, but raises fundamental questions about the relations of art and religion. Savonarola was not anti-art, believing it a valid stimulus to devotion. He asked only that images be kept simple, stripped of all superfluous adornment. Vasari lists a number of artists who came under Savonarola's sway, but for only two is there any independent confirmation. Botticelli was one of the artists Vasari named, and there are indeed two paintings by him with probable Savonarolian content. But both seem to date from after the friar's death, and may well have been executed at the specifications of donors rather than as outpourings of the artist's emotions.

109. PIETRO PERUGINO *The Vision of Saint Bernard*, c. 1490-94. Panel, 69¹/₄ x 68" (173 x 170 cm). Alte Pinakothek, Munich.

The repetitive idealization of Perugino's figures, commented upon adversely by Vasari, is in striking contrast to the forthright variety and naturalism of Ghirlandaio.

110. Pietro Perugino
Lamentation over the Dead Christ, 1495. Panel, 84¹/₂ x 76³/₈″ (214 x 195 cm). Pitti, Florence.

Savonarola's call for an austerely simple art, raises the issue as to whether he saw this as an ideal yet unattained, or was favoring the work of an artist or artists whom he does not name. Filippino Lippi's (1457/58-1504) *Vision of St. Bernard* of about 1485-90 is certainly a mainstream exemplar of religious painting in these years (FIG. 108). The subject is lucidly presented, but the way of rendering it is visually discursive, with supplementary events in the background, and so much attention given to landscape details that the eye and mind tend to wander. Pietro Perugino's (1445-1523) altarpiece of the same subject, painted a decade

later, offers a clear stylistic alternative (FIG. 109). The subject is distilled to its essence, with simply garbed figures framed by a sober architecture. Perugino was one of the most popular painters in Florence during the 1490s. In 1495, he painted the *Lamentation Over the Dead Christ* for the convent of Santa Chiara (FIG. 110). While death is at the center of the subject, neither blood nor rigor mortis is emphasized. Restrained mourners, backed by an idealized landscape that knows no season or time of day, surround the body. They are motionless in the crystalline air. While this lack of emphasis on physical death highlights symbolically the sacrament of communion, it also is arguably a personal predisposition of the artist, revealed throughout his career.

Vasari suspected Perugino of disbelief, perhaps an opinion derived from the even-handedly emotional blandness of the latter's pictures. Would not, then, Botticelli be the Savonarolian painter par excellence, openly anguished at one of the events at the heart of the Christian story? Sometime between 1490 and 1500 Botticelli painted the same subject for the church of San Paolino (FIG. 111). The stiffly arched body of Christ fairly exudes physical anguish in the presence of mourners almost sinister in gesture and demeanor. The oblong format of the panel compresses them, the split and faceted rocks of the cave behind threaten-

111. SANDRO BOTTICELLI *Lamentation Over the Dead Christ*, 1490s. Panel, 54³/₈ x 82″ (140 x 207 cm). Alte Pinakothek, Munich.

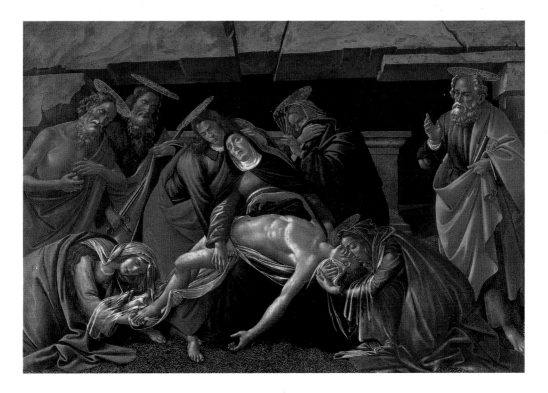

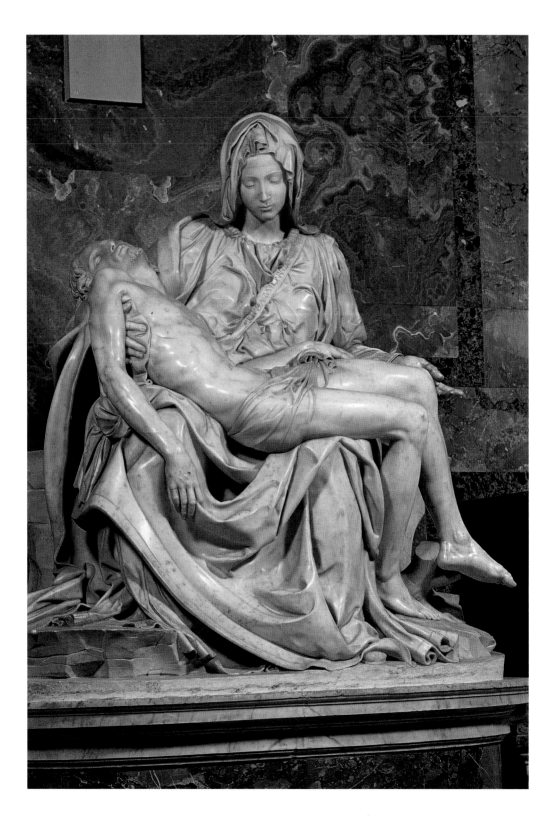

The "Gods" of Florence

ing to break loose and crush the group. The emotional temperature is hot, conveyed both by linear angularity and angry colors that assault the eye. If Perugino denies death, Botticelli mirrors its horror.

112. MICHELANGELO
Pietà, 1498-99. Marble,
height 68" (174 cm).
St. Peter's, Rome.

One of the great works of the century, Michelangelo's *Pietà* of 1498-99 for St. Peter's, followed the road opened by Perugino (FIG. 112). An Apollonian Christ rests upon the lap of his young Mother. The triangular mass is restful, the drapery a fluid configuration of curved lines, as far from Botticelli's distraught angularity as can be imagined. Mother and Son, the same in age and beauty, seem the very embodiment of the theological paradox uttered by St. Bernard in the prayer that opens the last canto of Dante's *Divine Comedy*: "Vergine madre, figlia del tuo figlio" – Virgin Mother, daughter of thy Son.

The God of Florence

The story of early Florence and its art ends sometime around 1500; the age itself saw 1492 (the death of Lorenzo) and 1494 (the French invasion) as the defining events of the close of an era. The years around 1500 make a change from an art based on close study of nature to one whose hallmark is a self-conscious monumentality and idealization of forms. Already Vasari saw Leonardo as the transitional figure, and modern art historians usually call the time between about 1500 and 1520 the "High Renaissance," an unfortunate term in that it suggests progress from the earlier period, which presumably should be called the "Low Renaissance."

From a wider perspective, clearly Florentine republican ideals were terminally ill before the death of Lorenzo, and he was the harbinger of the princely court of the Medici dukes. That court enjoyed what has been called a "stylish style" in art often in the service of autocratic propaganda. While sixteenth-century Florence is often defined as Renaissance, and so would seem to beg comparison with the previous century, the truer comparison surely is with the court of sixteenth-century papal Rome, and both look forward to the princes and courtiers of seventeenth-century Europe.

A work of art that uniquely straddles the old and new is Michelangelo's *David*. His *Pietà* completed in 1499, Michelangelo soon returned to Florence, there in 1501 to receive the commission that confirmed his artistic supremacy. The gigantic *David* (FIG. 113) was expeditiously finished by 1504, and set up outside the entrance to the Palazzo della Signoria, where it was to remain until replaced by a copy in 1873. Giorgio Vasari, writ-

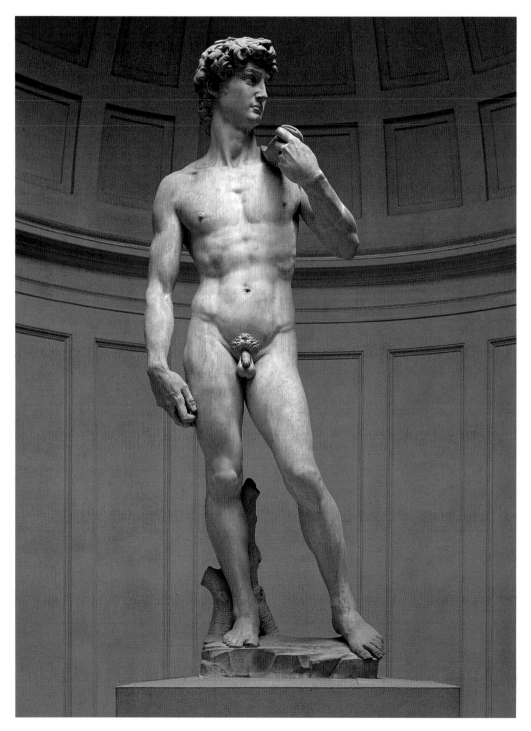

113. MICHELANGELO
David, 1501-04. Marble, height 14'3" (4.1 m).
Accademia, Florence.

ing some forty years after the fact, had no doubts about either its artistic importance or political meaning: "And without any doubt the figure has put in the shade every other statue, ancient or modern, Greek or Roman – this was intended as a symbol of liberty for the Palace, signifying that just as David had protected his people and governed them justly, so whoever ruled Florence should vigorously defend the city and govern it with justice."

It requires an act of will to deal with *David* and restore him to his historical context, to remember that where he stands is not where he stood for four centuries, nor is the latter the place for which he was originally intended.

When Michelangelo undertook the *David*, several things were probably on his mind. Just possibly, one was the sort of political message later attached to the sculpture by Vasari. Another was the tradition of David statues, including those by Donatello and Verrocchio. If these works spurred a covert competition with the past, another rival was more immediately pressing in the form of Leonardo da Vinci, recently returned to Florence after eighteen years in Milan. Probably most compelling for the artist, he knew that the David would mark the culmination of a hundred-year-old project, only fitfully addressed, to adorn the tribune of the Duomo with prophets the size of colossi. *David* would be the biggest and bravest of that sculpted race of heroes begun almost a century earlier, an achievement sure to fan the glory of both the artist and his city.

Many earlier works celebrated the city's history, and honored the fame of the men who forged it. Florence remembered her military leaders in the Duomo itself, as witness the large frescoes of the *condottieri* (soldiers of fortune) Giovanni Acuto and Niccolò da Tolentino, respectively by Paolo Uccello and Andrea del Castagno. No less attention was lavished on writers, such as in the elegant marble tomb in Santa Croce to Leonardo Bruni, historian and second chancellor, carved by Bernardo Rossellino (FIG. 114). Dante and Petrarch were vividly in mind, commemorated in large *intarsia* doors in the Palazzo della Signoria. Late in the fifteenth century, the Florentines commemorated their artis-

114. BERNARDO ROSSELLINO Tomb of Leonardo Bruni, after 1444. Marble. Santa Croce, Florence.

Bruni, chancellor of Florence and state historian of the city, died on 9 March 1444. His funeral was held "according to the custom of the ancients," the body dressed in a toga and crowned with laurel, and a copy of his *Florentine History* placed in his hands.

115. DONATELLO
David, c. 1440 in my view, but various proposals range from c. 1430 to 1445 and after. Bronze, height 5'2¼" (158 cm). Museo Nazionale, Florence.

tic giants with memorial busts mounted in the cathedral. Taken as a group, these works and many others like them are secular talismans, confirming the city's historical importance. As a group, they represent the two highest callings of a man of virtue, arms and letters.

But what of propagandistic art, where more complex symbolism or allegory is brought into play through a cast of mythological and biblical personages? One looks in vain for the heavy-handed sorts of programs dear to the next century, and to Baroque popes, kings, and princes. In the fifteenth century the message was more muted, and indeed it seems that the political significance of works of art was at times assigned to them only after they had been completed.

The theme of David is a case in point. In 1408-09, Donatello carved a prophet *David* for the north side of the cathedral (FIG. 97, page 143). Apparently judged too small to be visually effective, it seems to have been stored until acquired by the Signoria in 1416. Though the details are debated, the figure was then re-carved to stress a warrior David with his sling as against the prophet with a scroll. The sculpture was displayed with an accompanying inscription: "To those who strive mightily for their fatherland the gods will lend aid even against the most fearful foes." As with verbally inscribed paintings of the time, words give the image an iconographical focus that the image unassisted could never quite possess, and may not have been intended to possess in the first place.

Donatello's later bronze *David*, nude but for his hat and leggings, so impassively impenetrable, has elicited many interpretations (FIG. 115). Since neither its date nor original location are known, political interpretations must be speculative. In 1469 it stood in the courtyard of the new Palazzo Medici, and in 1495, after the expulsion of the Medici, was moved to the courtyard of the Palazzo della Signoria. But if it dates to before 1445, as most scholars believe, then it predates the Palazzo Medici, and its original context is a mystery.

But a political meaning of the sculpture is salvageable if it can be connected

to a second work by Donatello, the bronze *Judith and Holofernes* of the 1450s (FIG. 116). This statue probably stood in the garden of the palace, and so would have been on a visual axis with the *David*. It bore two inscriptions: "Kingdoms fall through luxury, cities rise through virtue; behold the neck of pride severed by humility." And the second, "Piero son of Cosimo de' Medici has dedicated the statue of this woman to the liberty and fortitude bestowed on the republic by the invincible and constant spirit of its citizens." This statue, like the *David*, was moved to the Palazzo della Signoria in 1495.

Clearly the names Judith and David are linked, for both were the physically weak who through spiritual fortitude saved their people. If the two sculptures were indeed together at the Palazzo Medici, and if as much as fifteen years separates them in date, then the iconography linking them may be an afterthought arrived at when the second sculpture was executed. Or again, the reading may simply be an invention of modern scholars. So while Michelangelo had a tradition of David-making to look back on, it was sporadic, its sharply-focused political significance in doubt. As an artist, Michelangelo had quite another tradition in mind – that of the prophets and saints of the campanile and Orsanmichele, and the prodigious appearance of a colossus among them.

The idea of the colossus – the famed Colossus of Rhodes, colossi described by the Roman Pliny, the ancient group of the horse tamers of Montecavallo and the remains of a colossal statue of Constantine brought to the Capitoline in Rome – these haunted the imagination of the time. In 1410, Donatello executed a terracotta statue of *Joshua*, similar in size to Michelangelo's David. The work was for the north tribune of the Duomo, and a prominent feature of the cityscape until it finally disintegrated three centuries later. Later Agostino di Duccio, it seems under the direction of Donatello, began work on a marble colossus, abandoned at the latter's death in 1466. It was this block of

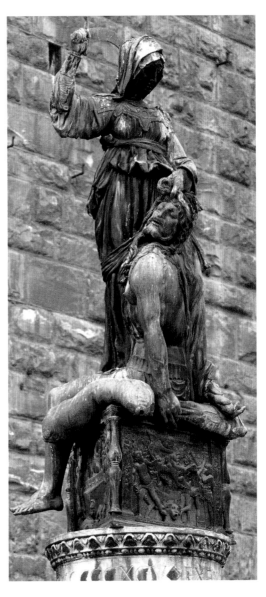

116. DONATELLO
Judith and Holofernes,
c. 1456-57. Bronze, height
7'9" (236 cm). Palazzo
della Signoria, Florence.

The photograph shows the sculpture as it was *in situ* in the Piazza della Signoria, before its removal indoors to the palazzo.

marble that the *operai* (directors of construction) of the Duomo ceded to Michelangelo in 1501.

When finished, the *David* was never put in its intended place, probably because the engineering capability to lift such a piece high on the cathedral simply did not exist. This technological obstacle and the growing threat posed by the pope's bellicose son Cesare Borgia (c. 1475-1507), who had designs on Florentine territory, and perhaps on Florence itself (a situation eerily similar to the Milanese threat of a century earlier), probably influenced the choice of the statue's final destination.

A large advisory committee of artists deliberated on the placement of the *David*. Only two recommended a site at the Duomo, the others split between a location under the central arch of the Loggia della Signoria (apparently Michelangelo's preference), and a position by the west door of the palace, the site finally chosen. That decision taken, the interpretation of *David* as an exhortation to the Florentines and a warning to foreigners that the city had the will and power to vanquish would-be oppressors would have been irresistible.

However, for the average Florentine *David* was simply "il gigante" – the giant – a far larger than life culmination of that group of public sculptures of prophets and saints done in years gone by. David's piercing glance connected with the street (FIG. 117), as had that of Donatello's *St. George* a century earlier (see FIG. 32, page 61). *David* was the epitome of Florentine exaltation of the body, here in full, splendid nudity, a heroic body as vessel for a heroic spirit.

Carved by a man who, like Leonardo, had taken leave of the guild structure and had raised art to an intellectual standing, *David* was the largest of the "gods" of Florence, a Janus-like figure who looked back to a time of steadfast civic virtue, and as it turned out, forward to an age of the physically grand but too often spiritually vacuous. His creator, Michelangelo Buonarroti, Florentine to the core but a mere man, was, thanks to Vasari, dubbed "divino," and so himself entered the pantheon of the "gods" of Florence. This was fair enough, but the miracles that we remember were not miracles of holy persons, but miracles wrought by ordinary mortals; by which of course I mean incomparable Florentines.

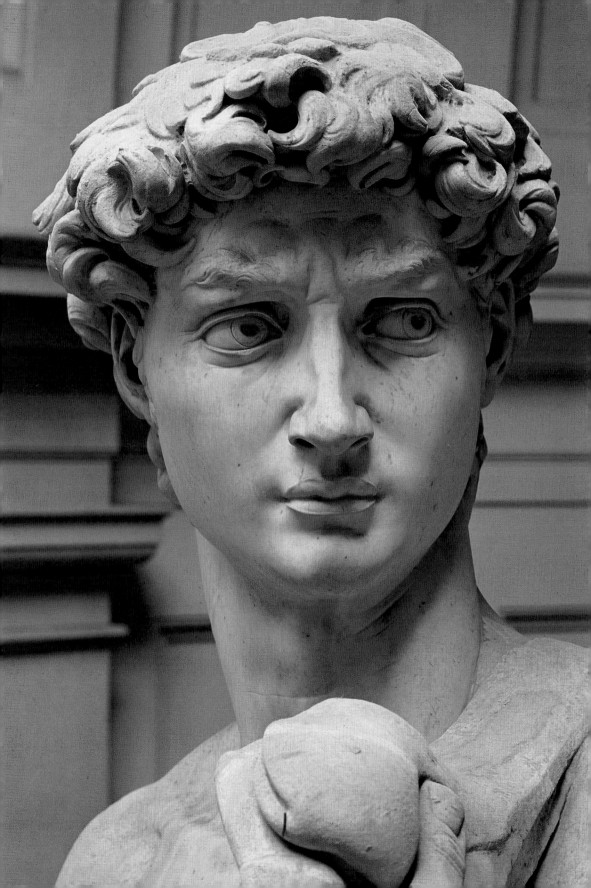

Historical Events

1300–1400

1309-77 Papacy resident in Avignon, France, reducing Rome to a negligible influence

1337 Start of the Hundred Years War between England and France

1346 Bardi and Peruzzi banks fail in Florence

1347-50 Black Death: one-third to one-half of the European population dies

1378 Revolt of Ciompi in Florence, first major labor unrest in the post-medieval west
Papal schism: rival popes until 1417

1385 Giangaleazzo Visconti unites Milan and Pavia

1397 Medici bank founded in Florence

1400–50

1402 Death of Giangaleazzo Visconti spares Florence from invasion by the Milanese

1406 Florence captures Pisa
Portuguese explorations begin in Africa

1434 Return of Cosimo de' Medici from exile

1439 The Council of Florence attempts to unite the Catholic and Orthodox churches

1444 Death of St. Bernardino of Siena

1446 Antonino appointed Archbishop of Florence

1450 Francesco Sforza assumes power in Milan

1450–1500

1453 Fall of Constantinople, Greek scholars flee to Italy

1454 Peace of Lodi: three decades of peace on the Italian peninsula

1464 Death of Cosimo de' Medici

1469 Lorenzo de' Medici becomes head of Medici family

1478 Pazzi Conspiracy: Giuliano de' Medici assassinated

1480s Florentine mathematician Paolo Toscanelli sends map of Atlantic to Columbus

1492 Death of Lorenzo de' Medici
"Discovery" of America

1494 French invasion of the Italian peninsula. Expulsion of the Medici

1494-98 Savonarola assumes power in Florence

Literature	Visual Arts
c. 1300 onwards: First widespread availabilty of paper in Europe	c. 1300 Florentine building boom
c. 1315 Dante's *Divine Comedy*	c. 1300 Frescoes of the life of St. Francis at Assisi
1347 Petrarch, Latin humanist and vernacular poet, crowned in Rome with laurel in the ancient manner	c. 1305 Giotto's frescoes at the Arena chapel, Padua
c. 1348-53 Boccaccio's *Decameron*	c. 1320 Giotto's frescoes at the Bardi and Peruzzi chapels, Santa Croce
1387 Chaucer begins writing *The Canterbury Tales*	1336 Andrea Pisano's Baptistery doors
	1366-67 Decision to raise a dome on Florence cathedral
c. 1400 onwards: Civic writings of the Florentine humanists; including Alberti, Bruni, Palmieri, and Salutati	1402 Baptistery doors competition
1417 Manuscript of Vitruvius discovered	c. 1410-25 Orsanmichele sculptures
early 1430s: Alberti's *On the Family*	c. 1413-23 Brunelleschi's perspective panels
1435 Alberti's *On Painting*	1425-27 Brancacci chapel
1445 Gutenberg prints first book in Europe	1420-36 Cathedral dome
c. 1450 Alberti's *Ten Books on Architecture* Ghiberti's *Commentaries*	1420-30s Brunelleschi's loggia and churches
	1425-52 Ghiberti's "Gates of Paradise" for the Baptistery
	1438-52 Fra Angelico frescoes at San Marco
1460s Ficino's translations of the Platonic corpus	1460s-70s Diversified workshops of Verrocchio and Pollaiuolo
1470s-80s Lorenzo de' Medici the leading Italian poet	1470s-80s Botticelli's mythologies
1470-early 1490s: Development of Ficino and Lorenzo's intellectual circle: Poliziano's *Verses for the joust* Pico della Mirandola's *Oration on the Dignity of Man* Landino's *Commentary on Dante*	1480s Florentine artistic diaspora: –1481 several painters to Rome to work on walls of Sistine chapel –1481-82 Leonardo to Milan –early 1480s Verrocchio to Venice
1490 Aldine Press established in Venice	1495-97 Leonardo's *Last Supper,* Milan
1490s Savonarola's sermons and writings Leonardo begins his *Treatise on Painting*	1501-04 Michelangelo's *David*

Select Bibliography

This selection concentrates on the background and contextual issues of Florentine art. It is biased towards recent scholarship, readability, and availability, but excludes art surveys, museum catalogues, and most monographs on artists, for which see the bibliography in F. Hartt, rev. D. Wilkins, *History of Italian Renaissance Art: Painting, Sculpture, Architecture*, 4th ed. (New York: Prentice Hall and Harry N. Abrams, 1994).

GENERAL HISTORY AND BROAD ISSUES

ANDRES G., J. HUNISAK AND R. TURNER, *The Art of Florence*, 2 vols (New York: Abbeville Press, 1988). The fullest selection of illustrations of Florentine art in any book, mainly in color.

BOLGAR, R., *The Classical Heritage and its Beneficiaries* (Cambridge: Cambridge University Press, 1958)

BORSOOK, E., *The Mural Painters of Tuscany from Cimabue to Andrea del Sarto*, rev. edn (Oxford: Oxford University Press, 1979)

——*The Companion Guide to Florence* (London: Fontana Books, 1973). The most readable guidebook.

BRUCKER, G., *Renaissance Florence* (New York and London: John Wiley and Sons, 1969). A concise synthesis by the American dean of Florentine Renaissance studies, author also of a number of more specialized books, all highly readable.

BURKE, P., *The Italian Renaissance: Culture and Society in Italy*, rev. edn (Princeton: Princeton University Press, 1986) Fundamentally important study of the cultural elite in a social context.

BURCKHARDT J., *The Civilization of the Renaissance in Italy*, 2nd edn (Oxford: Phaidon, 1981). First published in German in 1860, Burckhardt's still most readable book is the indispensable point of departure for a century and a half of literature on the concept of the Renaissance.

GRENDLER, P., *Schooling in Renaissance Italy. Literacy and Learning, 1300-1600* (Baltimore and London: Johns Hopkins University Press, 1989)

HALE, J., *The Civilization of Europe in the Renaissance* (New York: Atheneum, 1994). The last magisterial book by an erudite and gifted writer.

HAY, D., *The Italian Renaissance in its Historical Background* (Cambridge: Cambridge University Press, 1961)

HIBBERT, C., *Florence: The Biography of a City* (New York: Norton, 1993)

HOLMES, G., *Florence, Rome and the Origins of the Renaissance* (Oxford: Clarendon Press, 1986)

LARNER, J., *Culture and Society in Italy, 1290-1420* (London: B. T. Batsford, 1971)

LEWIS, R., *The City of Florence: Historical Vistas and Personal Sightings* (New York: Farrar, Straus, and Giroux, 1995) A delightful book, the latest in a long line of personal books on the city which include those of John Ruskin, Henry James, and Mary McCarthy.

MACADAM, D., *Blue Guide: Florence* (New York: W. W. Norton, 1991)

MARTINES, L., *Power and Imagination: City-States in Renaissance Italy* (New York: Knopf, 1980). Arguably the most successful treatment of this broad and complex subject. The author elaborates the idea of a two-piece Renaissance, the first economic, the second cultural.

MEISS, M., *The Great Age of Fresco: Discoveries, Recoveries, and Revivals* (New York: Braziller, 1970)

PANOFSKY, E., *Renaissance and Renascences in Western Art* (Stockholm: Almquist and Wiskell, 1960)

Touring Club Italiano: Firenze e Dintorni, 6th edn (Milan, 1974). The most thorough guide to Florence.

TREXLER, R., *Public Life in Renaissance Florence* (Ithaca: Cornell University Press, 1991)

WEISS, R., *The Renaissance Discovery of Classical Antiquity* (New York: Humanities Press, 1969)

SOURCES

ALBERTI, L.B., (ed. M. Kemp, trans. C. Crayson), *On Painting* (London: Penguin, 1991)

—— (ed. and trans. J. Rykeart, N. Leach, R. Tavernor), *On the Art of Building in Ten Books* (Cambridge, Mass.: MIT Press, 1988)

—— (trans. and intro. R. Watkins), *The Family in Renaissance Florence* (Columbia, SC: University of South Carolina Press, 1962). The quotation in Chapter 6 is from this translation.

BRUCKER, G., *The Society of Renaissance Florence. A Documentary Study* (New York and London: Harper and Row Inc., 1971)

CASSIRER, E., P. KRISTELLER, J. RANDALL (eds), *The Renaissance Philosophy of Man* (Chicago: University of Chicago Press, 1948)

CENNINI, C. (trans. D. V. Thompson), *The Craftsman's Handbook, "Il Libro dell' Arte"* (New Haven: Yale University Press, 1933; reprint New York Dover, Dover Books, 1954)

FALLICO, A. AND H. SHAPIRO (ed. and trans.), *Renaissance Philosophy Vol. I: The Italian Philosophers* (New York: The Modern Library, 1967)

FICINO, M. (ed. G. Bensi), *Sopra lo Amore ovvero Convito di Platone* (Milan: ES, 1992)

GARIN, E. (ed.), *Prosatori Latini del Quattrocento* (Milan and Naples: Riccardo Ricciardi Editore, 1952)

GHIBERTI, L. (ed. O. Morisani), *I Commentari* (Naples, Riccardo Ricciardi Editore, 1947)

GILBERT, C., *Italian Renaissance Art: Sources and Documents* (Englewood Cliffs and London: Prentice Hall, 1980)

KEMP, M., AND M. WALKER (eds and trans.), *Leonardo on Painting* (New Haven and London: Yale University Press, 1989). The best introduction for the student.

LANDUCCI, L., *A Florentine Diary from 1450 to 1516* (New York: Arno Press, 1969)

HOFSTADTER, A., AND R. KUHNS (eds.), *Philosophies of*

Art and Beauty: Selected Readings in Aesthetics from Plato to Heidegger (New York: The Modern Library, 1964). Selection of writings, including Ficino.

MEDICI, LORENZO DE' (ed. J. Thieme, trans. Thieme et al.), *Lorenzo de' Medici: Selected Poems and Prose* (University Park, PA: The Pennsylvania State University Press, 1991)

POLIZIANO, A. (trans., D. Quint), *The Stanze of Angelo Poliziano* (University Park, PA: The Pennsylvania State University Press, 1993)

RICHTER, J.-P., AND I. RICHTER, *The Literary Works of Leonardo da Vinci* (London: Phaidon, 1970)

VARESE, C., *Prosatori Volgari del Quattrocento* (Milan and Naples: Riccardo Ricciardi Editore, 1955)

VASARI, G., (ed. Gaetani Milanesi), *Vite de' più eccellenti pittori scultori, ed architettori*, 9 vols (Florence: Sansoni, 1877-85)

—— (trans. G. Bull), *Lives of the Artists*, 2 vols (Harmondsworth: Penguin Books, 1965 and 1987). A handy and excellent translation of selected lives of major artists.

VESPASIANO DI BISTICCI, *Renaissance Princes, Popes and Prelates. The Vespasiano Memoirs: Lives of Illustrious Men of the XVth Century* (New York and London: Harper and Row, 1963)

VILLANI, G., *La Prima Parte delle Historie Universali de suoi Tempi* (Venice: Ad instantia di Giunti di Fiorenza, 1559)

INTRODUCTION

ARTUSI, L., *Le arti e I mestieri di Firenze* (Rome: Newton Compton Editori, 1990)

BELTING, H., *Likeness and Presence. A History of the Image before the Era of Art* (Chicago and London: University of Chicago Press, 1994)

KREYTENBERG, G., *Orcagna's Tabernacle in Orsanmichele Florence* (New York: Abbeville Press, 1994). See also D. Hay, *The Italian Renaissance*, for an expanded consideration of issues raised in the introduction.

ONE: THE CITY RISES

FANELLI, G., *Firenze: Archittetura e città* (Florence: Vallechi Editore, 1973). A comprehensive work on Florence from the beginnings to our time (unfortunately hard to find outside major libraries).

FEI, S., G. SICA, AND P. SICA, *Firenze: Profilo di Storia Urbana. An Outline of Urban History* (Florence: Alinea Editrice, 1995). Parallel Italian and English texts. Basically a radical condensation of Fanelli, *Firenze*, though original.

NORMAN, D. (ed.), *Siena, Florence and Padua: Art, Society and Religion 1280-1400*, 2 vols (New Haven and London: Yale University Press, 1995). Astute text and wide selection of illustrations.

PUCCI, E., *Com' era Firenze 100 anni fa* (Florence: Bonechi Editore, 1969). Old views of the city before modern "improvements."

RUBENSTEIN, N., *The Palazzo Vecchio, 1298-1532: Government, Architecture, and Imagery in the Civic Palace of the Florentine Government* (Oxford: Clarendon Press, 1995)

TWO: THE MARKETPLACE OF ART

In the interests of convenience, writings on art patronage are listed here. However, many of these works are also relevant to other topics in this book.

AMES-LEWIS, F., intro. E. Gombrich, *Cosimo 'Il Vecchio' de' Medici, 1389-1464* (Oxford: Clarendon Press, 1992). Chapters on patronage.

AMES-LEWIS, F. (ed.), *The Early Medici and their Artists* (London: Birkbeck College)

BEYER A., AND B. BOUCHER, *Piero de' Medici "Il Gottoso" (1416-1469): Kunst im Dienste der Mediceer* (Berlin: Academie Verlag, 1993). Essays in several languages.

CHAMBERS, D. S., *Patrons and Artists in the Italian Renaissance* (London: Macmillan, 1970)

GLASSER, H., *Artists' Contracts of the Early Renaissance* (New York: Garland Press, 1977)

GREGORI, M., AND S. BIASIO, *Firenze nella pittura e nel disegno dal Trecento al Settecento* (Milan: Silvona, 1994)

HOLLINGSWORTHY, M., *Patronage in Renaissance Italy* (Baltimore: The Johns Hopkins University Press, 1982)

JACOB, E., *Italian Renaissance Studies: A Tribute to the Late Cecilia M. Ady* (London: Faber and Faber, 1960). Contains an important essay on Medici patronage by E. Gombrich. Also printed in Gombrich's *Norm and Form* (Oxford: Phaidon, 1966).

KEMPERS, B., *Painting, Power, and Patronage: The Rise of the Professional Artist in the Italian Renaissance* (London: Allen Lane, 1992)

KENT, F., AND P. SIMONS (eds), *Patronage, Art, and Society in Renaissance Italy* (Oxford: Clarendon Press, 1987)

MARTINDALE, A., *The Rise of the Artist in the Middle Ages and Early Renaissance* (New York: McGraw Hill, 1972)

THOMAS, A., *The Painter's Practice in Renaissance Tuscany* (Cambridge: Cambridge University Press, 1995)

WACKERNAGEL, M., T*he World of the Florentine Renaissance Artist: Projects and Patrons, Workshop and Art Market* (rep. Princeton: Princeton University Press, 1981). This 60-year old book remains a sound overview.

THREE: SPEAKING STATUES

ARTUSI, L., AND S. GABRIELLI, *Orsanmichele in Firenze* (Florence: Edizione Becocci-Canto de' Nelli, 1982)

BARON, H., *The Crisis of the Early Italian Renaissance: Civic Humanism and Republican Liberty in an Age of Classicism and Tyranny* (Princeton: Princeton University Press, 1955)

JANSON, H., *The Sculpture of Donatello*, 2 vols (Princeton: Princeton University Press, 1957). The basic catalogue. See also books by J. Pope-Hennessy (1993); Bennett and Wilkins (1984); and J. Poeschke (1990), the latter two usefully placing the sculptor in a wide context.

KRAUTHEIMER, R., AND T. KRAUTHEIMER-HESS, *Lorenzo Ghiberti* (Princeton: Princeton University Press, 1956). Six final chapters on broad problems of early Renaissance art.

SHEARMAN, J., *Only Connect…Art and the Spectator in the Italian Renaissance* (Princeton: Princeton University Press, 1992)

FOUR: IN THE SHADOW OF THE DOME
ARGAN, G., "The Architecture of Brunelleschi and the Origins of Perspective Theory in the Fifteenth Century," *Journal of the Warburg and Courtauld Institutes*, 9 (1946): pp. 96-121

GOLDTHWAITE, R., *The Building of Renaissance Florence* (Baltimore: The Johns Hopkins University Press, 1980)

JARZOMBEK, M., *Leon Battista Alberti: His Literary and Aesthetic Theories* (Cambridge, Mass: MIT Press, 1989)

JENKINS, A. D. F., "Cosimo de' Medici's Patronage of Architecture and the Theory of Magnificence," *Journal of the Warburg and Courtauld Institutes*, 33 (1970): pp. 162-70

MILLON, H. A., AND V. MAGNANO-LAMPUGNANI (eds), *The Renaissance from Brunelleschi to Michelangelo: The Representation of Architecture* (exh. cat.; Venice: Palazzo Grassi, 1994; London: Thames and Hudson, 1994)

PEROSA, A., *Giovanni Rucellai ed il suo Zibaldone I: "Il Zibaldone Quaresimale"* (London: Warburg Institute, 1960)

RYKWERT, J. AND A. ENGEL (eds), *Leon Battiste Alberti* (exh. cat; Mantua: Palazzo del Tè, 1994; Milan: Olivetti/Electa, 1994). See, in particular, the essay by R. Tavernor, p. 300ff.

SMITH, C., *Architecture in the Culture of Early Humanism: Ethics, Aesthetics, and Eloquence, 1400-1470* (New York and Oxford: Oxford University Press, 1992). A brilliant book, on which I have relied heavily in parts of Chapter 4.

THOMSON, D., *Renaissance Architecture: Critics, Patrons, Luxury* (Manchester and New York: Manchester University Press, 1993)

WITTKOWER, R., *Architectural Principles in the Age of Humanism*, rev. edn (London: Alec Tiranti, 1962)

FIVE: THE WORLD SEEN THROUGH A WINDOW
ANDREWS, L., *Story and Space in Renaissance Art: The Rebirth of Continuous Narrative* (Cambridge: Cambridge University Press, 1995)

BAXANDALL, M., *Giotto and the Orators* (Oxford: Clarendon Press, 1971). The important relation of Alberti's *On Painting* to rhetorical writing of the ancients, only mentioned in Chapter 5, is explored fully here.

—*Painting and Experience in Fifteenth-Century Italy* (Oxford: Clarendon Press, 1972)

BLUNT, A., *Artistic Theory in Italy, 1450-1600* (Oxford: Clarendon Press, 1966). Dated in particulars, but a useful introduction to this subject.

BURCKHARDT, J., *The Altarpiece in Renaissance Italy* (Cambridge: Clarendon Press, 1988)

DAMISH, H., *The Origin of Perspective* (Cambridge, Mass., and London: MIT Press, 1994)

EDGERTON, S., *The Renaissance Rediscovery of Linear Perspective* (New York: Basic Books, 1975)

—— *The Heritage of Giotto's Geometry: Art and Science on the Eve of the Scientific Revolution* (Ithaca and London: Cornell University Press, 1991)

ELKINS, J., *The Poetics of Perspective* (Ithaca and London : Cornell University Press, 1994). I find this account persuasive, and am much indebted to it. The reader, however, should be aware that there is little consensus on interpretation of perspective as an intellectual phenomenon.

HUMFREY, P., AND M. KEMP (eds), *The Altarpiece in the Renaissance* (Cambridge: Cambridge University Press, 1990)

KEMP, M., *Leonardo da Vinci: The Marvellous Works of Nature and Man* (Cambridge, Mass.: Harvard University Press, 1981). The best general book on Leonardo the artist and scientist.

—— *The Science of Art: Optical Themes in Western Art from Brunelleschi to Seurat* (New Haven and London: Yale University Press, 1990)

KLEIN, R., *Form and Meaning* (New York: Viking, 1979)

KRAUTHEIMER, R., AND T. KRAUTHEIMER-HESS, *Lorenzo Ghiberti* (Princeton: Princeton University Press, 1956). Includes a chapter on the origins of perspective.

KUBOVY, M., *The Psychology of Perspective and Renaissance Art* (Cambridge: Cambridge University Press, 1986)

PANOFSKY, E. (trans. C. Wood), *Perspective as Symbolic Form* (New York: Zone Books, 1991). The opening salvo of the perspective wars first appeared in German in 1924. Extremely difficult; clarifying essay by the translator C. Wood.

WHITE, J., *The Birth and Rebirth of Pictorial Space*, 3rd edn (London: Faber and Faber, 1989)

SIX: HOME ECONOMICS
ACKERMAN, J., *The Villa: Form and Ideology of Country Houses* (Princeton: Princeton University Press, 1990)

ALEXANDER, J. J. G. (ed.), *The Painted Page: Italian Renaissance Book Illumination, 1450-1550* (exh. cat.; London: Royal Academy of Arts; and New York: Pierpont Morgan Library, 1994; Munich and New York: Prestel, 1994)

BARRIAULT, A., *Spalliera Paintings of Renaissance Tuscany: Fables of Poets for Patrician Homes* (University Park, Pa.: The Pennsylvania State University Press, 1994)

CAMPBELL, L., *Renaissance Portraits* (New Haven and London: Yale University Press, 1990)

DUBY, G. (ed.), *A History of Private Life. II: Revelations of the Medieval World* (Cambridge, Mass., and London: Harvard University Press, 1988)

FRANCOVICH, R., *Maiolica Arcaica Toscana e "Zaffera a rilievo"* (Florence: S.P.E.S., 1989)

GOLDTHWAITE, R., *Wealth and Demand for Art in Italy, 1300-1600* (Baltimore: John Hopkins University Press, 1993)

HOOD, W., *Fra Angelico at San Marco* (New Haven and London: Yale University Press, 1993)

KING, M., *Women of the Renaissance* (Chicago and London: University of Chicago Press, 1991). The best introduction to this subject.

KLAPISCH-ZUBER, C., *Women, Family, and Ritual in Renaissance Italy* (Chicago: University of Chicago Press, 1985)

PHILLIPS, M., *The Memoir of Marco Parenti: A Life in Renaissance Florence* (Princeton: Princeton University Press, 1987)

POPE-HENNESSY, J., *The Portrait in the Renaissance* (New York: Pantheon Books, 1966)

POPE-HENNESSY, J., AND K. CHRISTIANSEN, "Secular Painting in 15th-Century Tuscany. Birth Trays, Cassone Panels, and Portraits," *Metropolitan Museum of Art Bulletin*, XXXVIII (Summer 1980): pp. 4-64

THORNTON, P., *The Italian Renaissance Interior, 1400-1600* (New York: Harry N. Abrams, 1991)

SEVEN: THE "GODS" OF FLORENCE

ADRIANI, M., *Firenze Sacra* (Florence: Nardini Editore, 1990)

ANGELERI, C., *Il Problema Religiosa del Rinascimento: Storia della Critica e Bibliografia* (Florence: Felice Le Monnier, 1952)

BORSOOK, E., AND J. OFFERHAUS, *Francesco Sassetti and Ghirlandaio at Santa Trinità, Florence: History and Legend in a Renaissance Chapel* (Doornspijk: Davaco Publishers, 1981)

CARDINI, F., *Lorenzo il Magnifico* (Rome: Libreria dello Stato Editalia, 1992)

CHASTEL, A., *Art et Humanisme à Florence au temps de Laurent le Magnifique* (Paris: Presses Universitaires de France, 1959)

DEMPSEY, C., *The Portrayal of Love: Botticelli's Primavera and Humanist Culture at the Time of Lorenzo the Magnificent* (Princeton: Princeton University Press, 1992)

FALLANI, G., *La Letturatura Religiosa Italiana. Profilo e Testi* (Florence: Felice Le Monnier, 1963)

GOMBRICH, E., *Symbolic Images: Studies in the art of the Renaissance* (London: Phaidon, 1972). Section on Botticelli and Neo-Platonism.

HANKINS, J., *Plato in the Italian Renaissance* (Leiden and New York: E.J. Brill, 1991)

HIRST, M., and J. DUNKERTON, *Making and Meaning: The Young Michelangelo* (London: National Gallery Publications Limited, 1994)

MELTZOFF, S., *Botticelli, Signorelli and Savonarola. Theologia Poetica and Painting from Boccaccio to Poliziano* (Florence: Leo S. Olschki Editore, 1987)

SEYMOUR, C., *Michelangelo's David. A Search for Identity* (Pittsburg: University of Pittsburg Press, 1967)

STEINBERG, R., *Fra Girolamo Savonarola: Florentine Art and Renaissance Historiography* (Athens, Ohio: Ohio University Press, 1977)

VERDON, T., AND J. HENDERSON (eds), *Christianity and the Renaissance: Image and Religious Imagination in the Quattrocento* (Syracuse: Syracuse University Press, 1990)

WEINSTEIN, D., *Savonarola and Florence: Prophecy and Patriotism in the Renaissance* (Princeton: Princeton University Press, 1970)

Picture Credits

Collections are given in the captions alongside the illustrations. Sources for illustrations not supplied by museums or collections, additional information, and copyright credits are given below. Numbers are figure numbers unless otherwise indicated.

Fratelli Alinari, Florence: 12; 41; 48; 52; 96 below
Artothek, Peissenberg, Germany: 109; 111
Raffaello Bencini, Florence: 23
Berenson Collection, Florence, reproduced by permission of the President and Fellows of Harvard College: 81 (photo Studio Fotografico Quattrone, Florence)
Biblioteca Medicea Laurenziana, Florence: 4 (MS Tempi 3, c 79)

Bildarchiv Preussischer Kulturbesitz, Berlin: 57; 87; 106
Courtesy of the antique dealer Alberto Bruschi, Florence: 51
Italfoto Gieffe, Florence: 98
The Metropolitan Museum, New York, Rogers Fund, 1918 (18.117.2): 84
All rights reserved Museo del Prado, Madrid: 86
Studio Fotografico Quattrone, Florence: frontispiece; 1; 2; 3; 5; 6; 7; 8; 9; 10; 11; 13; 14; 16; 19; 20; 21; 22; 24; 25; 26; 28; 29; 30; 31; 33 left; 34; 35; 36; 37; 43; 45; 46; 47; 53; 55; 56; 58; 59; 60; 61; 62; 63; 66; 67; 68; 69; 70; 71; 72; 73; 74; 75; 76; 77; 78; 80; 82; 85; 91; 92; 93; 95; 96 right; 97; 99; 100; 101; 102; 103; 104; 105; 107; 108; 110; 113; 114; 115
Biblioteca Riccardiana, Florence: 94 (Ricc.492 c.18)

Réunion des Musées Nationaux, Paris: 88
Scala, Florence: 15; 17; 27; 39; 40; 42; 49; 50; 64; 65; 79; 112; 116; 117

Detail page 9, from FIG. 4 (Biblioteca Medicea Laurenziana, Florence)
Detail page 23, from FIG. 10 (photo Quattrone)
Detail page 35, from FIG. 17 (photo Quattrone)
Detail page 51, from FIG. 30 (photo Quattrone)
Detail page 69, from FIG. 46 (photo Quattrone)
Detail page 91, from FIG. 58 (photo Quattrone)
Detail page 117, from FIG. 95 (photo Quattrone)
Detail page 143, from FIG. 105 (photo Quattrone)

Index